HIGH ABOVE THE CANADIAN ROCKIES

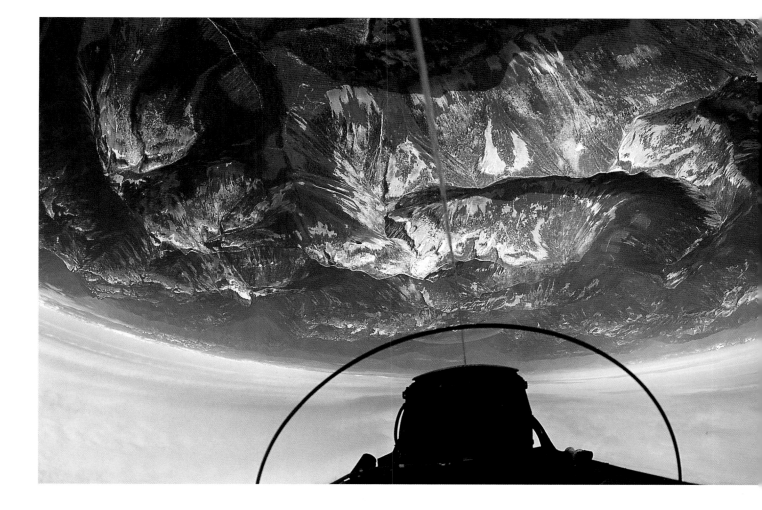

HIGH ABOVE
THE CANADIAN
ROCKIES

Russ Heinl

FIREFLY BOOKS

A Firefly Book

Published by Firefly Books Ltd. 1998

Cataloguing in Publication Data

Heinl, Russ, 1949
 High above the Canadian Rockies
ISBN 1-55209-232-1
1. Rocky Mountains,
Canadian (B.C. and Alta.)—Aerial photographs. I. Title
FC219.H44 1998 917.11'0022'2 C97-932808-X
F1090.H44 1998

Design: Adams + Associates Design Consultants Inc.
Production: Denise Schon Books Inc.

Published in Canada in 1998
by Firefly Books Ltd.
3680 Victoria Park Avenue
Willowdale, Ontario
Canada M2H 3K1

Published in the United States in 1998
by Firefly Books (U.S.) Inc.
P.O. Box 1338, Ellicott Station
Buffalo, New York
USA 14205

We acknowledge the financial support of the Government of
Canada through the Book Publishing Industry Development
Program for our publishing activities.

Printed and bound in Canada by Friesens, Altona, Manitoba

Russ Heinl's images are available from:
Image Network Inc., 16 East 3rd Avenue
Vancouver, BC, Canada V5T 1C3
tel: (604) 879-2533 fax: (604) 879-1290

To Linda and Ralph Bodine, wonderful friends whose generous support and endless encouragement made *High Above the Canadian Rockies* possible. Thank you both so much.

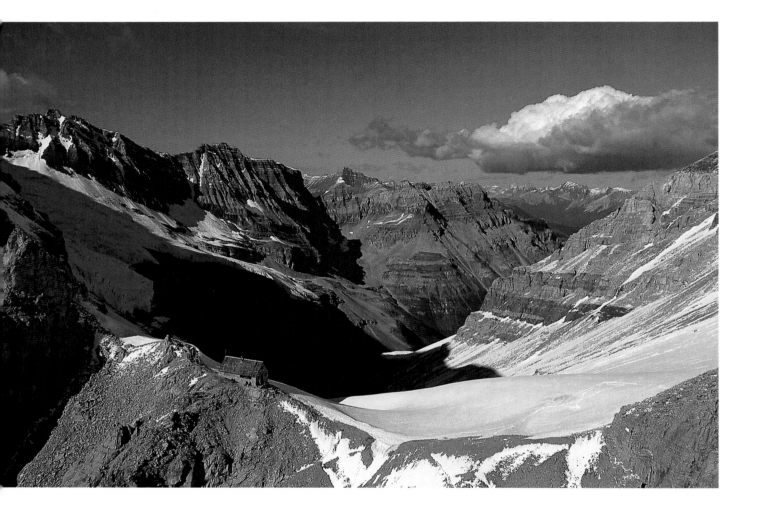

Acknowledgments

Special thanks to:

All those at Canadian Helicopters (especially Dean Bass, Carol Bennett, Ward Huntley, Al Miller, Derick Robinson, and Don McTighe) who worked so diligently to make our missions a complete success ... and were just plain fun to fly with. Thanks guys, and safe flying.

Pilot Dale Brady and everyone else at Yellowhead Helicopters, for some simply excellent flying. And to Garry Forman for his cooperation and kindness. And to B'Doll, for keeping things lively at the heli base.

Mark D. Hoole, Esq., for keeping all systems in trim and not glued up. Cheers, Mark.

Marsha Lee of Fuji Photo Film Canada for her encouragement and technical support. All the gang at Lens & Shutter in Victoria, BC, for their expert photog advice and excellent service (much appreciated Garry, Mark, Simon, and Sterling). Henry and Ron at Ken-Lab for building the world's finest gyro stabilizers, which keep my aerial world spinning round and round.

And very special thanks to my wife Anne, my son Matthew, and my daughter Megan. You have constantly encouraged and supported my aerial photographic efforts. Without your endless love and support, I could not have shot this book.

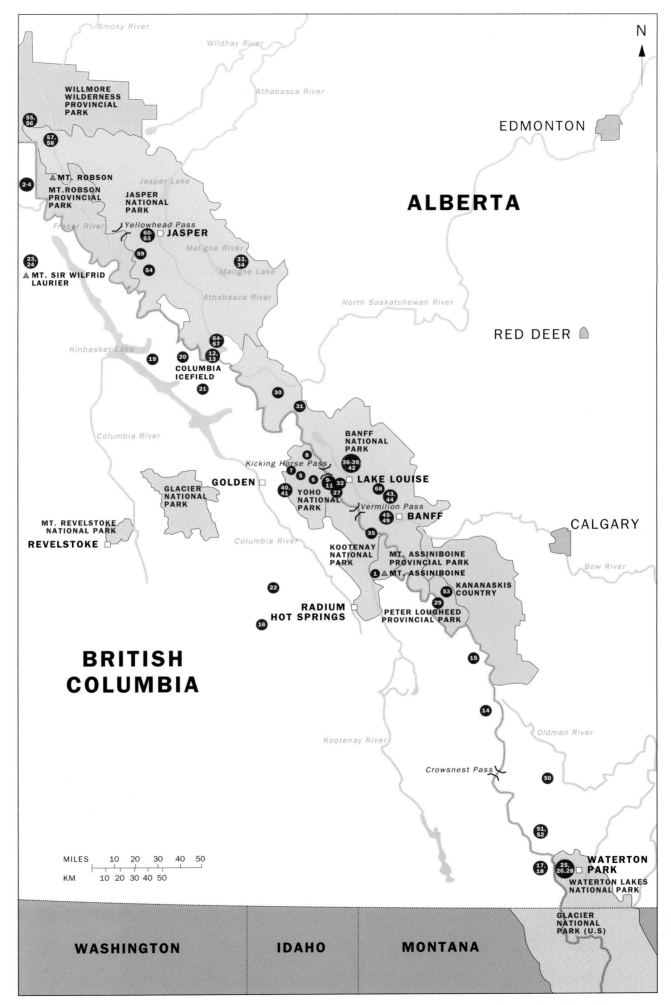

N

Aerial Photographer's Notes

We all agreed from the very start that shooting an aerial book on the legendary Canadian Rockies would be a challenge. Towering, gothic peaks newly chiseled from the earth's very crust. Pristine wilderness areas. Solitary alpine meadows. Long, low serpentine valleys coiling through the very belly of the Great Divide. And massive Ice Age glaciers of monolithic proportions straddling the Continental Divide, their meltwaters flowing spiderlike to all three of Canada's great oceans.

We felt it paramount to stay true to our original vision of the Canadian Rockies, probably best described as "Yoho" by the Cree Indians, a word used to express a deep and powerful sense of wonderment.

The helicopter allows me the total control needed to gain a sense of intimacy with a subject. I then become stimulated by that subject, and the portrait that follows is a reflection of my spontaneous feelings. The style of photography runs the gamut – from sweeping, majestic landscapes to dramatic close-ups accomplished only from an aerial platform equipped with a gyro-stabilized camera and long, fast glass. Shadows and counterpoint have been fully exploited at every opportunity for their visual sense of tension and drama. This is not passive photography!

My principal rotary machines of choice have been Bell 206 Jet Rangers and A-Star AS-350s. The beautifully smooth, fast, and powerful A-Stars were pressed into service for high altitude, subzero, and long-range missions. The Jet Rangers were, as always, our reliable workhorses. Helicopter doors must be removed or slid back regardless of prevailing weather conditions, sometimes at great

discomfort to both pilot and photographer, since shooting through plexi is counterproductive to achieving a sharp, clear image on film.

Helicopters were used for all but two shots in this book. The Snowbirds' graceful roll over the Rockies was shot from one of their Canadair CT-114 Tutors, which was used as a chase plane. I took the other shot from the rear seat of an inverted "T-Bird" T-33 Silver Star Jet Trainer, using a fish-eye lens. At such a high speed and high altitude, it was impossible for me to keep track of the landscape spinning below – although I'm sure (and do hope) the pilot knew where we were.

The cameras used consisted of a pair of gyro-stabilized Nikon F4s camera bodies combined with an arsenal of Nikon lenses ranging from a 16-mm fish-eye to a massive 600-mm telephoto. The choice of film was almost exclusively Fuji Velvia, the exception being the Mount Assiniboine shots recorded on Kodak Lumiere 100X for its slightly quicker speed and warm tonality.

The Canadian Rockies have been well photographed by many before me. I hope, however, that this unique aerial portrait of such a famous and endearing subject will ignite the adventurer in you as you join me on this aerial journey high above the Canadian Rockies.

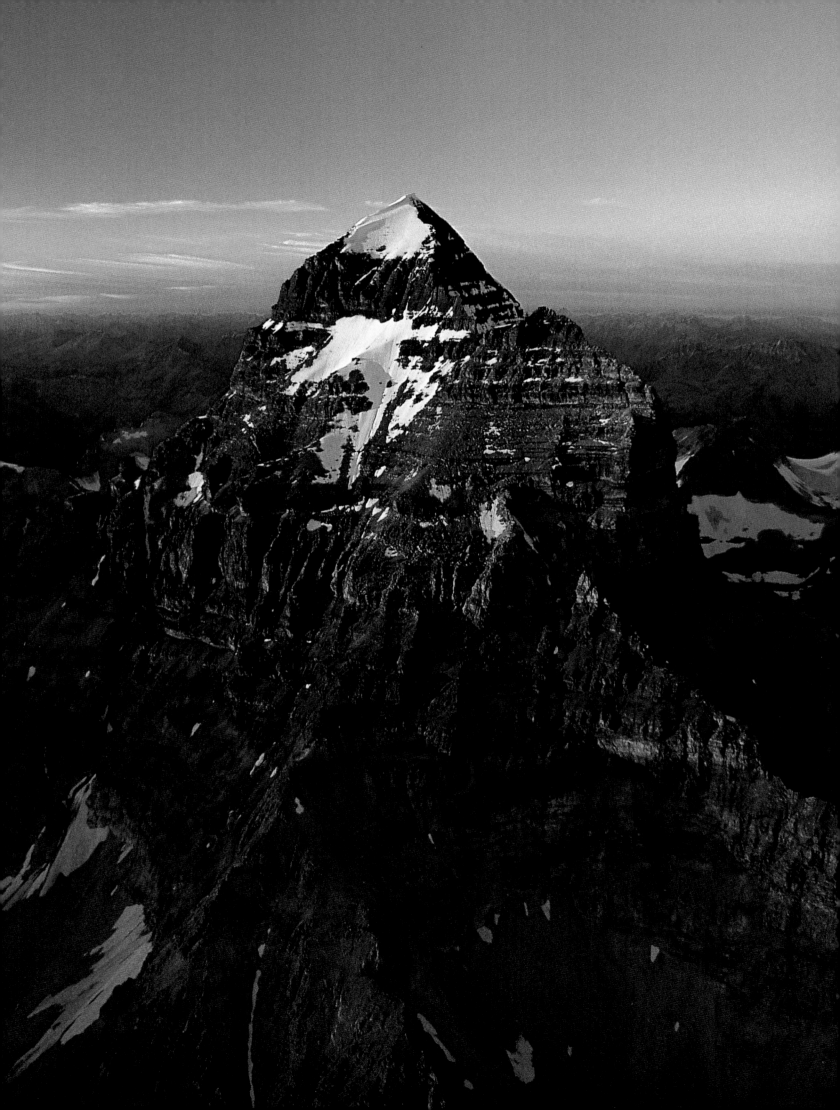

Left

Indian Peak on Mount Assiniboine stretches skyward, warmly illuminated by the final moments of a fading Rocky Mountain sunset. To the east over its shoulders, Banff National Park can be seen in the distance. [1]

Pages 18 and 19

Glacial water flows from Berg Lake and over Emperor Falls, snaking around Mount Robson. [2]

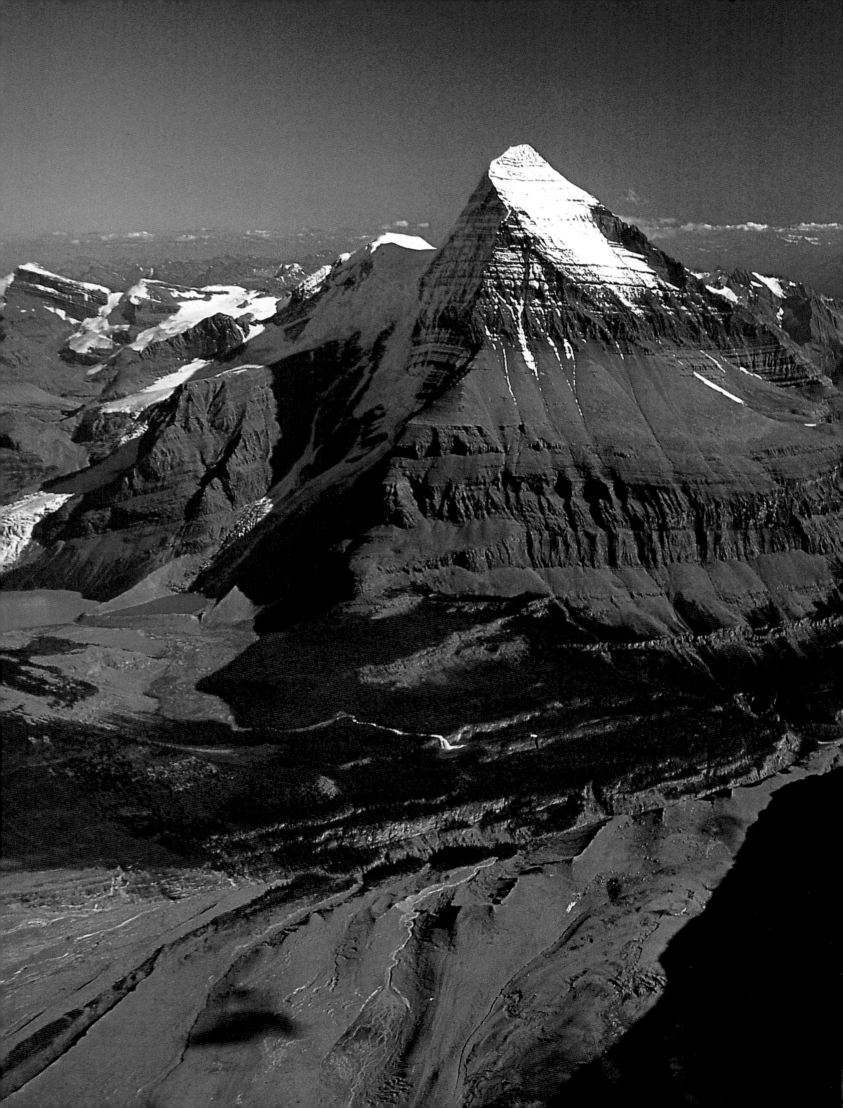

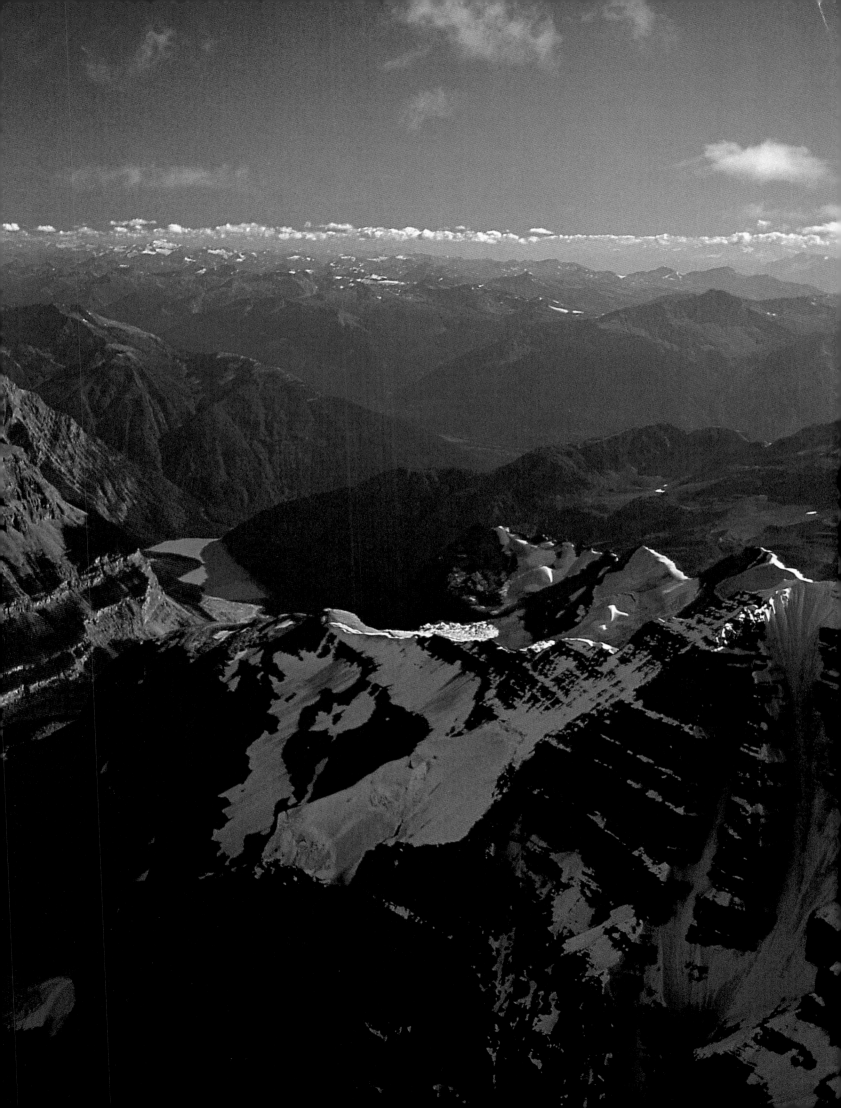

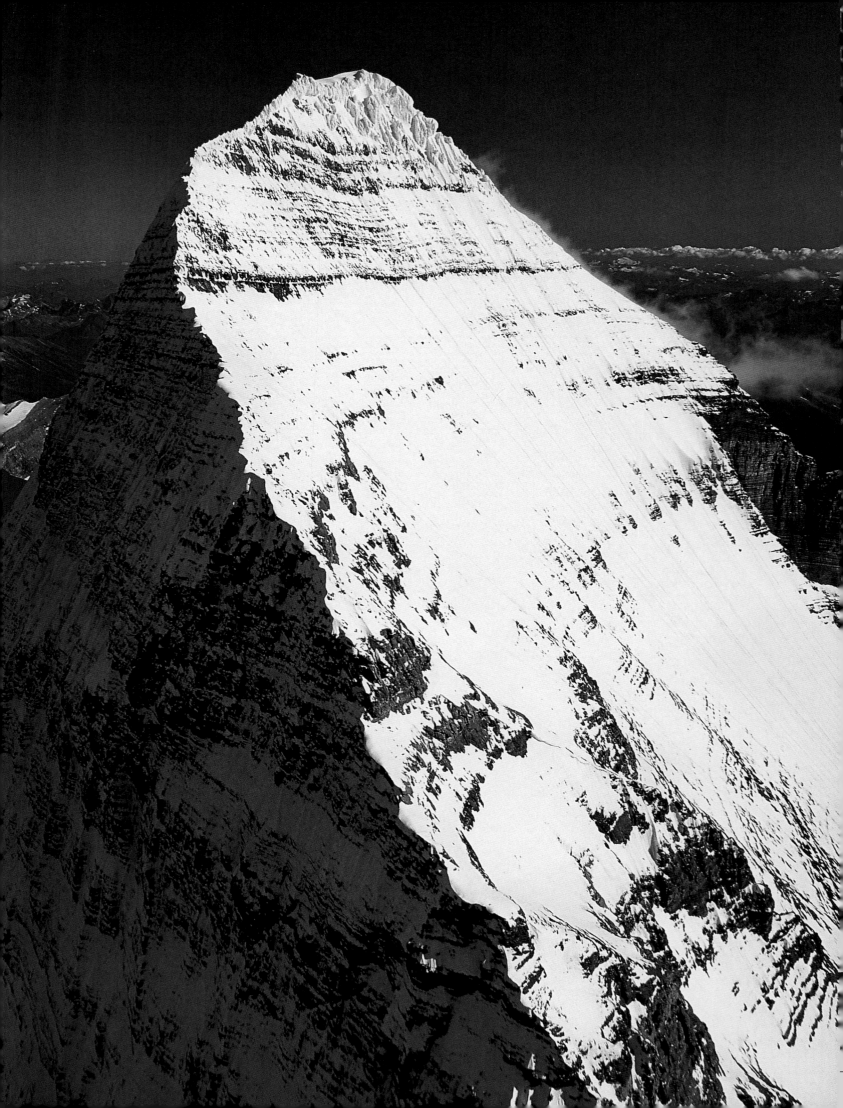

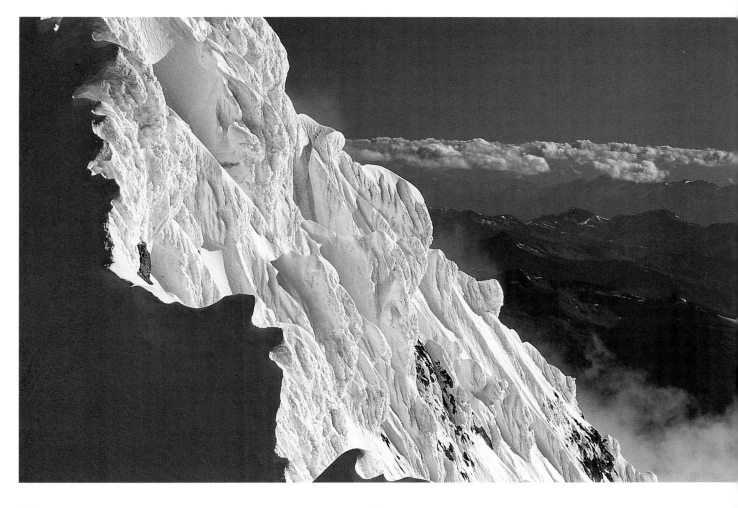

Left

Dramatically rising to 3954 metres (12,972 feet), Mount Robson's summit is the highest point in the Canadian Rockies. [3]

Above

The rare gargoyles of Mount Robson are found only on the ridge at the summit. [4]

Pages 22 and 23

Off the beaten path in Yoho National Park, the Magnificent Cascade falls into the Otterhead River, which eventually winds into the Kicking Horse River. [5]

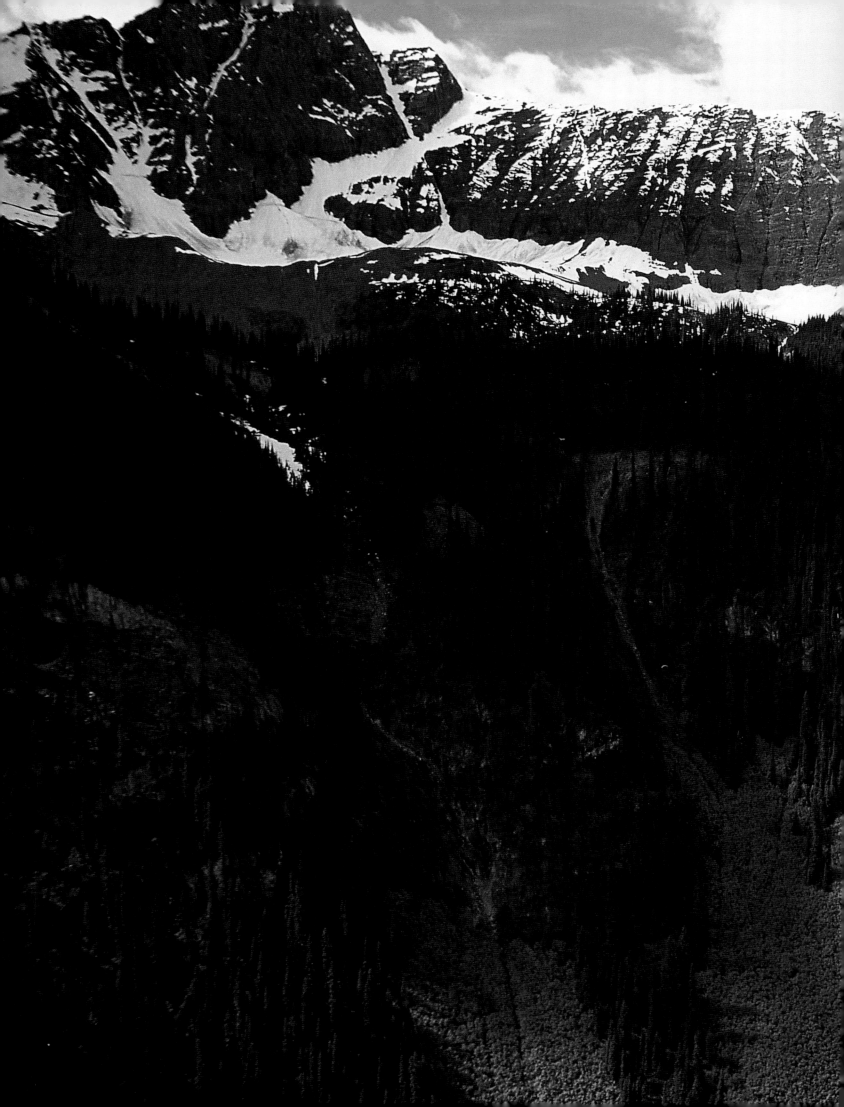

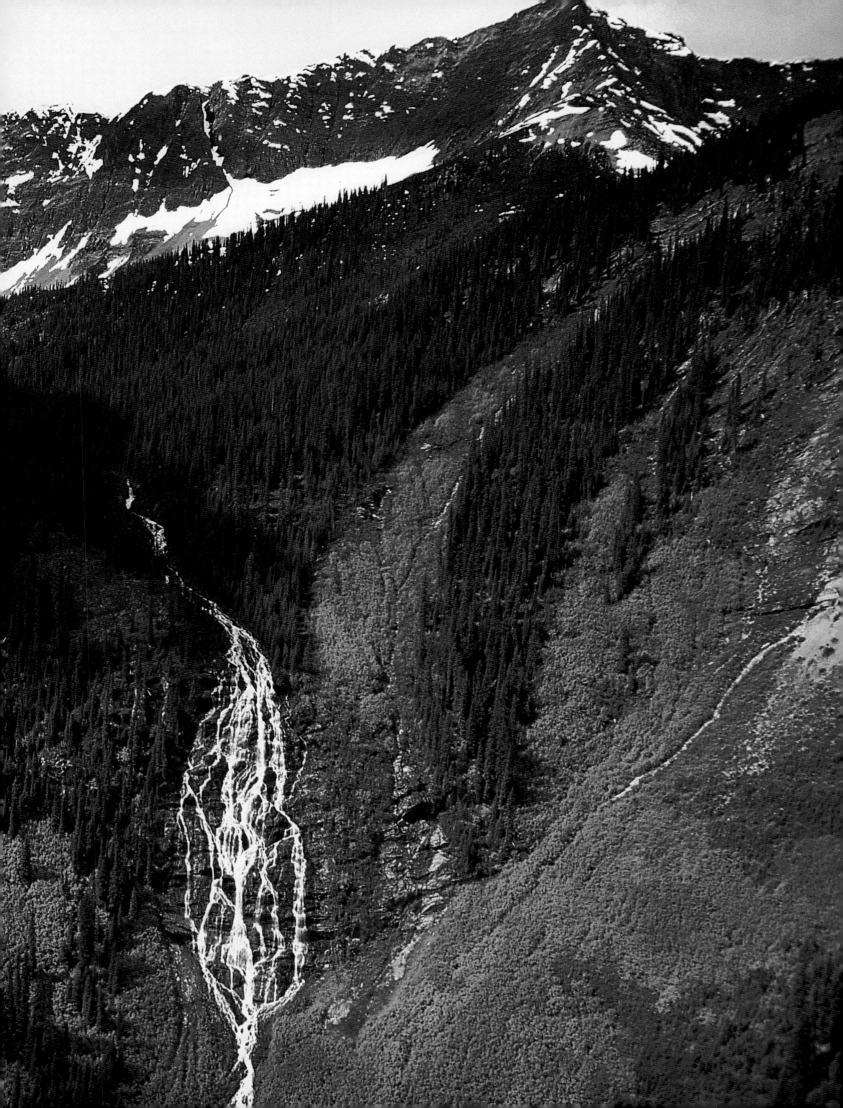

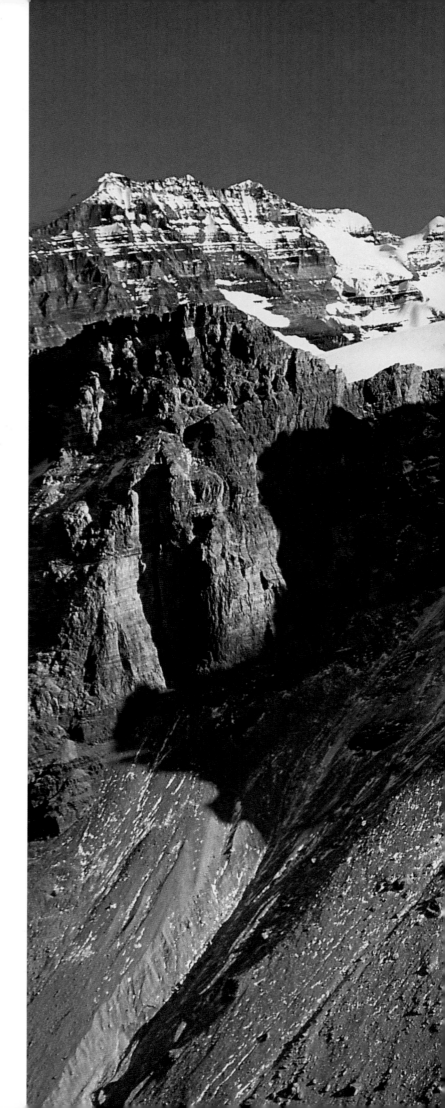

Right
Near the historic railway town of Field is Cathedral Mountain, which can be seen from the Trans-Canada Highway. [6]

Pages 26 and 27
Jewel-like Emerald Lake derives its color from the sunlight reflecting off rock dust suspended in the water. As glaciers flow down the mountainsides, they slowly grind the rock beneath, producing the rock dust, or "rock flower," that eventually finds its way into streams and lakes. [7]

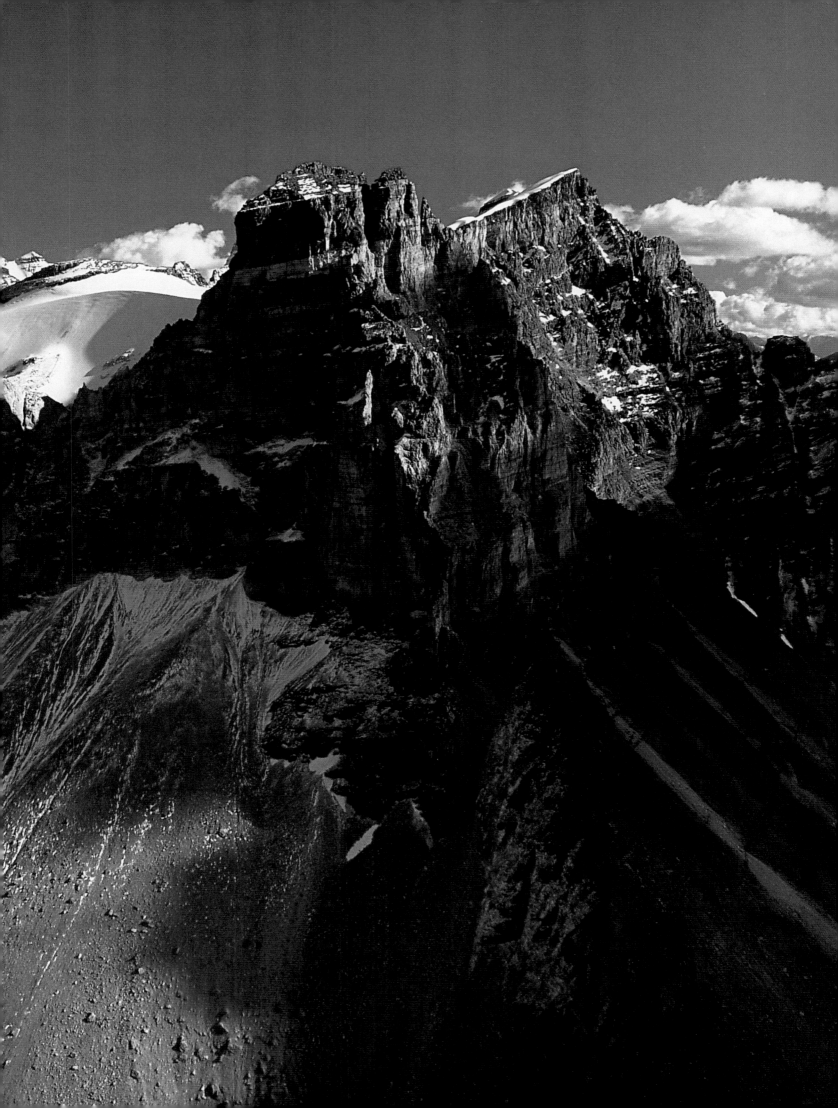

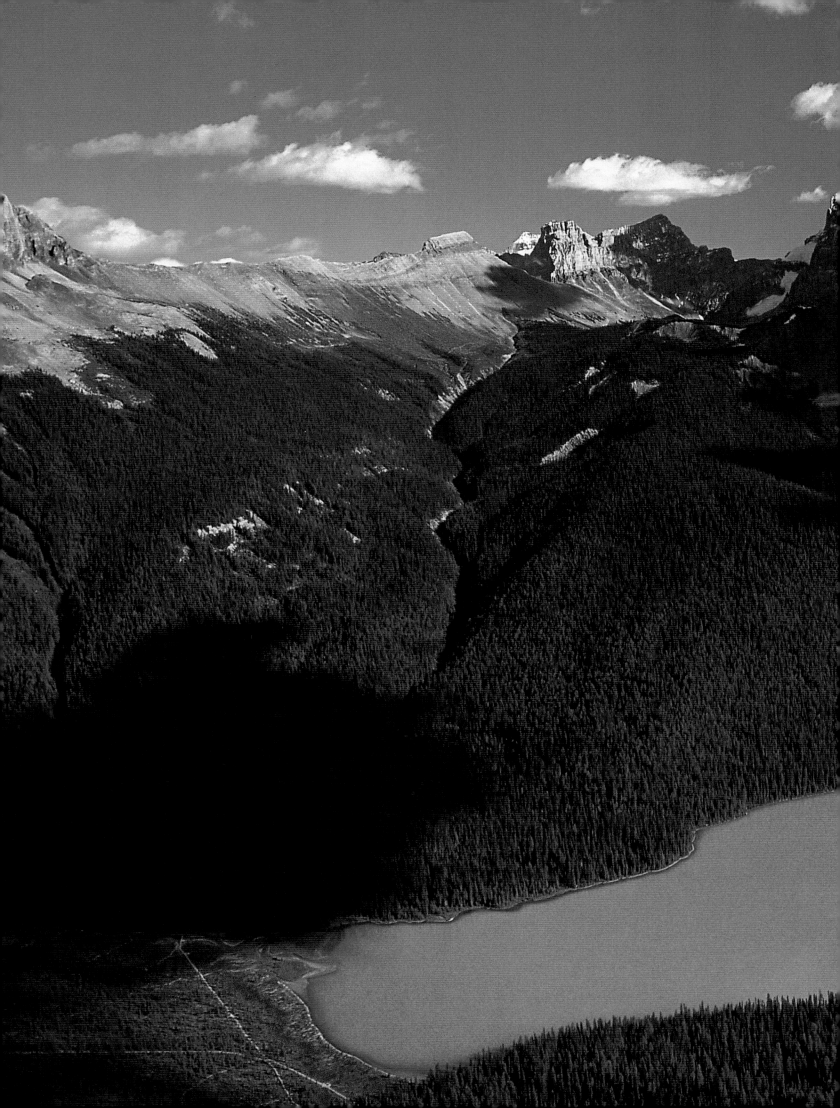

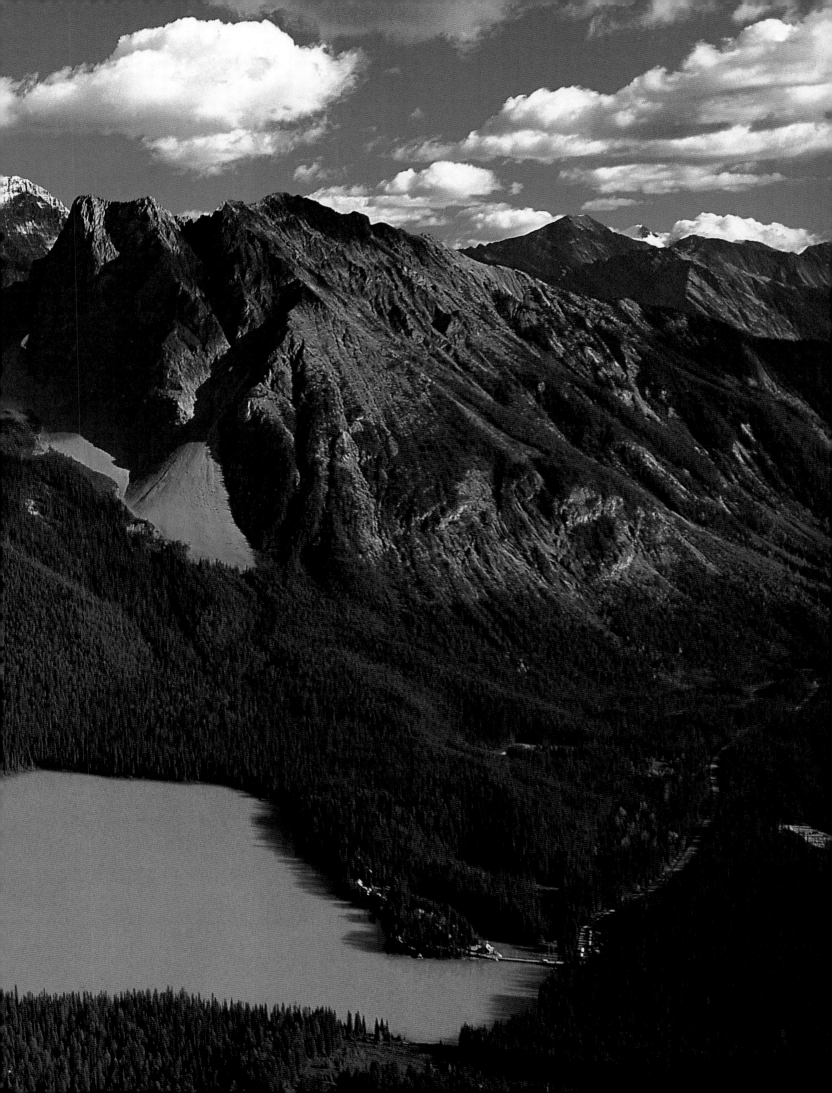

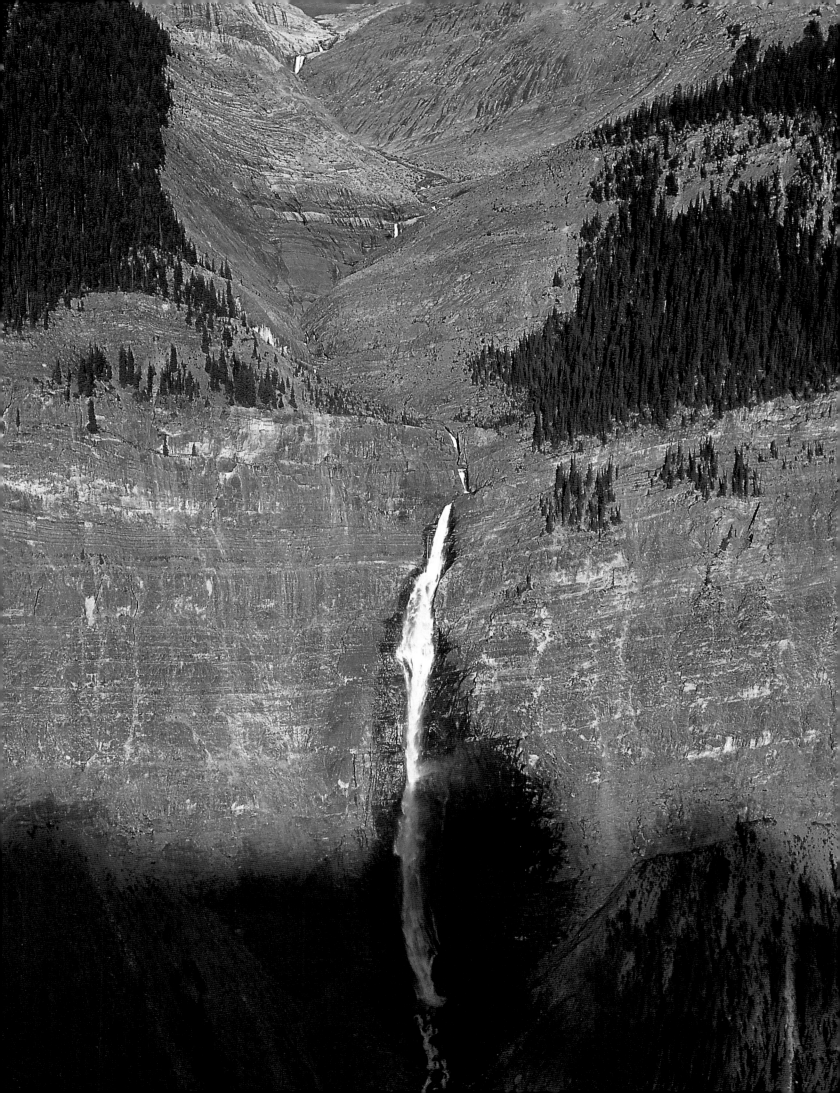

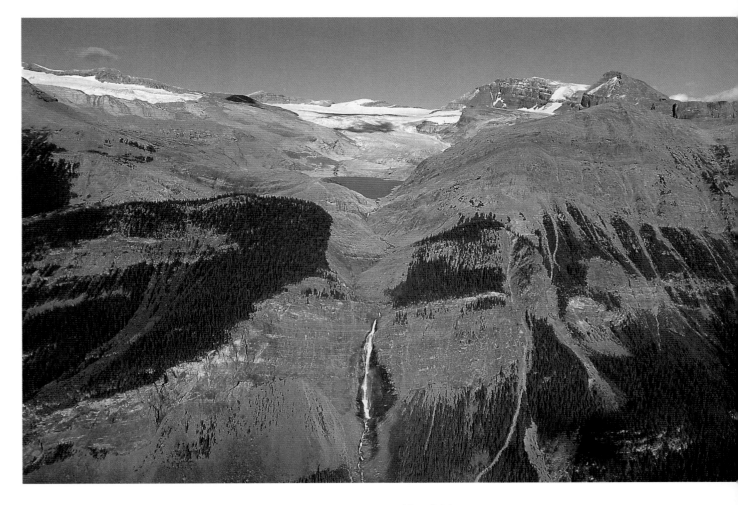

Left and above

To the Stoney Indians, takakkaw means "magnificent." The source of Takakkaw Falls, the second highest waterfall in Canada, is the Daly Glacier. [8]

Pages 30 and 31

Many would argue that Lake O'Hara is the most spectacular of all the lakes in the Rockies. A hiker's paradise, it is visited time and again by those wishing to enjoy in its amphitheatre setting. [9]

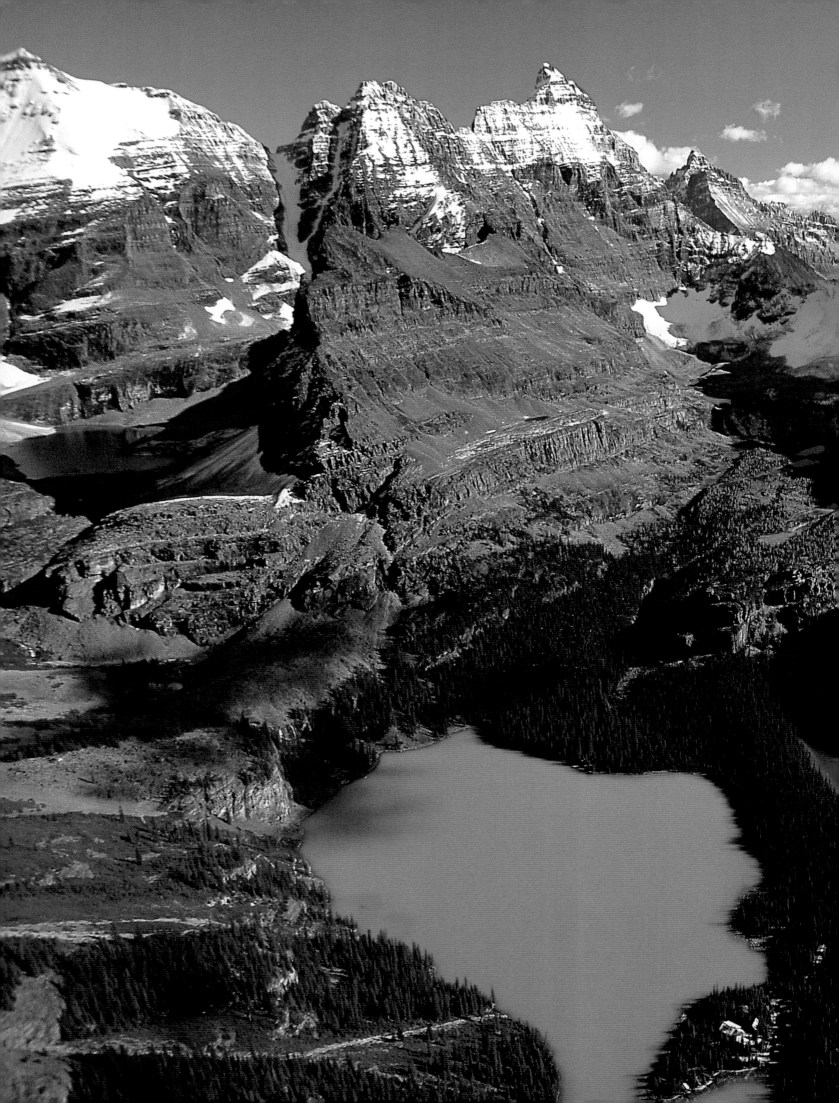

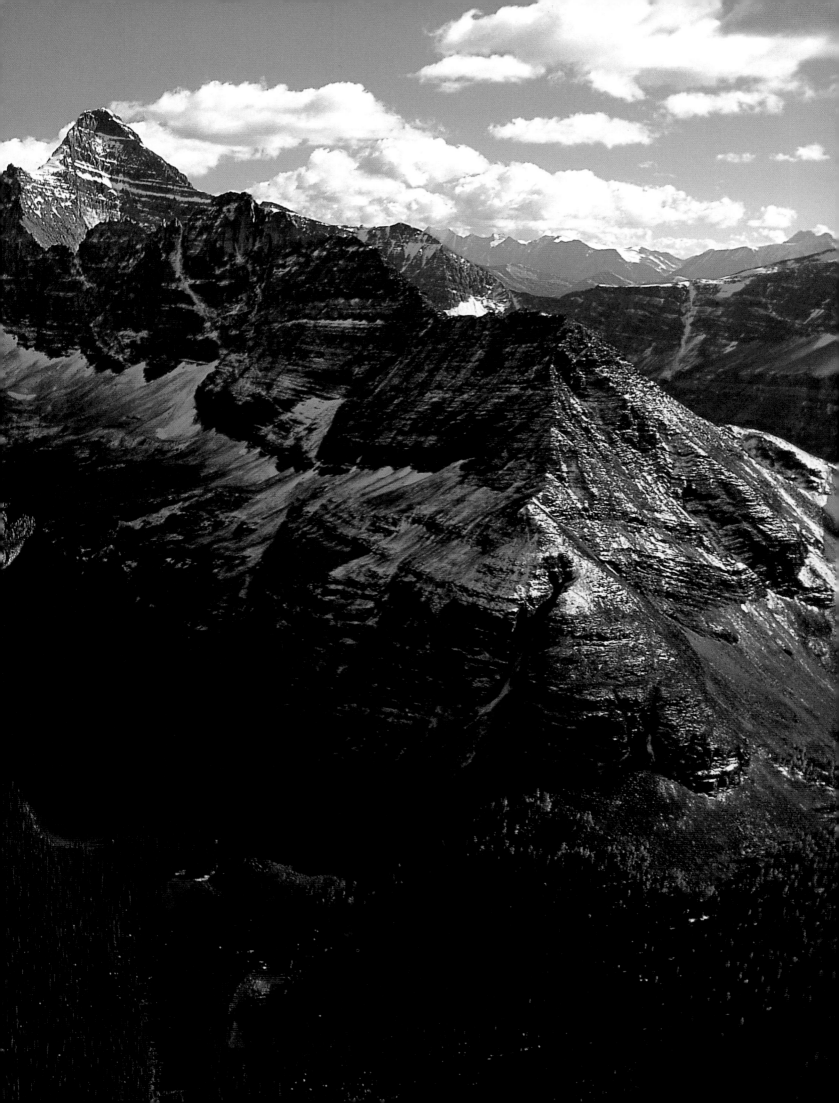

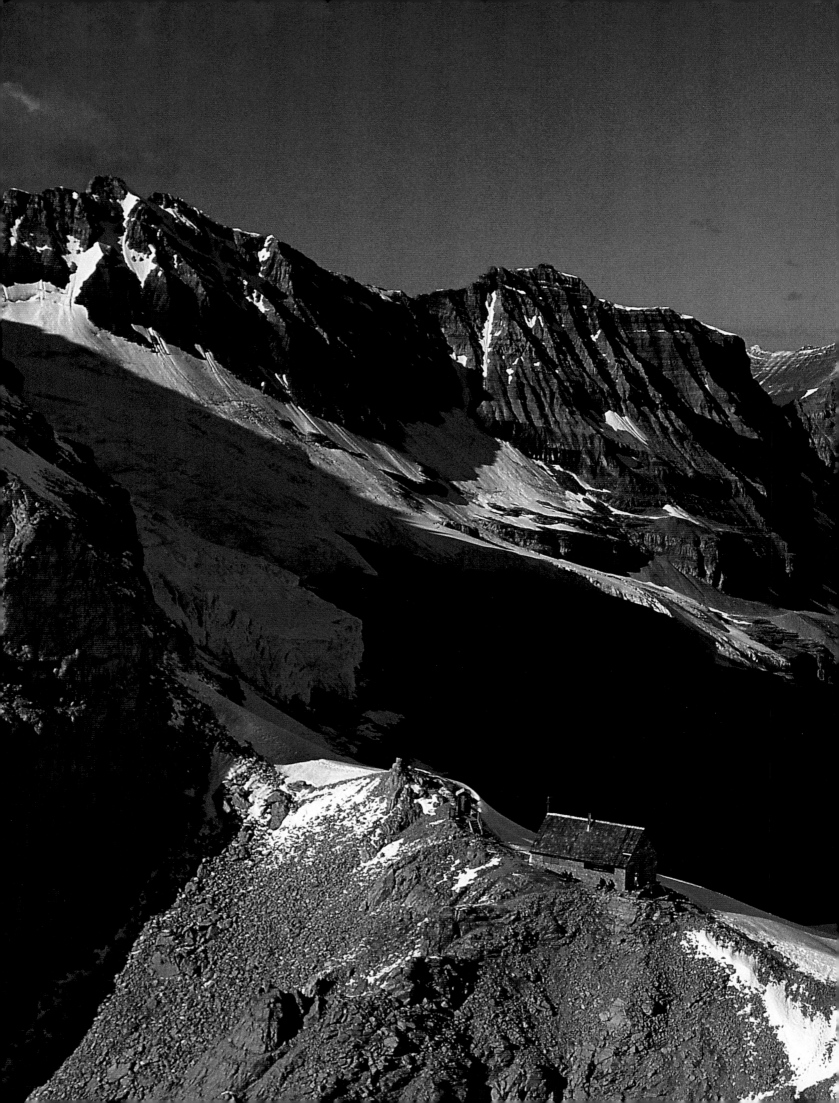

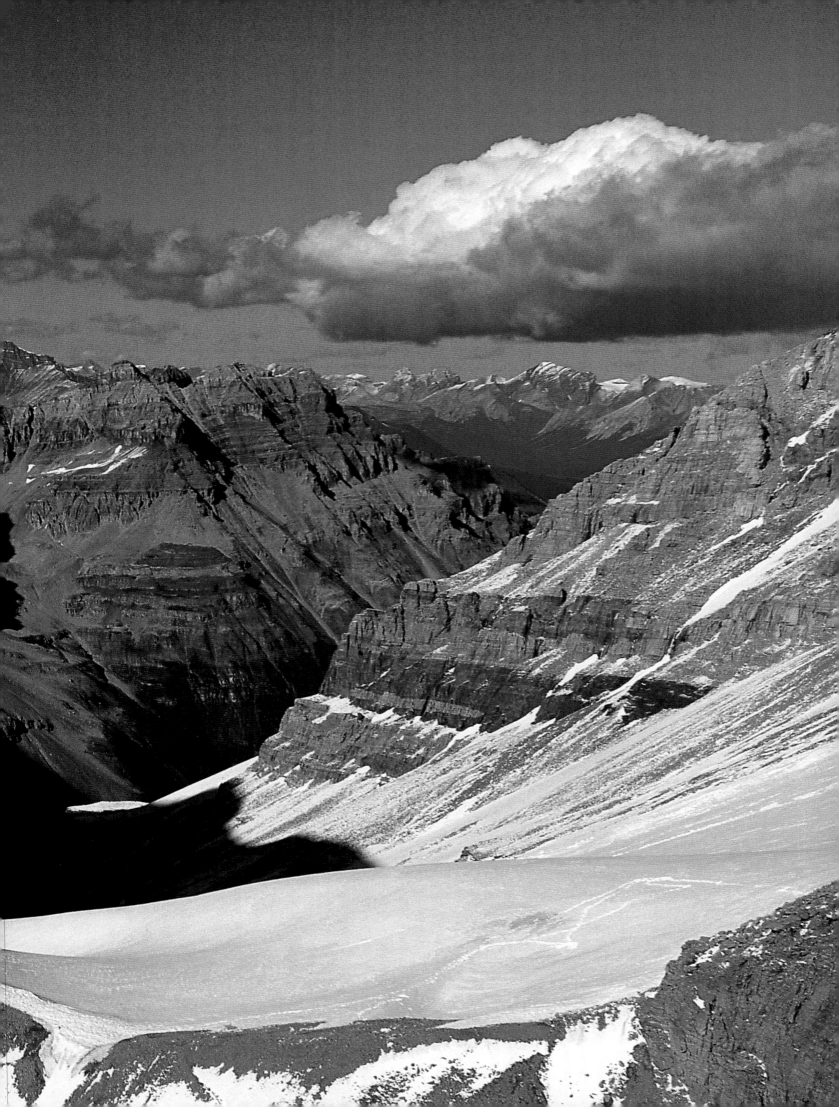

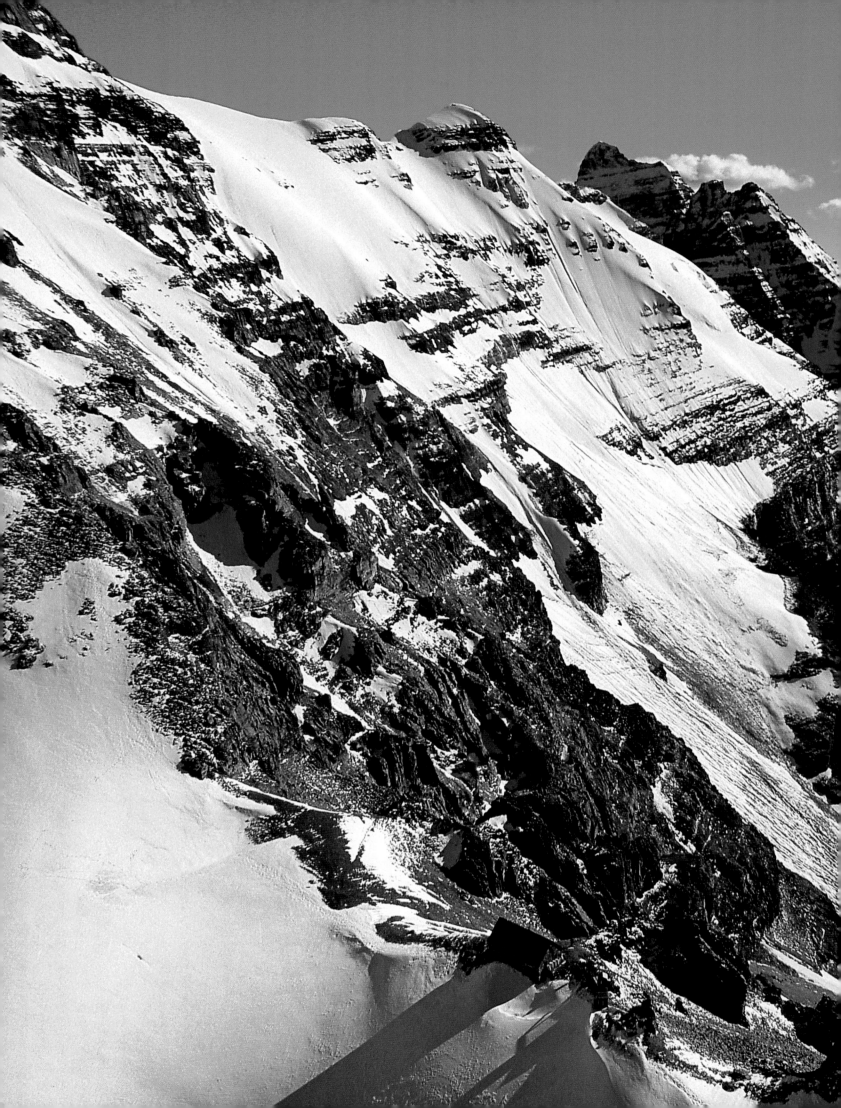

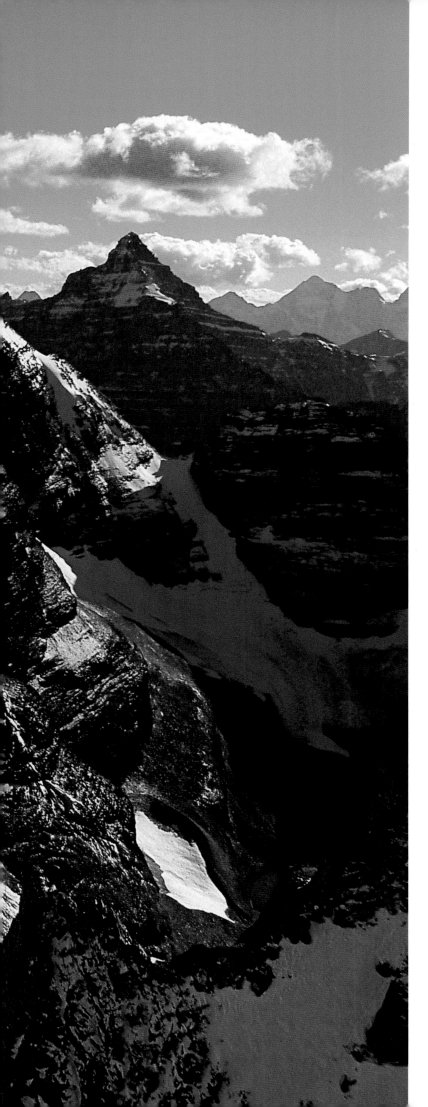

Pages 32 and 33

A few brave hikers relax in the warmth of the sun after their rigorous ascent to the stone house atop Abbot Pass. The Alberta–British Columbia border runs through the middle of the house; Alberta is in the background. [10]

Left

Abbot Pass and the stone house viewed from the opposite side. British Columbia now takes its turn as the background. [11]

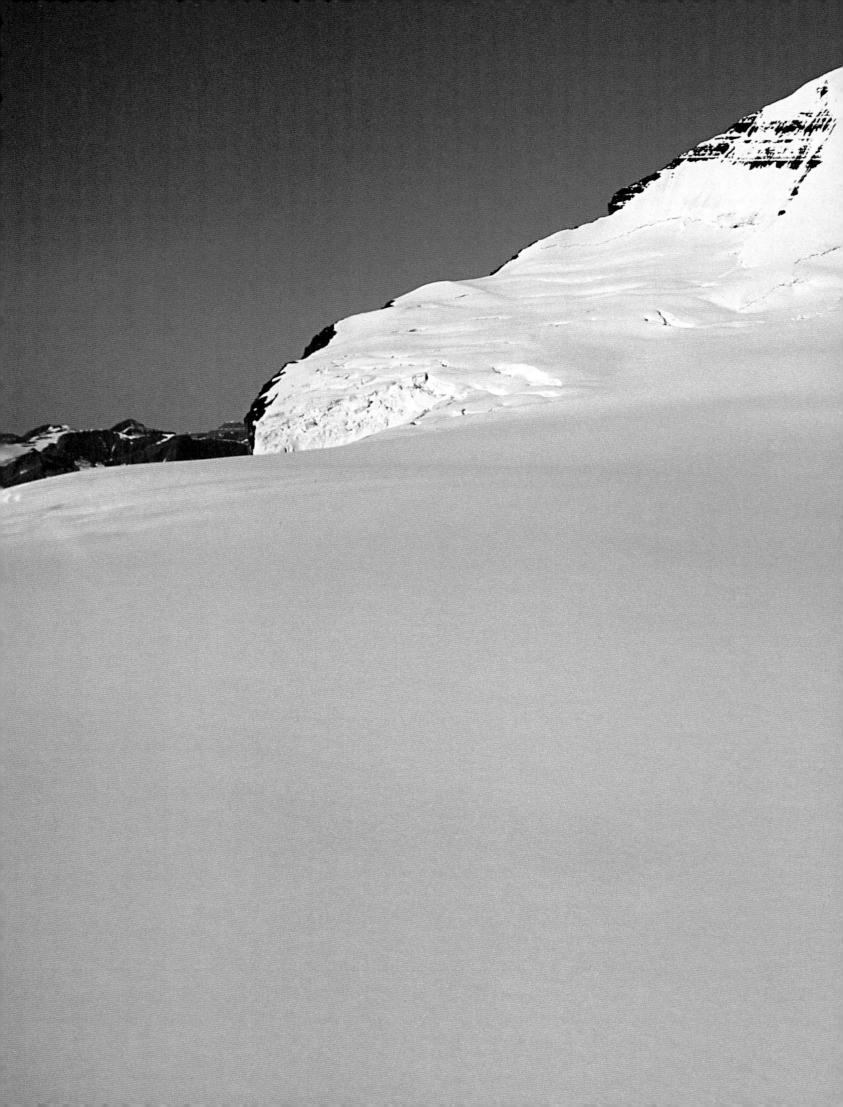

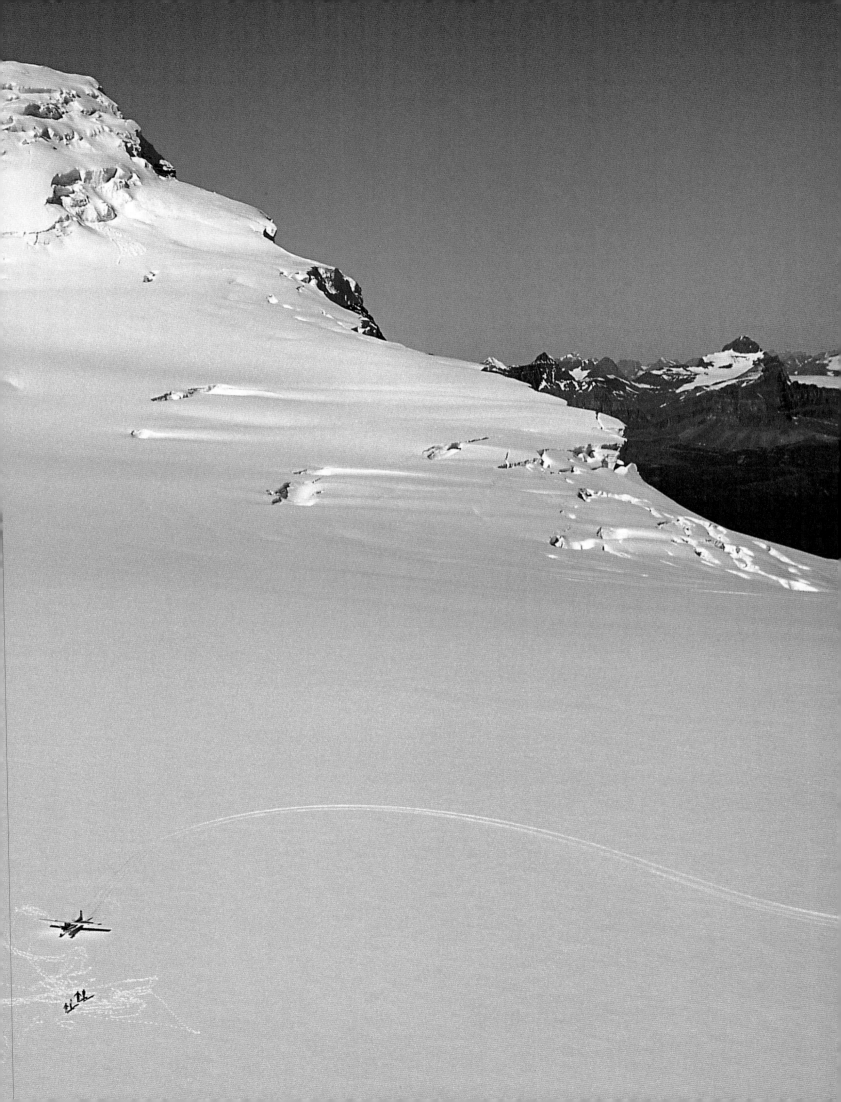

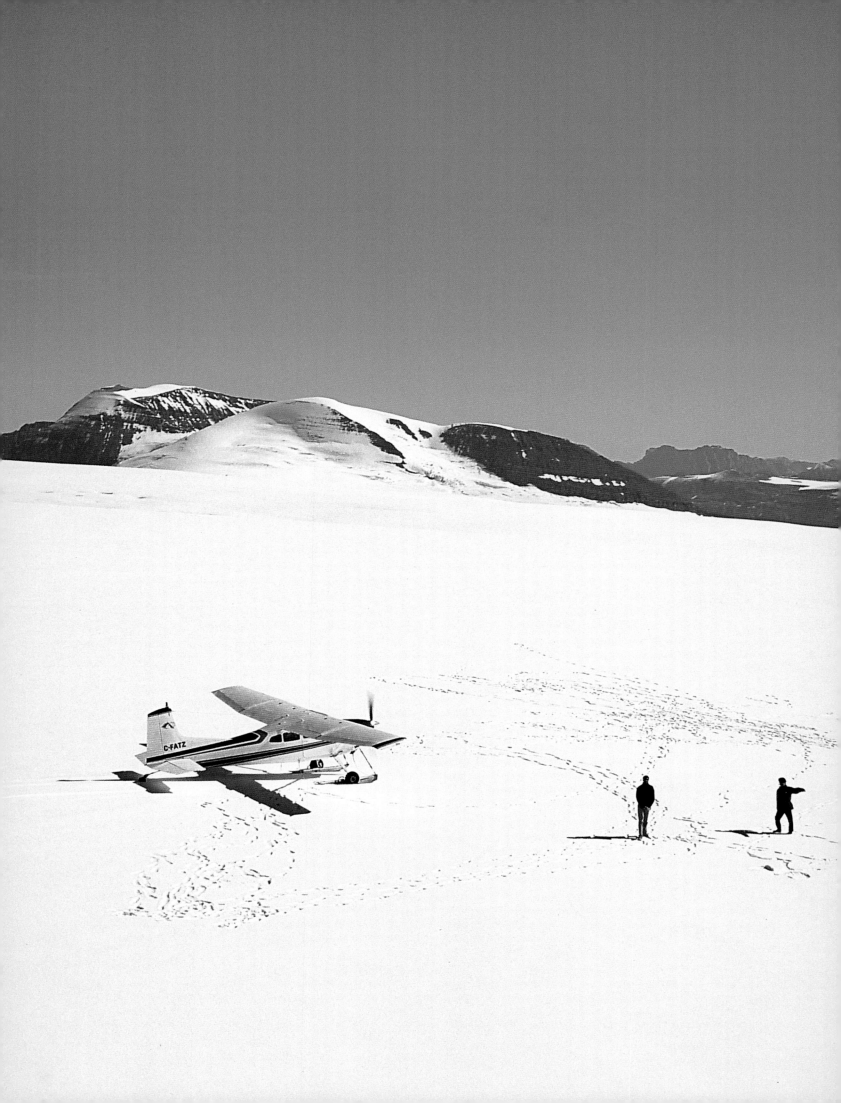

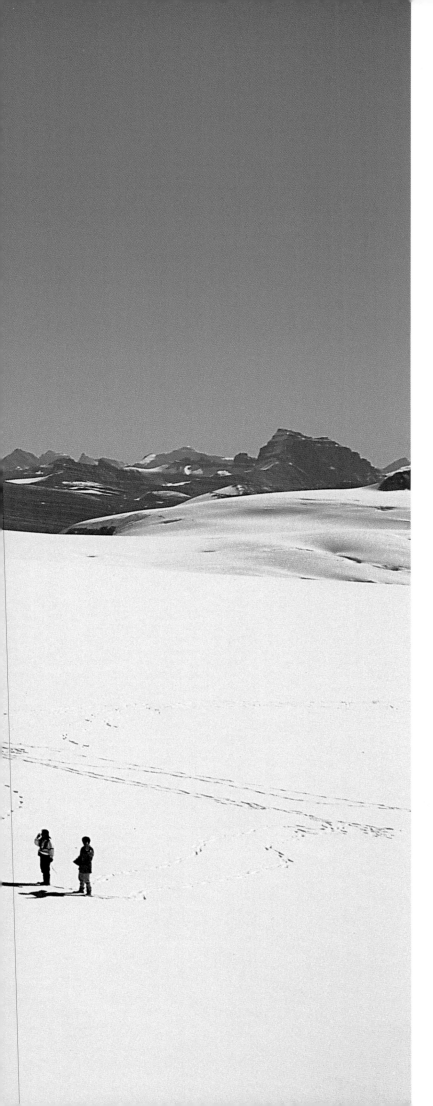

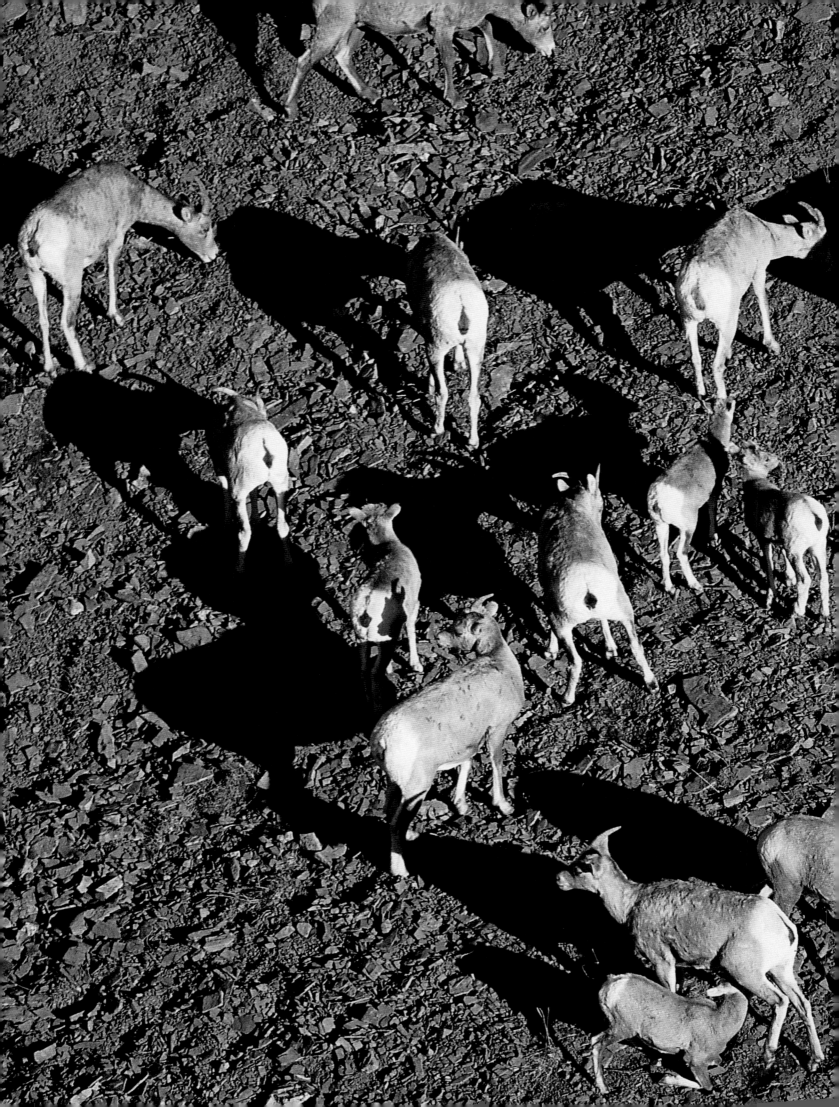

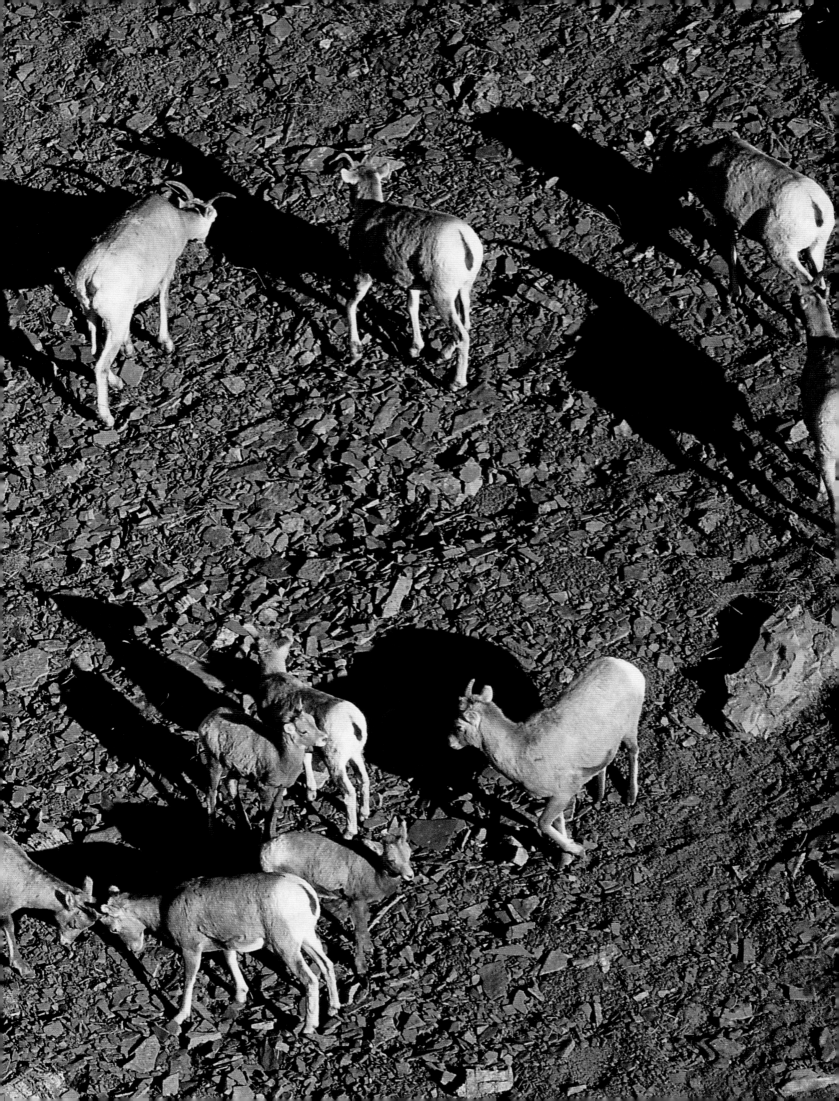

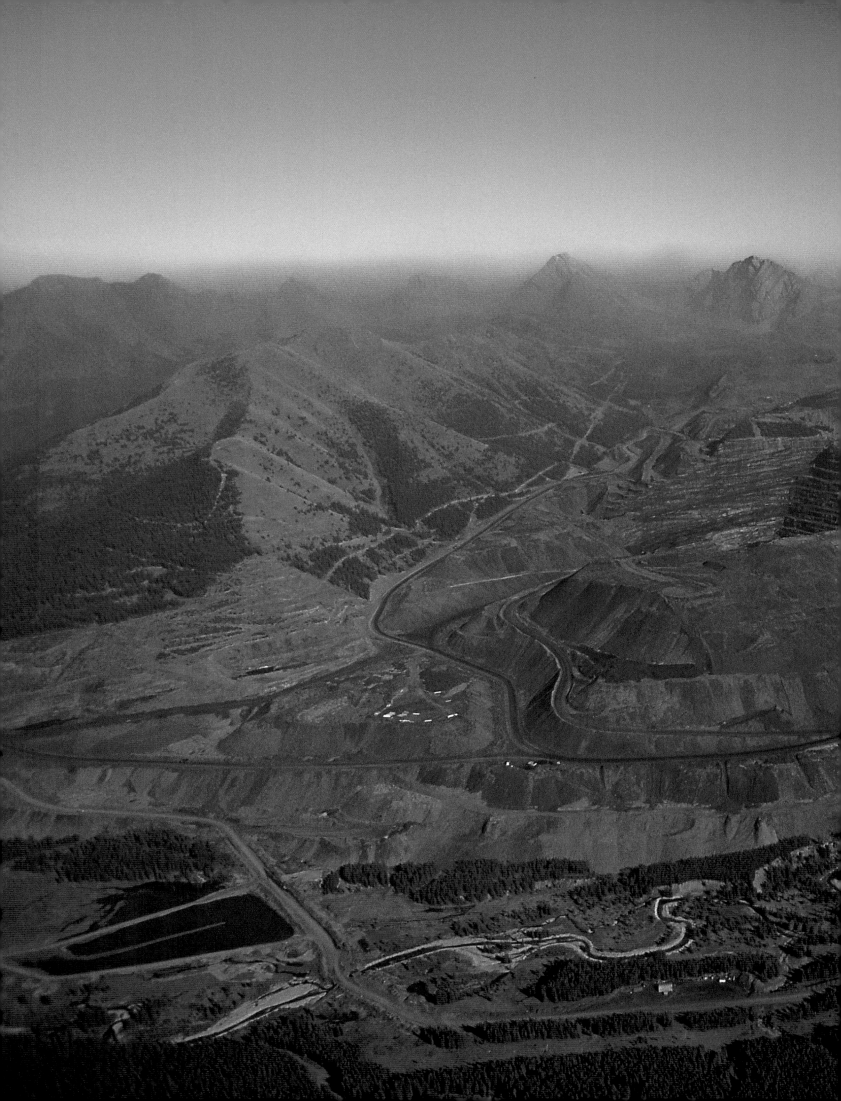

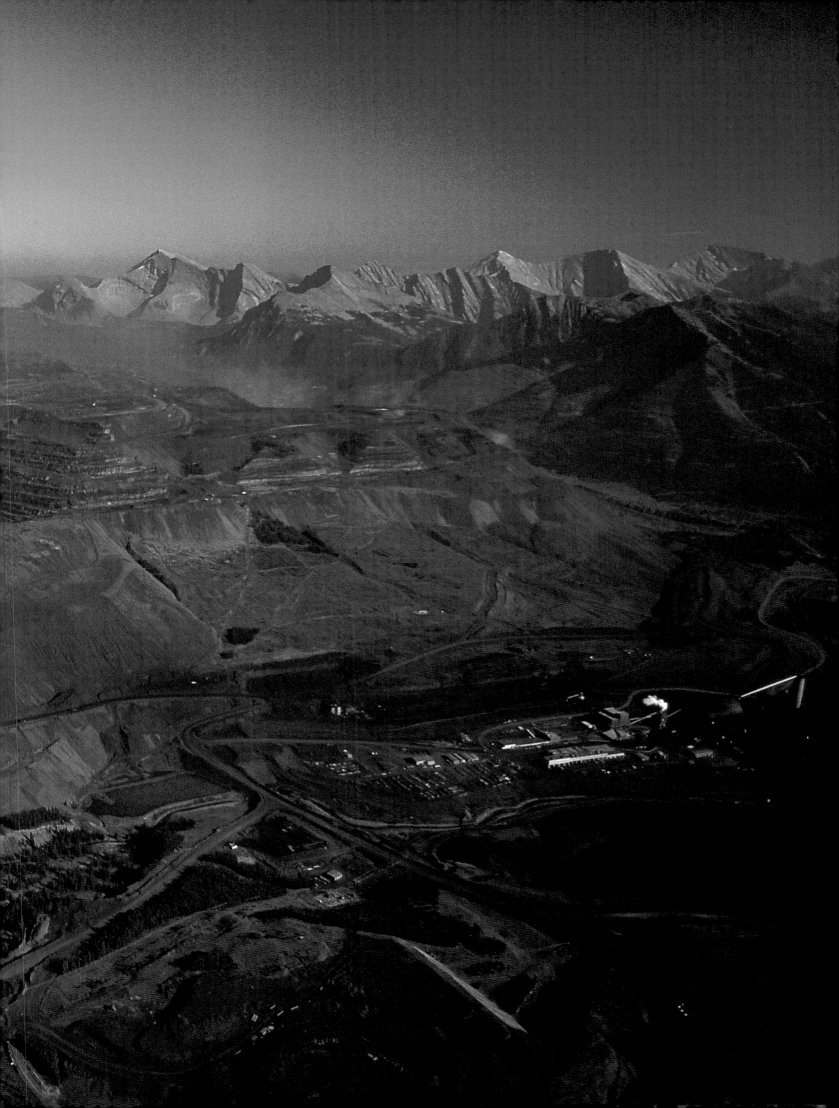

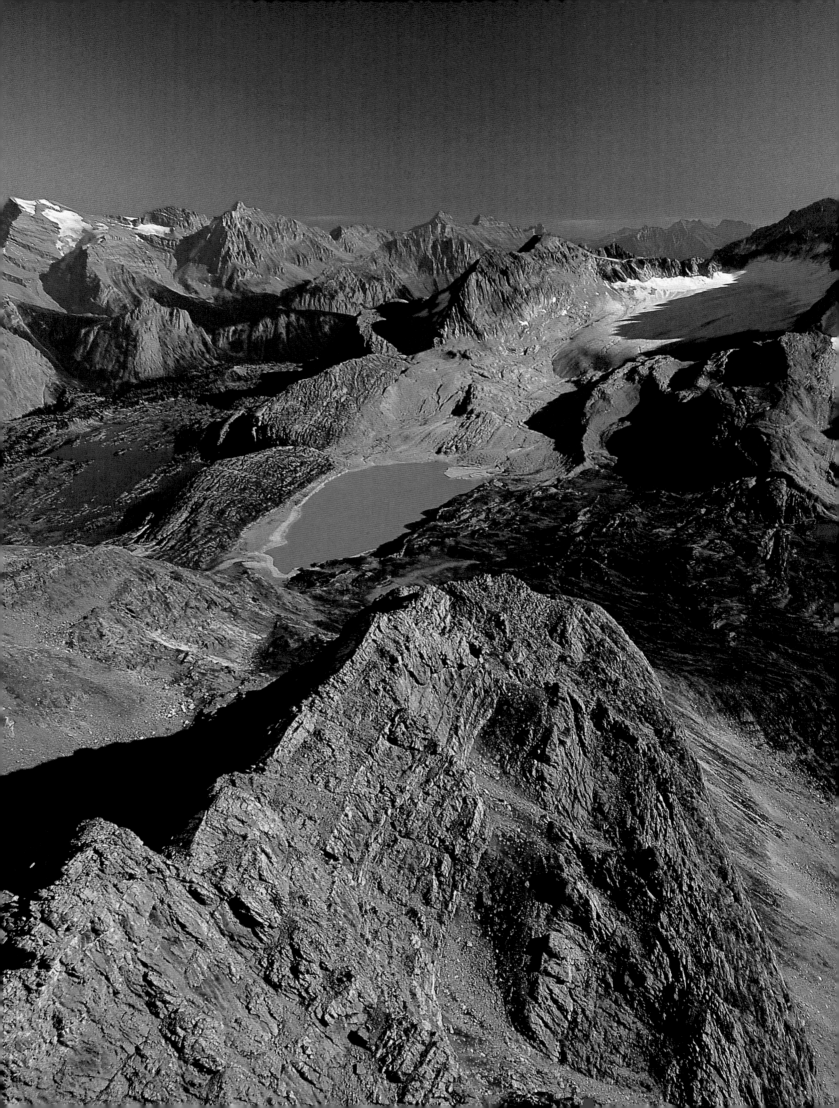

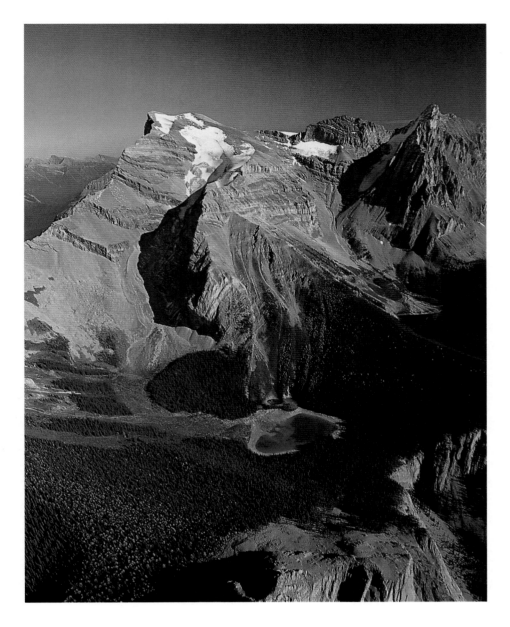

Left and above

Among my personal favorite places in the Rockies is British Columbia's Height of the Rockies Provincial Park. The setting offers a textured rock landscape and a broad palette of colors and hues. [15]

Pages 46 and 47

The Purcell Mountains are separated from the Rockies by the Rocky Mountain Trench. Long shadows cast by the Purcells darken the distant trench, while on the horizon the Rockies still bask in the glow of a setting sun. [16]

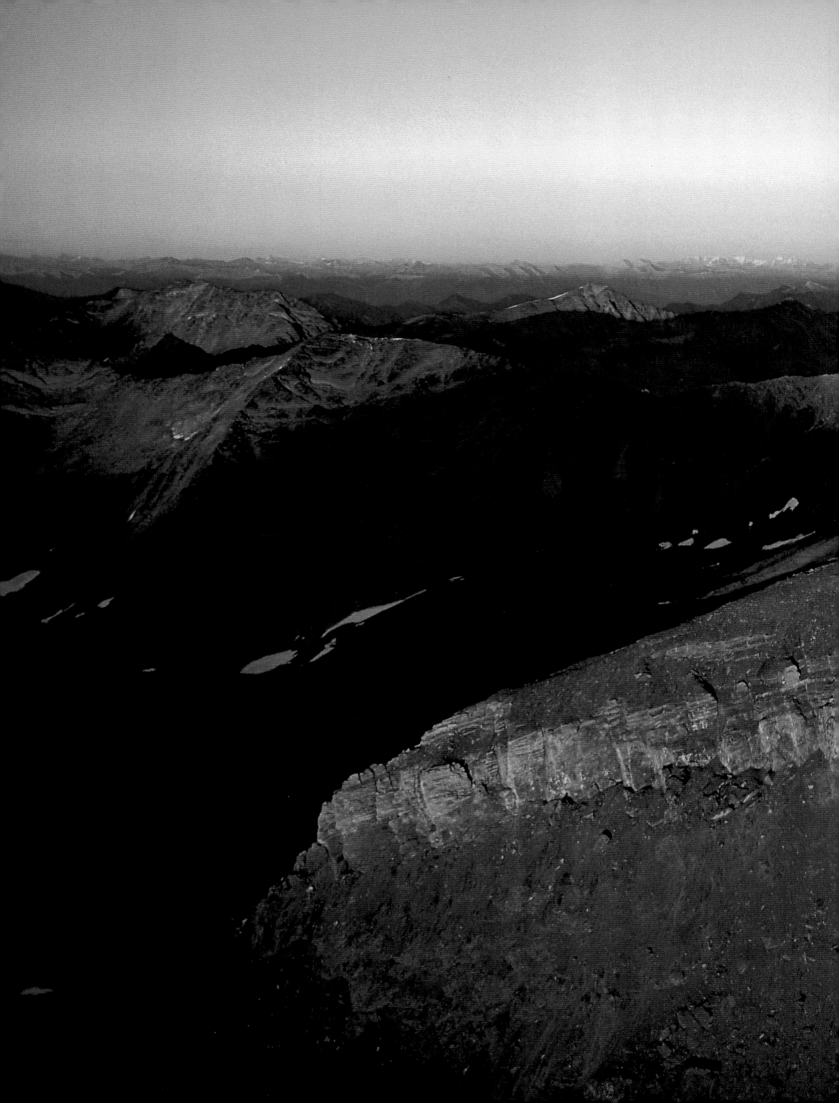

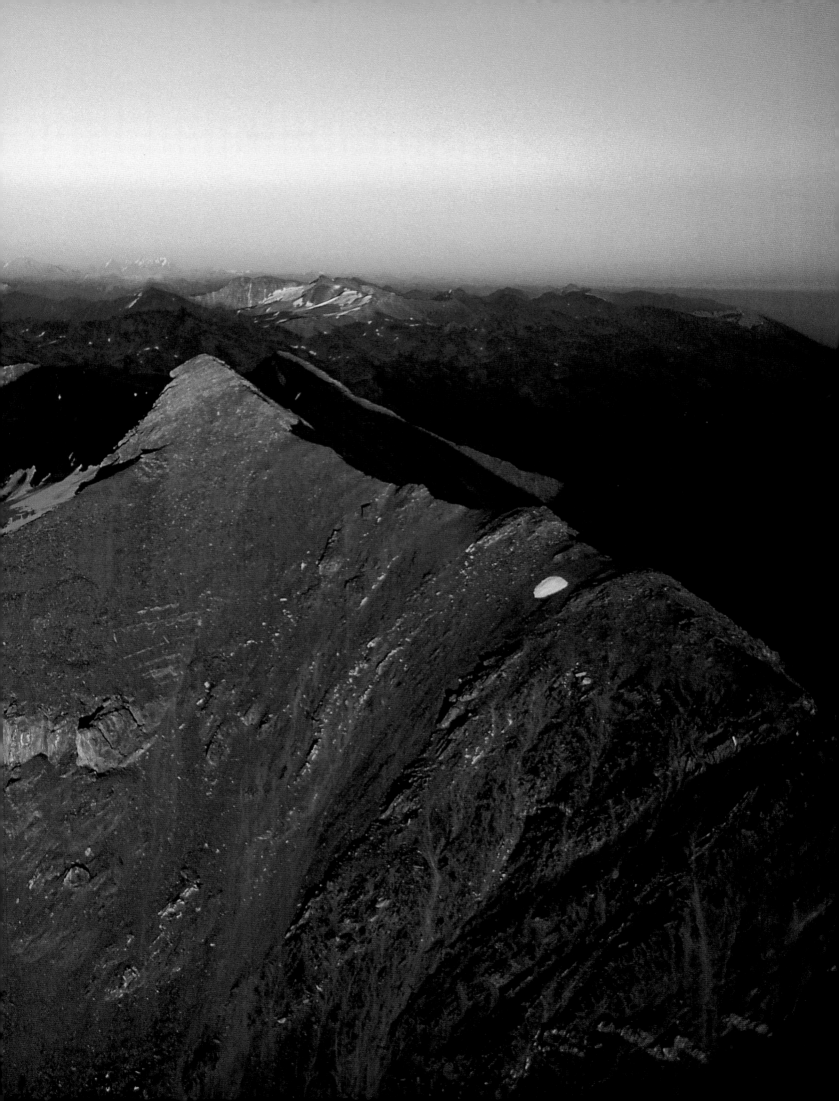

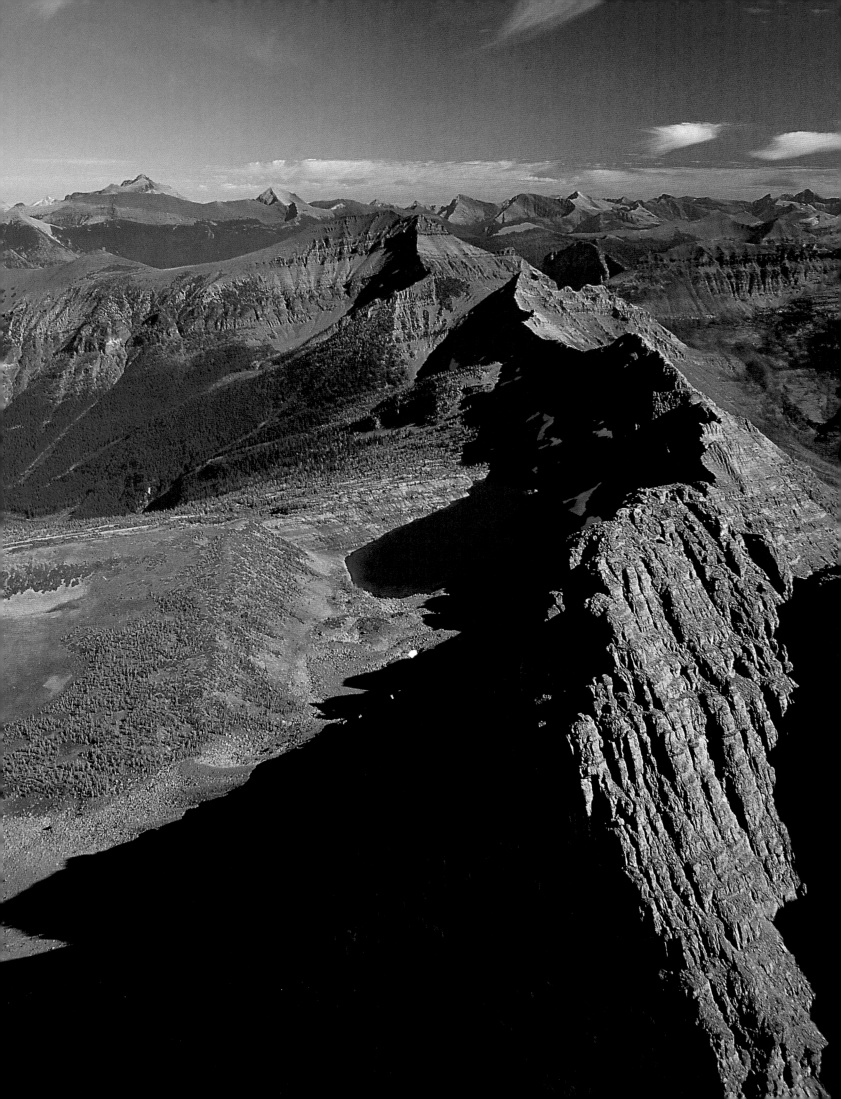

the parks

The parks

Stretching as they do along the Continental Divide that forms the border between British Columbia and Alberta, the Canadian Rockies tower over the prairies to the east and seemed to present an almost impenetrable barrier to the early explorers intent on reaching the west. Today, thanks to the almost unbroken chain of national and provincial parks and wilderness areas that stretch southward from the Yukon to the border of the United States, much of this magnificent wilderness is not only protected and preserved for future generations, but also made accessible to visitors.

The land in the Canadian Rockies stretches horizontally, from the Yukon border south to the United States. But the plant and animal life change as you go vertically up the sides of the mountains. Environments range from relatively lush and temperate valleys and lowlands in which an abundance of plants and animals thrive, to frozen tundra conditions at the tops of the peaks on which only the hardiest stunted vegetation can survive. Working from the bottom to the top of the mountains, scientists identify several different layers of vegetation: grasslands, mixed forest, boreal forest, a transition zone, a tundralike environment, and finally polarlike conditions at the top.

The history of the parks reads like a story of the opening of the Canadian west. Until the 1880s and the building of the Canadian Pacific Railway, the Rockies remained a largely unknown wilderness to all but the most stalwart settlers and explorers. As the railway slowly worked its way through the mountains, the beauty and grandeur of the area and its commercial potential became apparent. Always eager to increase traffic, the railway began to encourage tourism by constructing hotels at the most scenic locations and advertising them widely. In response to the pressure for commercial exploitation and the need for the maximum number of passengers to ensure the railway's success, the Canadian government began to set aside land for parks.

Banff is Canada's oldest national park. In 1883, workers on the Canadian Pacific Railway discovered hot springs on Sulphur Mountain while prospecting for gold in what was then called the Northwest Territories. In 1885 the federal government took over 25 square kilometres (9 square miles) around what was known as the Cave and Basin area to control its commercial exploitation, and named it Rocky Mountains Park. The popularity of the hot springs and the scenery led to a rapid expansion of facilities, most notably the famous Banff Springs Hotel, which opened in 1888 to serve the tourists arriving by rail. Today the park, renamed Banff National Park in 1930, covers 6641 square kilometres (2564 square miles).

(continued on page 63)

Left and pages 50 and 51

In the southeastern corner of British Columbia is Akamina-Kishinena, one of the province's newer provincial parks. [17]

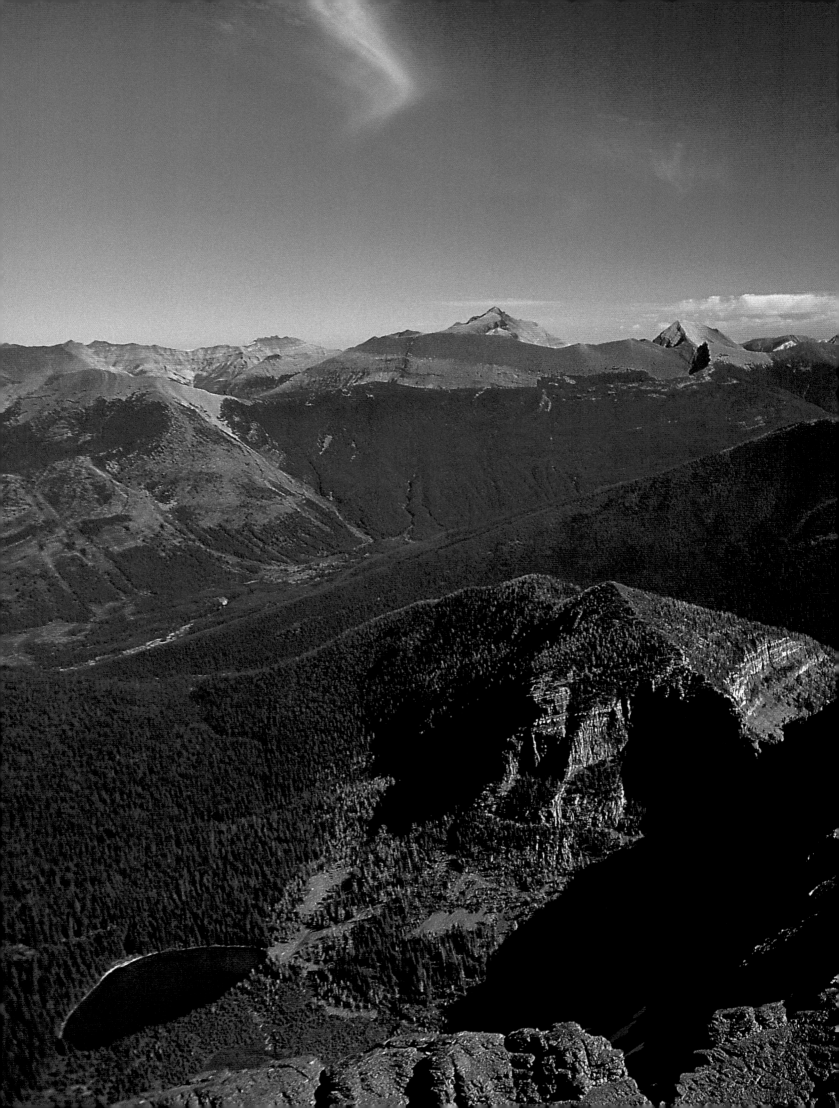

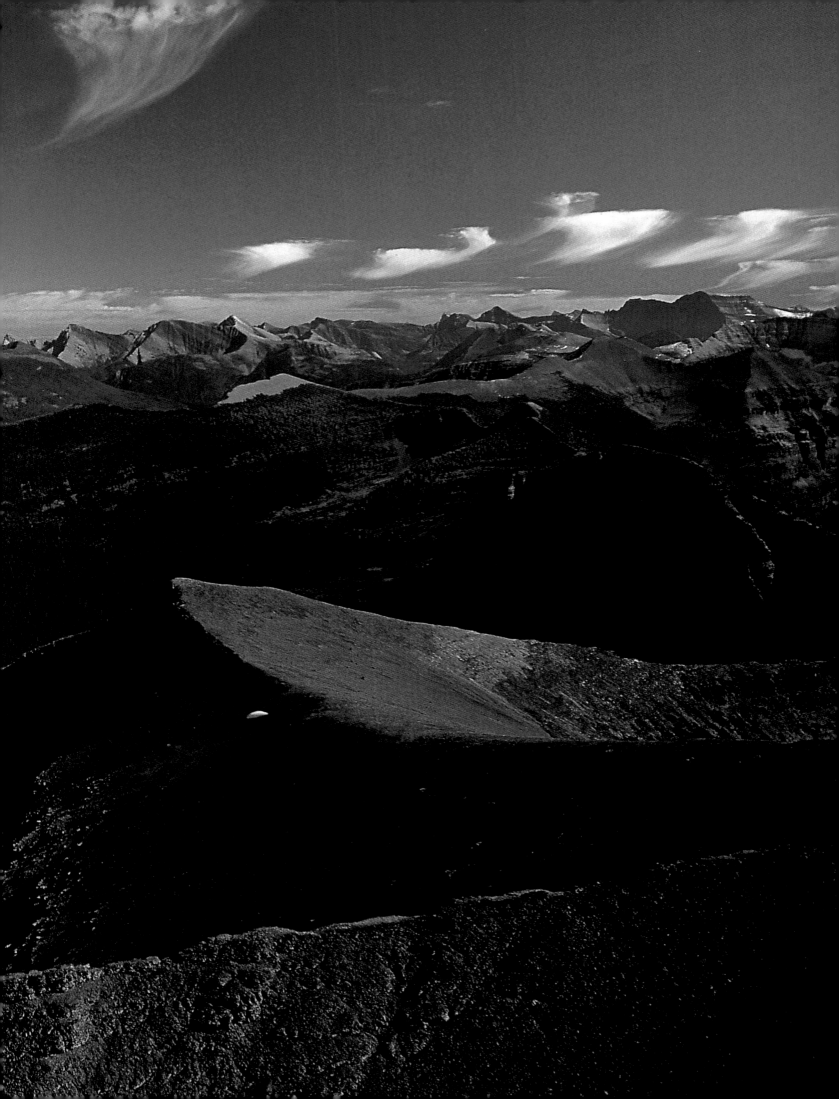

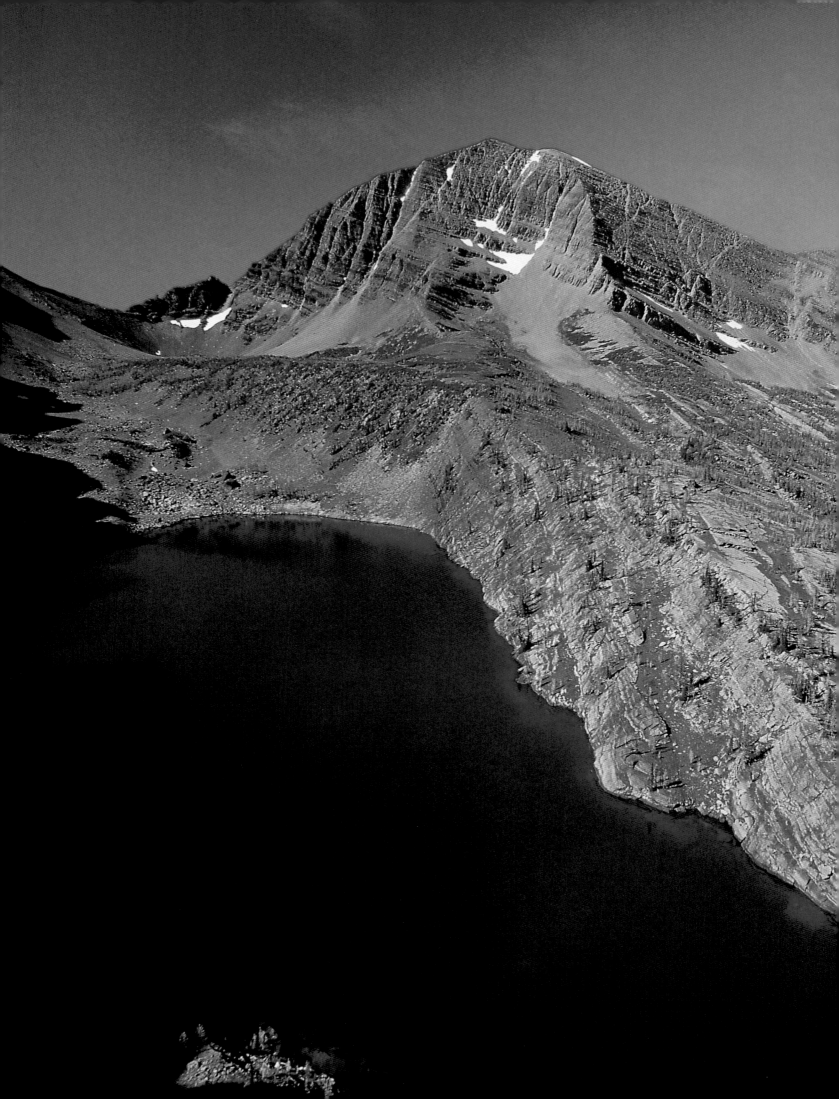

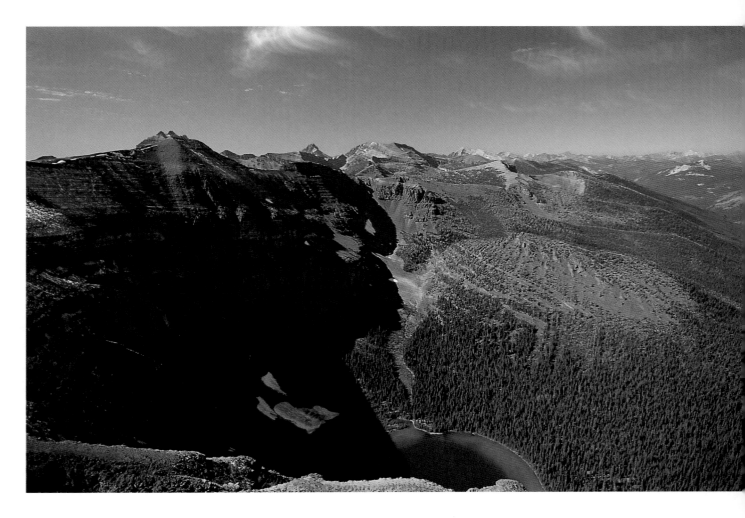

Left and above
Akamina-Kishinena is representative of the type of wilderness seen in many of British Columbia's mountain parks. [18]

Pages 54 and 55
Although not as well known, the Clemenceau Icefield is every bit as spectacular as the Columbia Icefield, its neighbor to the east. [19]

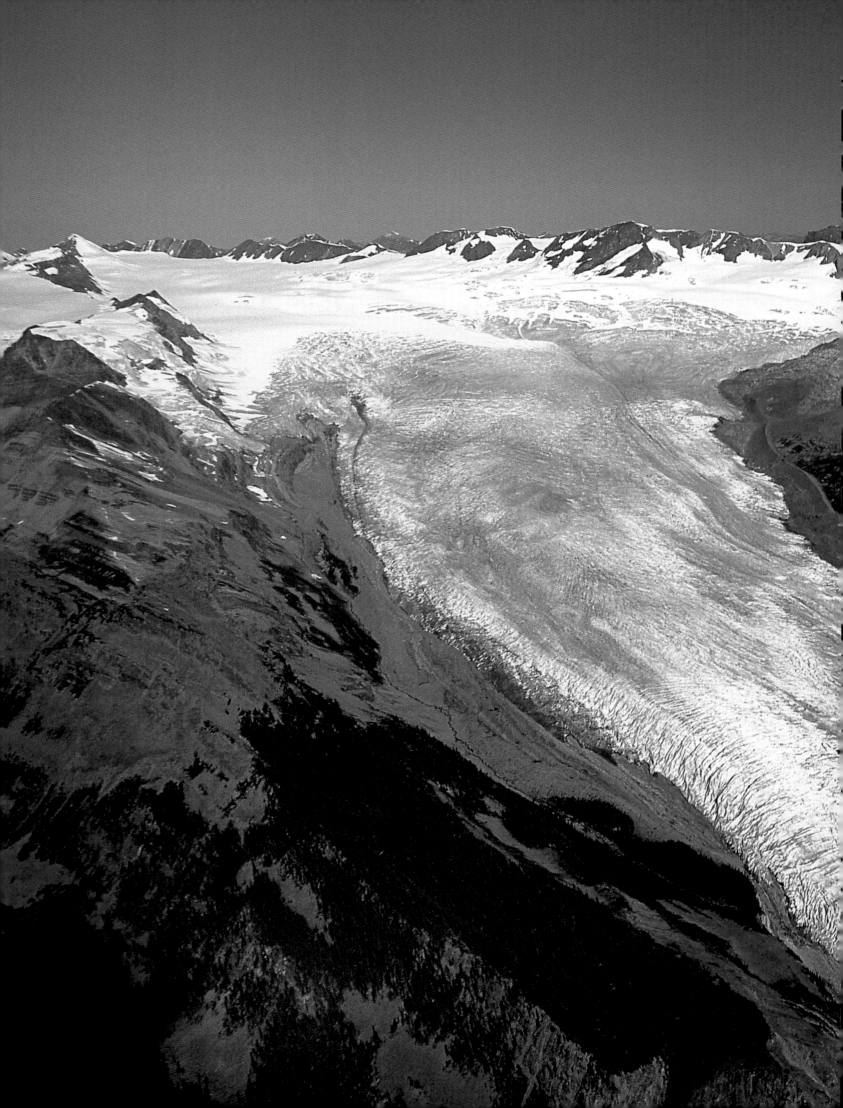

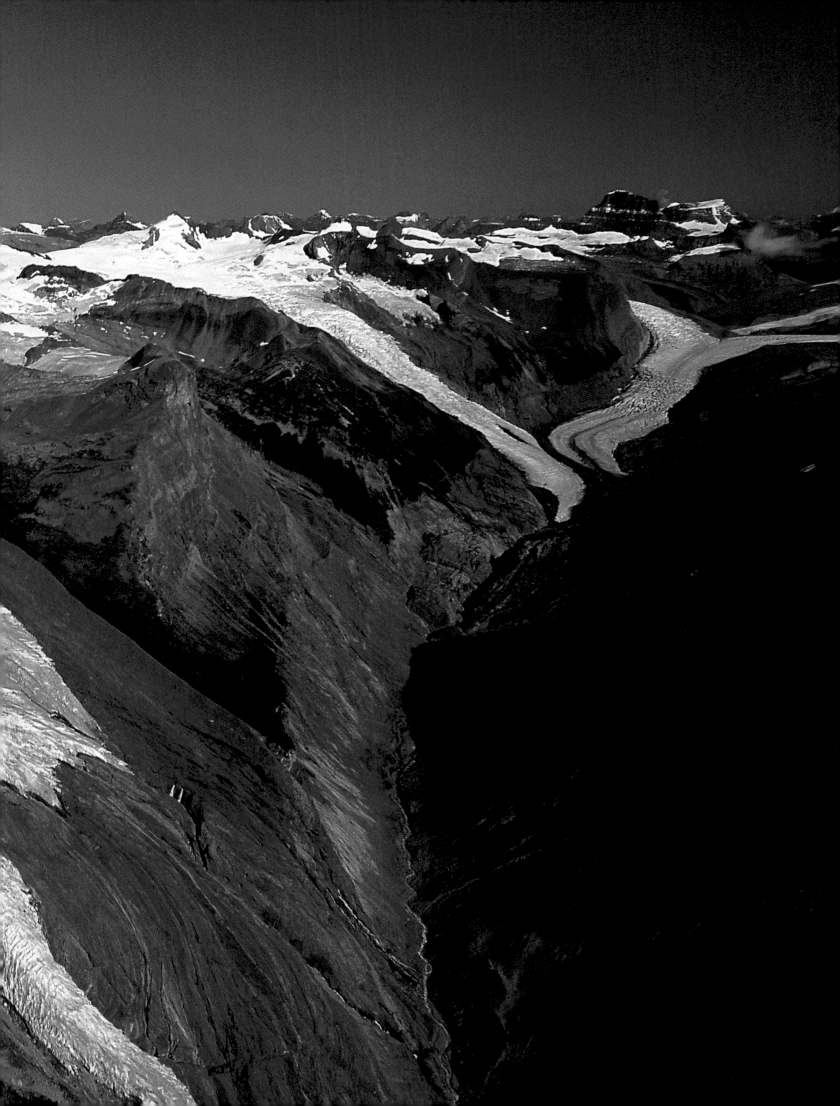

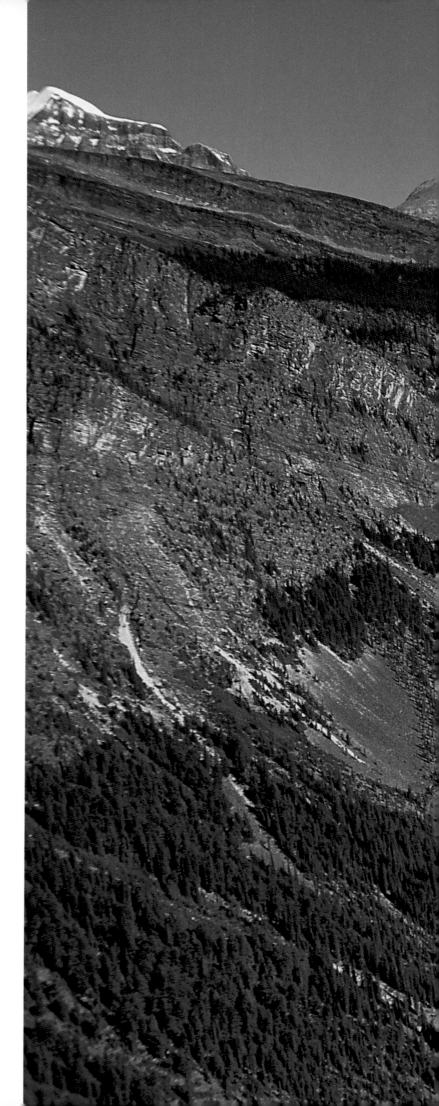

Right

The twin waterfalls of Cummins Lakes Provincial Park are fed by the chilled glacial waters of the upstream Clemenceau Icefield. [20]

Pages 58 and 59

Mother nature's raw power is displayed graphically in the contorted rockfolds of a Sullivan River mountainside. [21]

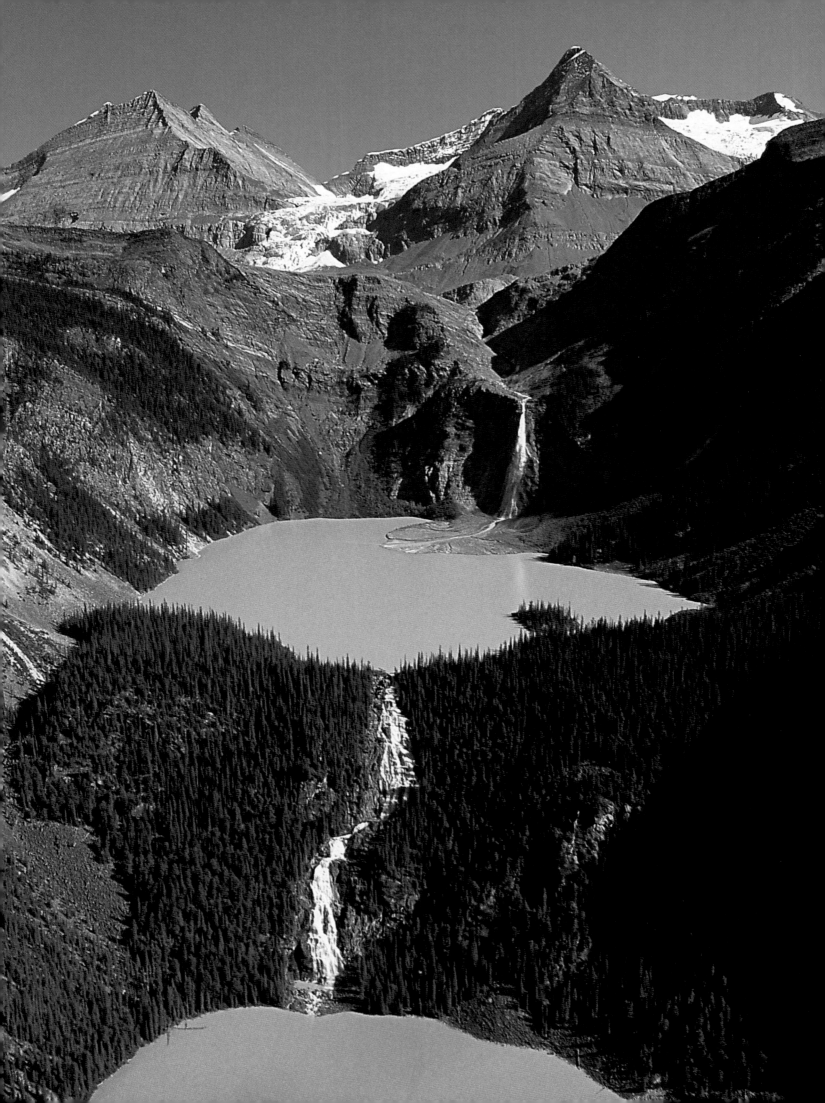

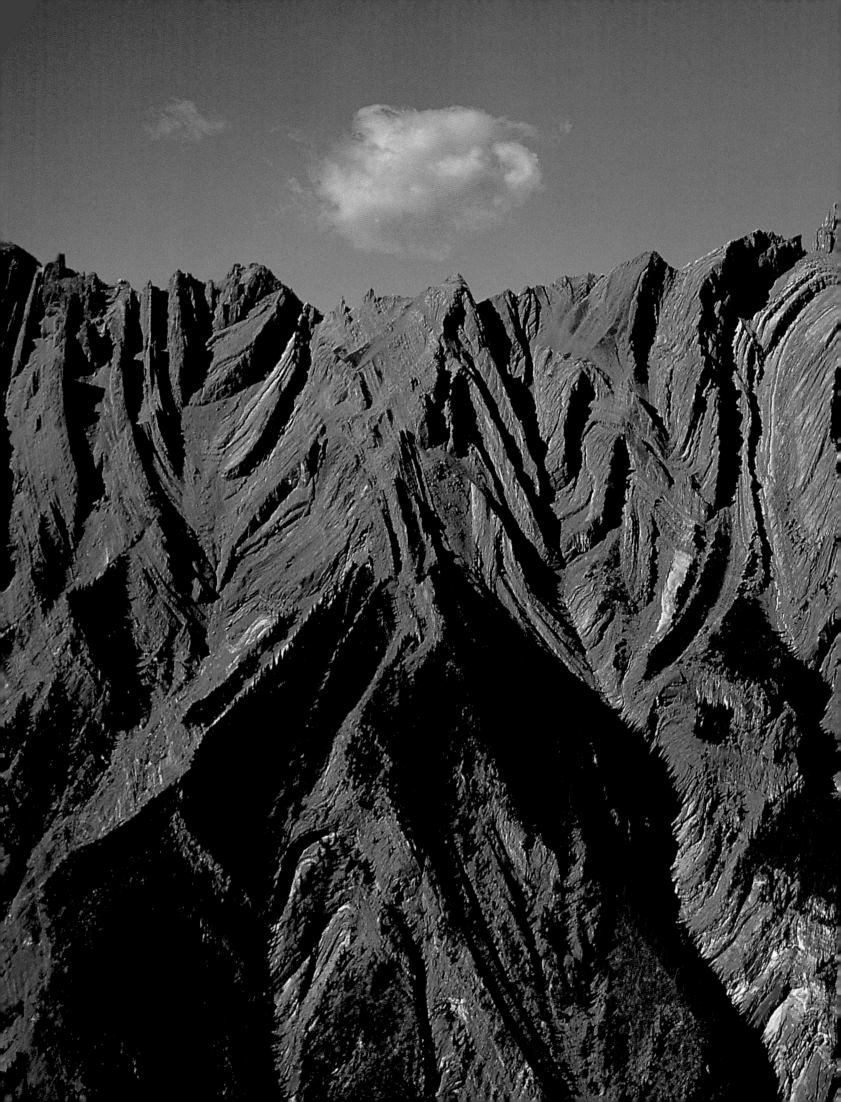

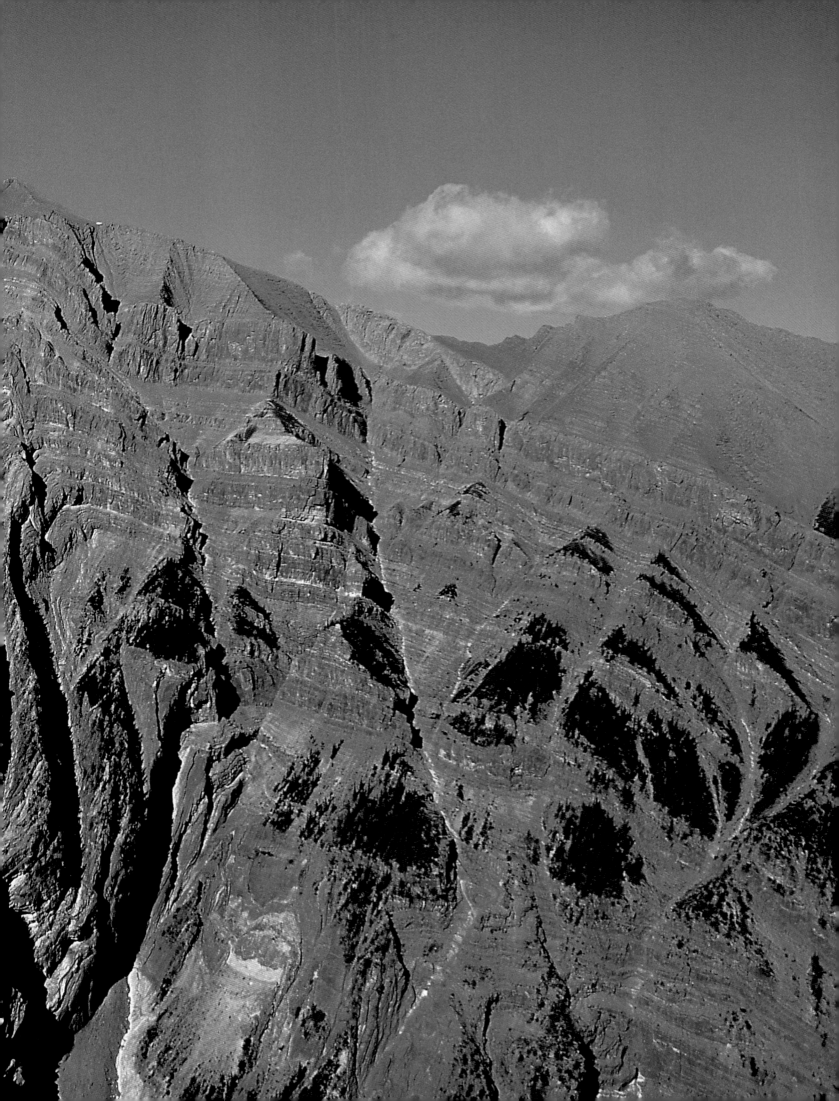

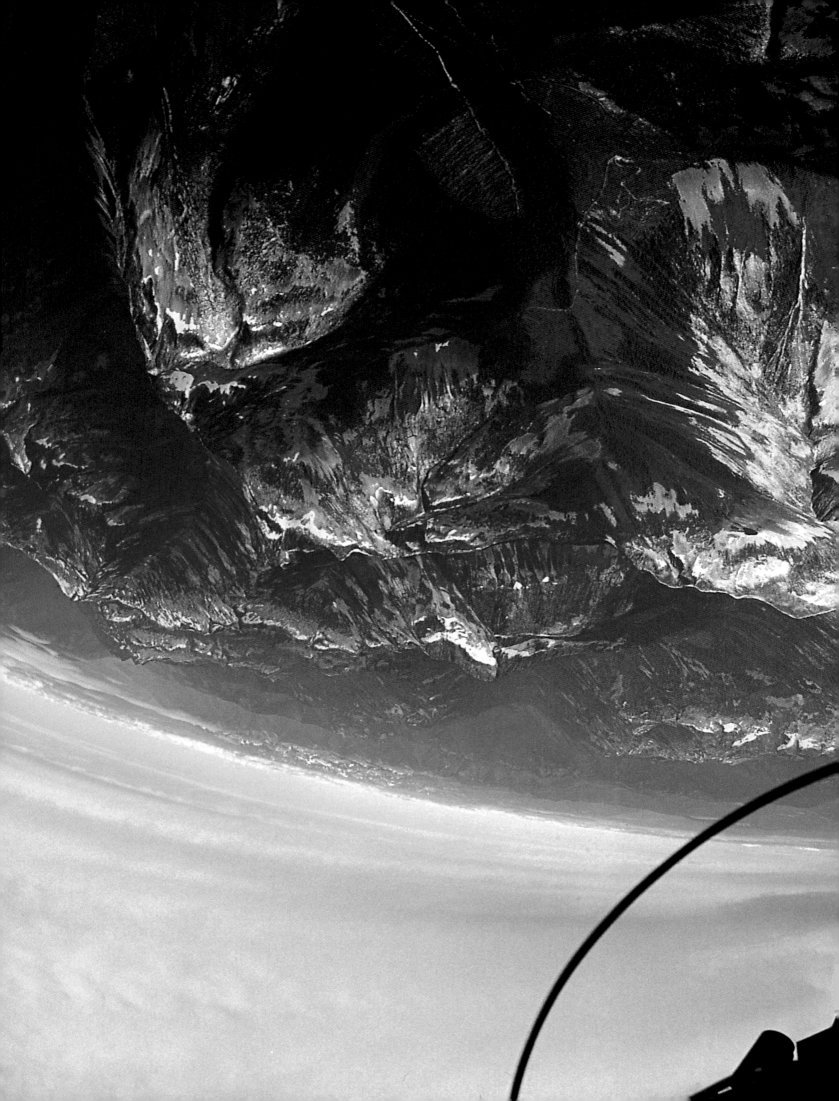

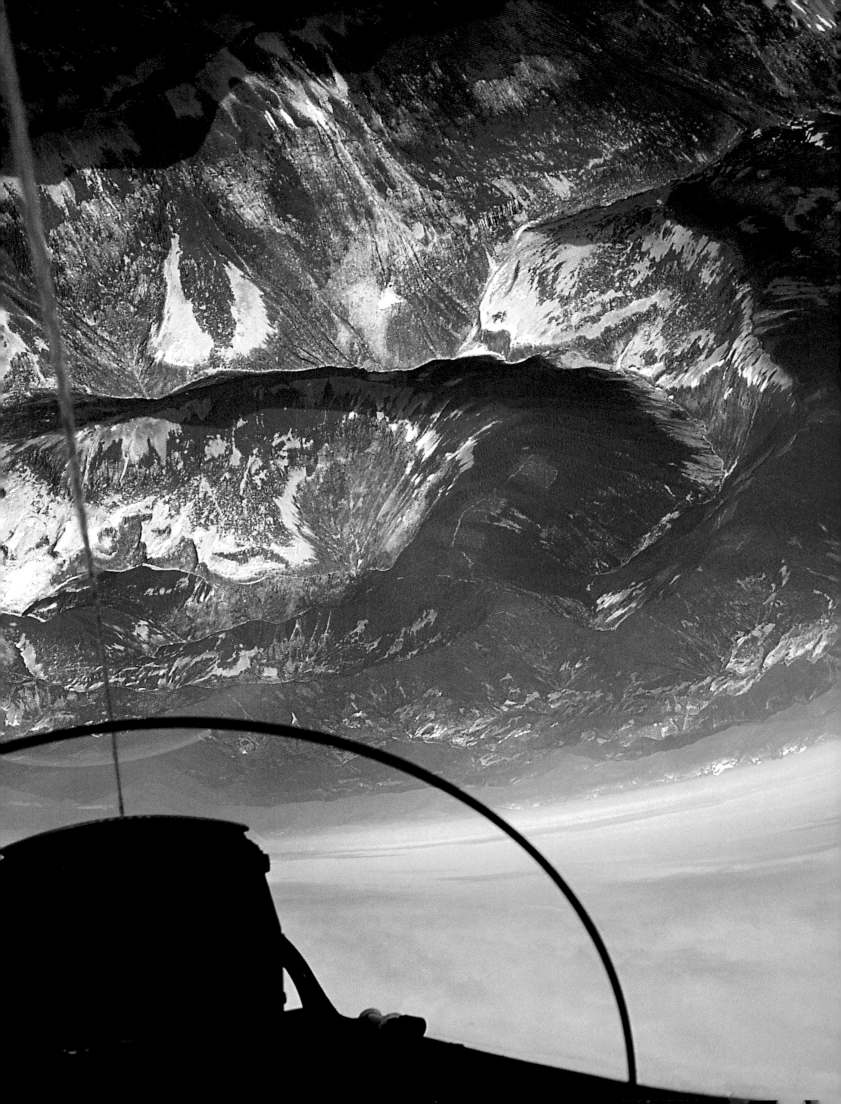

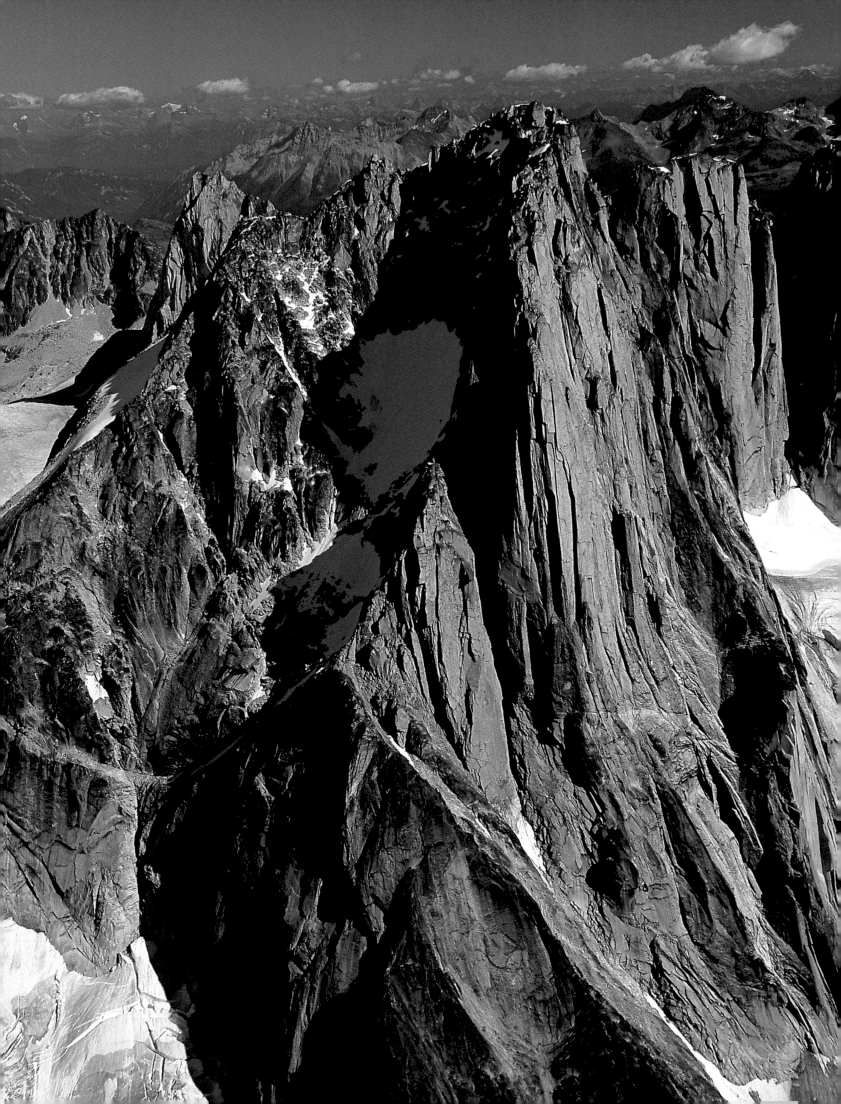

(continued from page 49)

In addition to spectacular mountain peaks, Banff National Park contains vast lowland valleys, meadows, and lakes and rivers. Visitors are likely most familiar with the resort areas of Banff and Lake Louise. Lake Louise is the highest community in Canada, and the beauty of seeing the towering Mount Victoria reflected in the lake is a sight never forgotten by anyone who visits the area.

Soon after Banff, the other great parks in the Rockies were established – Yoho in 1886, Waterton Lakes in 1895, Jasper in 1907, and Kootenay in 1920.

Jasper, the largest and northernmost of the mountain parks, includes Mount Robson and Mount Edith Cavell. (The crown of Mount Robson, the highest point in the Rockies, is located in Mount Robson Provincial Park, northwest of Jasper.) The beautiful Maligne Lake, the second largest glacial lake in the world, is one of more than 800 lakes and ponds.

Jasper also contains the largest icefield in the Canadian Rockies. The Columbia Icefield runs from the southwest corner of the park to the northwest boundary of Banff. At the opposite extreme, Jasper's hot springs are the result of volcanic activity deep in the earth that is vented up through the earth's crust.

Jasper's visitors can expect to see many species of animals that have become accustomed to the presence of humans. Black bears are a common sight – often near the road and campgrounds – while the grizzly bears in the park prefer more remote areas and are seen much less often by tourists. Moose, elk, and mule deer are found at lower altitudes and can be viewed without difficulty.

Yoho, on the western slope of the Rockies, is the smallest of the mountain parks. It is home to the Burgess Shale, one of the world's most fascinating fossil beds, where ancient mudslides fossilized the remains of sea creatures dating back some 530 million years. Yoho's Takakkaw Falls, with a vertical drop of 380 metres (1245 feet), is the second highest waterfalls in Canada.

Kootenay National Park, which slopes to the Rocky Mountain Trench, offers its visitors not only glaciers but cacti, and a host of ecological features in between. The Radium Hot Springs coat the walls of Sinclair Canyon at the southern edge of the park. The ochre beds at Painted Pots, an active spring, are the result of dissolved iron in the spring's waters. Rich in plant and animal life, the park is populated by bighorn sheep and mountain goat.

(continued on page 69)

Pages 60 and 61
A novel view from an inverted "T-Bird" T-33 Silver Star Jet Trainer, as captured by my 16-mm fish-eye lens while I hang by my bootstraps somewhere very high over the Rockies.

Left
Reaching heights of 3400 metres (11,000 feet), the Howser Spires are the most easily recognized natural feature of the Bugaboo Range in the Purcell Mountains. To the better acquainted, the range is fondly called "the Bugs." [22]

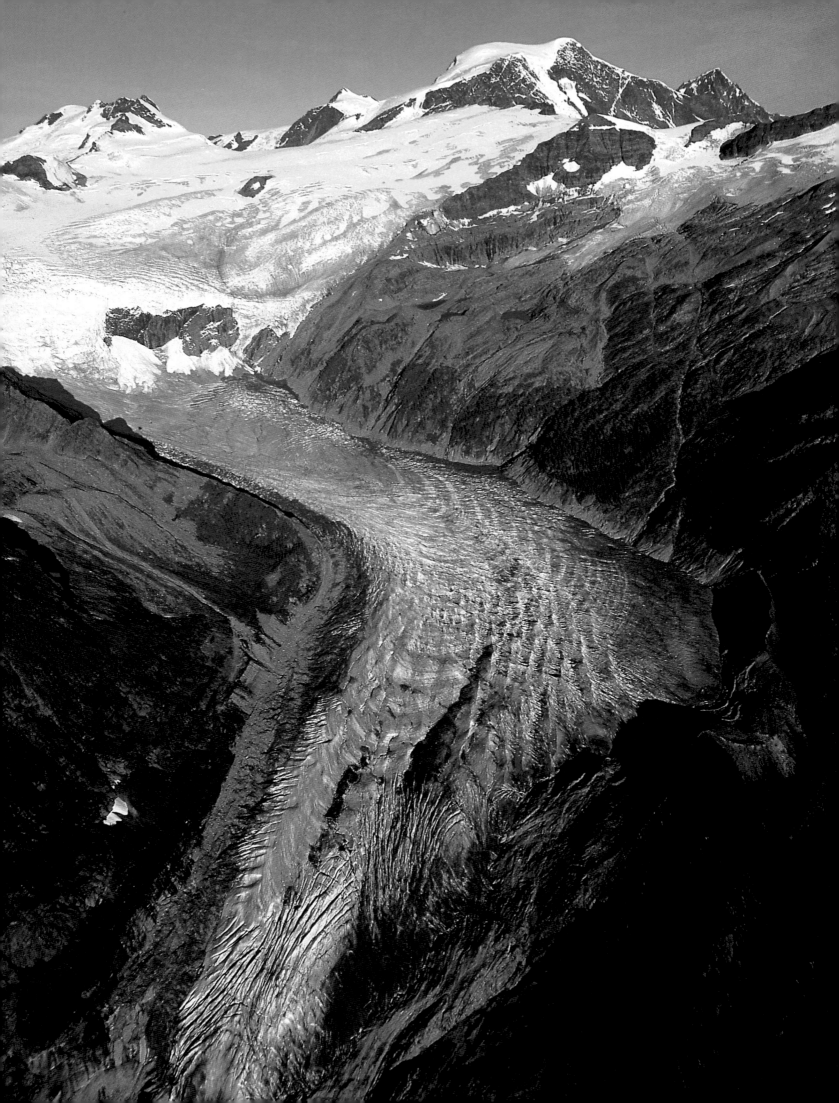

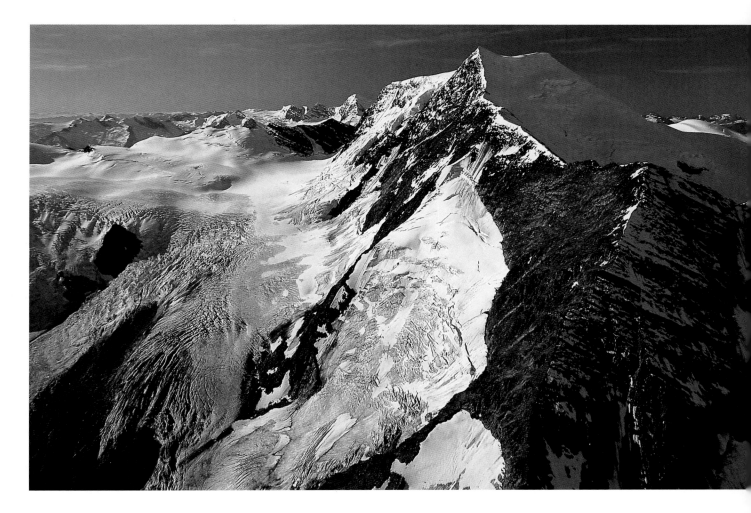

The centerpiece of the Cariboos is Mount Sir Wilfrid Laurier. No matter how often I fly over the area, I am always intrigued by the mountain's earthy tones and sharply sculpted edges. [24]

Pages 66 and 67
Normally we photograph only in the early morning and late in the day, to take full advantage of the softer long light. We had landed for lunch and to wait out the afternoon when we spotted grizzly bears near our landing site. We knew that upon takeoff there would be only a split-second chance to photograph them. Using a gyro-stabilized 600-mm lens, we got this shot of a bear as it bolted full tilt across the stream and out of sight.

Left
Because they are on the western side of the Rocky Mountain Trench, the Cariboo Mountains are not truly a part of the Rockies. Good neighbors nevertheless, the Cariboos have a distinctive appearance that enhances the adjoining landscapes. [23]

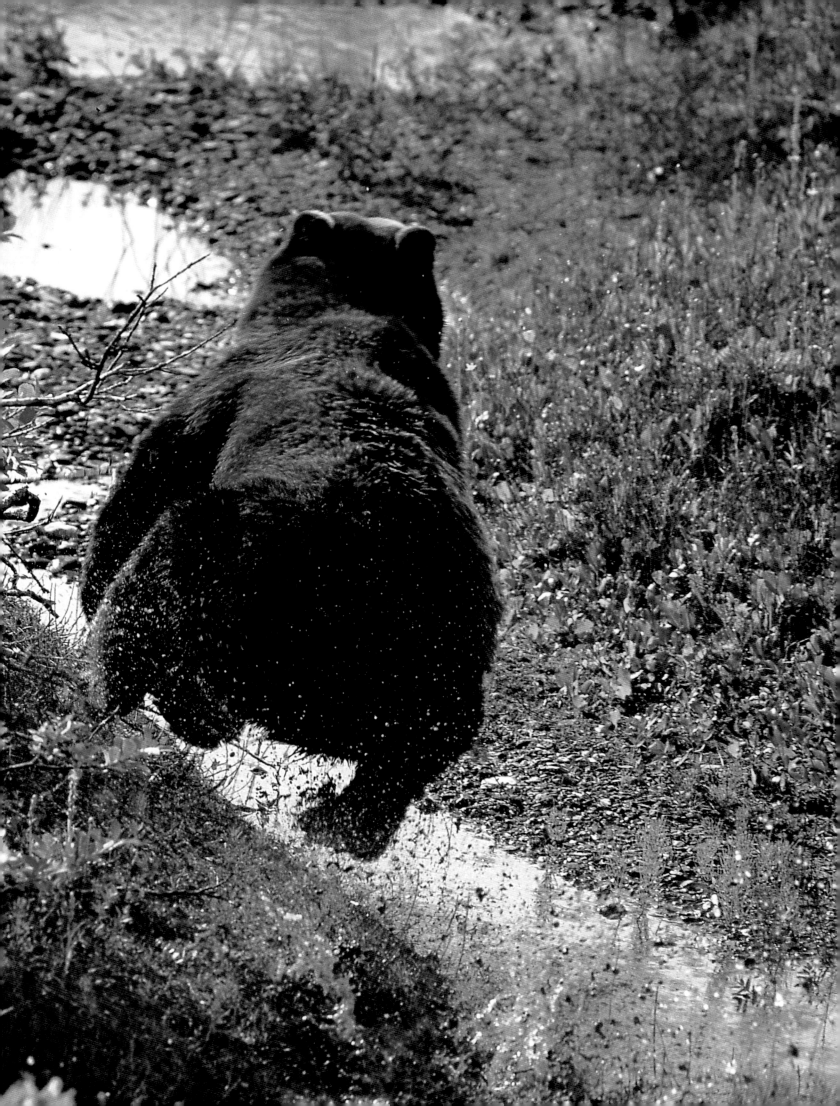

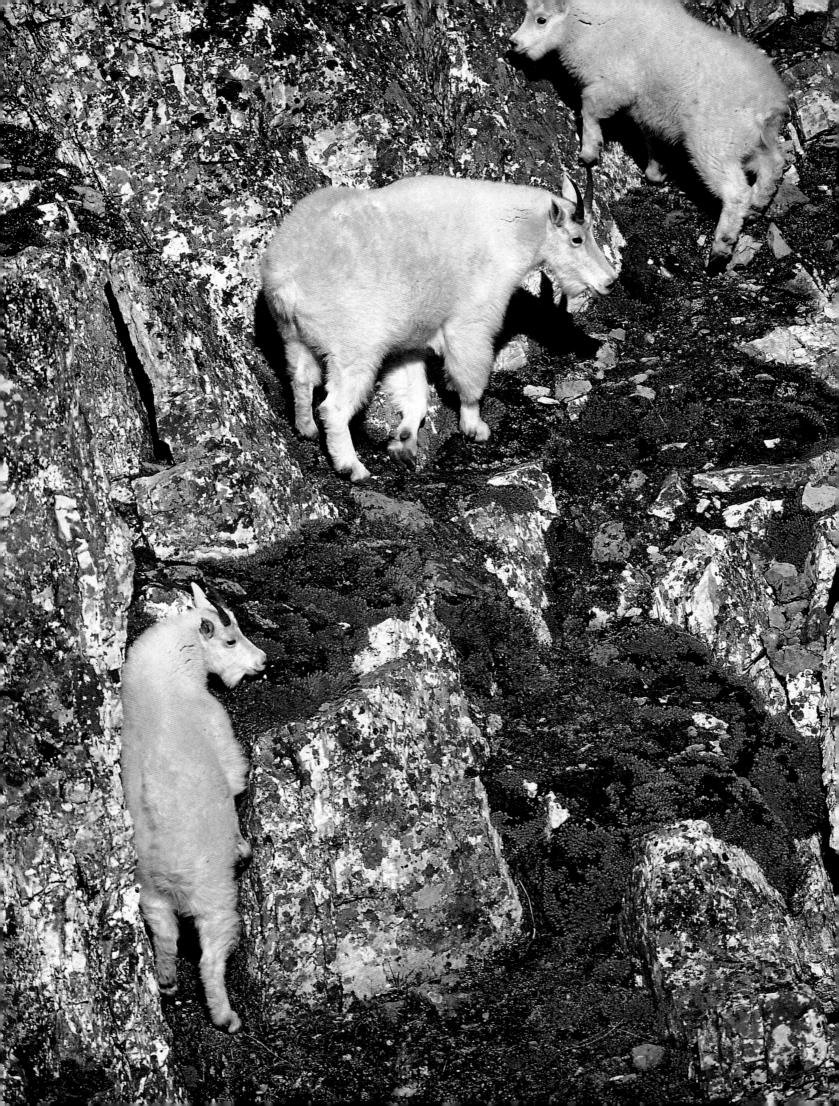

(*continued from page 63*)

Combined, Banff, Jasper, Yoho, and Kootenay make up 20,743 square kilometres (8001 square miles) of wilderness – about the same size as the state of New Jersey.

The fifth of the great parks of the region is Waterton Lakes National Park, located in the southwest corner of Alberta. Waterton presents a transition from the mountain landscape to the prairie grasslands. The sparsely populated Waterton Lakes, with its breathtaking mountain scenery and ice-blue lakes, is said to remind visitors of Banff in its earlier, less hectic days. More than half the plant species in Alberta are found at Waterton.

As if to confirm the stature and importance of the Canadian Rockies among the great wilderness areas of the world, the United Nations has designated the four mountain parks – Banff, Jasper, Yoho, and Kootenay – along with Mount Assiniboine, Mount Robson, and Hamber Provincial Parks, as one huge World Heritage Site.

In 1932, Waterton and its sister park, Glacier National Park in Montana, were dedicated an International Peace Park, the first in the world. The United Nations declared that area a World Heritage Site in 1995.

Left

Champion rock climbers, mountain goats inhabit
the roughest terrain in the Rockies. They can often
be found high up on the cliffs of Yoho National
Park and Kicking Horse Pass.

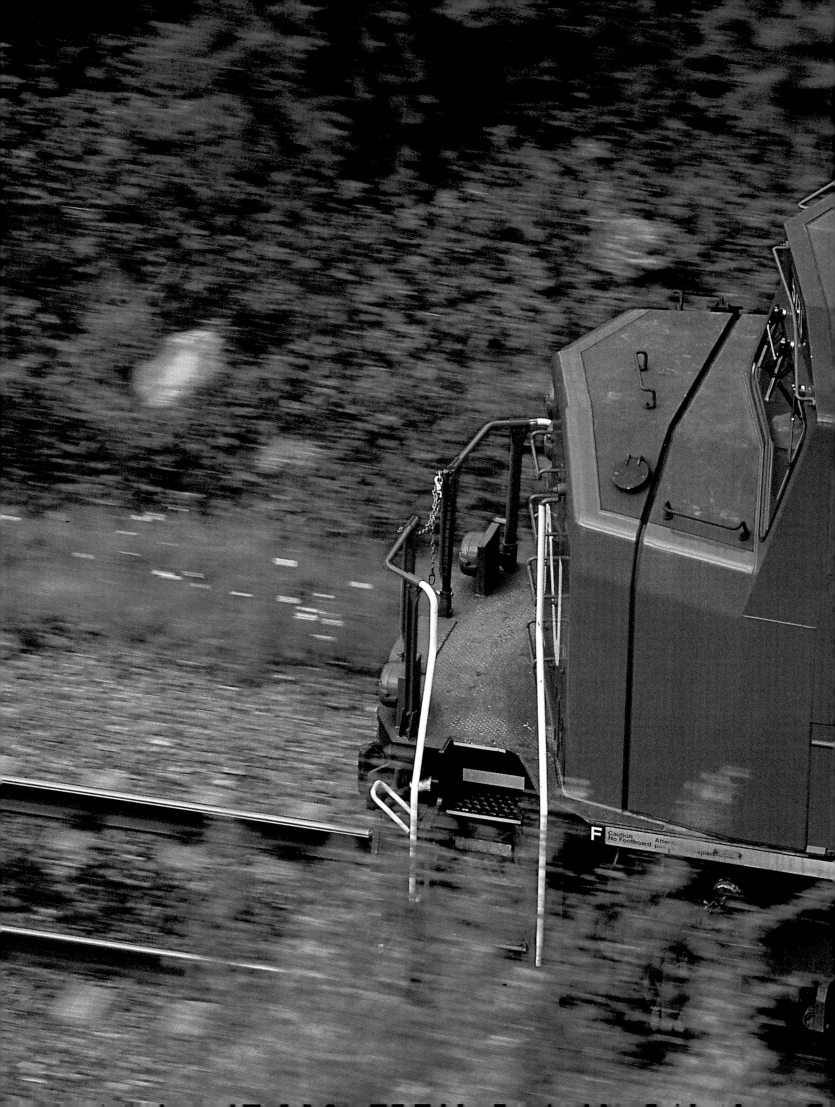

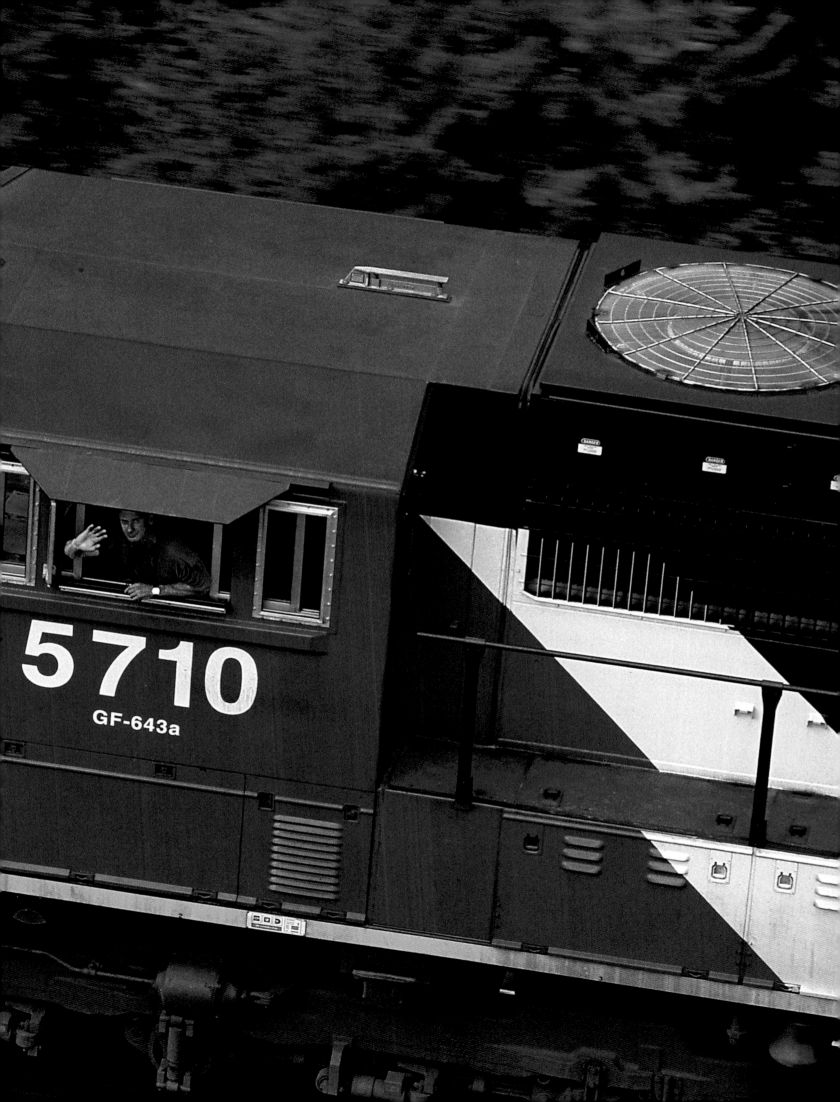

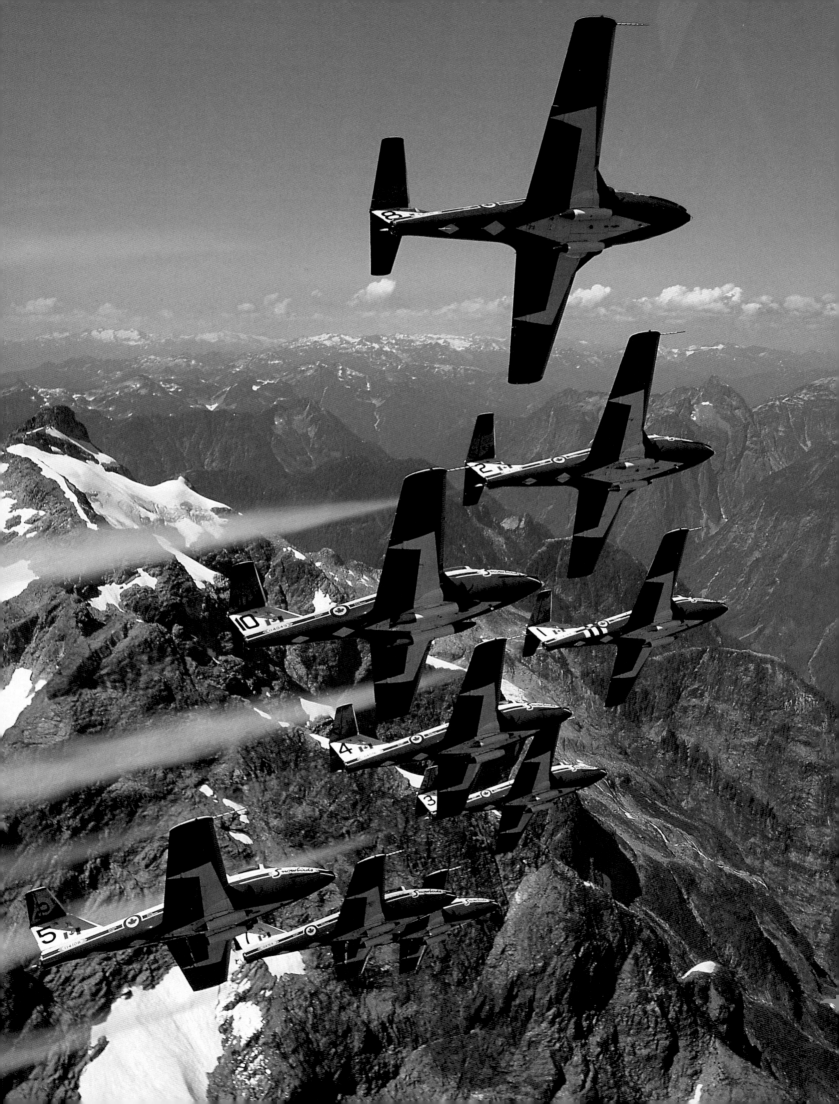

the mountains

The mountains

Visitors to the Canadian Rockies are often amazed to realize that the towering, immense, seemingly ageless and changeless expanse of rocks reaching into the sky was laid down millions of years ago at the bottom of some ancient ocean.

Few igneous rocks are found in the Rockies, and evidence of volcanic activity is rare. The tops of mountains that now stand over a mile high were formed, as evidenced by their fossil and sand content, just below sea level. Composed almost completely of sedimentary rock, the raw material of the Rockies was fashioned hundreds of millions of years ago at the bottom of ancient seas that once covered much of what is now the central North American continent.

The process of mountain-building is driven by the movement of the great continental plates that cover the globe and grind restlessly against one another as they float on the more fluid material below. Through the movement of plate against plate, the rock in what is now western Canada was heaved upward, broken and covered with other layers of rock – some hundreds of miles long. The forces that moved this immense pile are incomprehensible. The result is the huge expanse of tortured rock we call the Rockies.

As mountains go, the Canadian Rockies are youngsters. At only about seventy million years old they are still relatively steep and jagged. Erosion has not had time to grind them down or to erase the evidence of the last ice age. In comparison, rocks in the great Precambrian Shield, which covers much of northern and eastern Canada, are more than two billion years old. In time the great Canadian Rockies will crumble, and the same geological processes that formed the mountains we see today will throw up other mountains in their place.

The Canadian Rockies are composed of three mountain systems: the front system, the main system, and the western system. To the east the Rockies are framed by Alberta's prairie plains, and to the west by the deep valley called the Rocky Mountain Trench, which separates the Rockies from the Columbia Mountains in the interior of British Columbia. The front system marks the eastern mountain front. The main system forms the backbone, and is itself divided into eastern and western ranges. The western system borders the Rocky Mountain Trench.

(*continued on page 79*)

Pages 71 and 72
While many of us are fascinated watching trains, train conductors, it seems, are fascinated watching helicopters.

Left
Canada's world-famous Snowbirds practice high above the Rockies. Each year the air demonstration squadron dazzles some five million spectators at 60 Canadian and United States air shows.

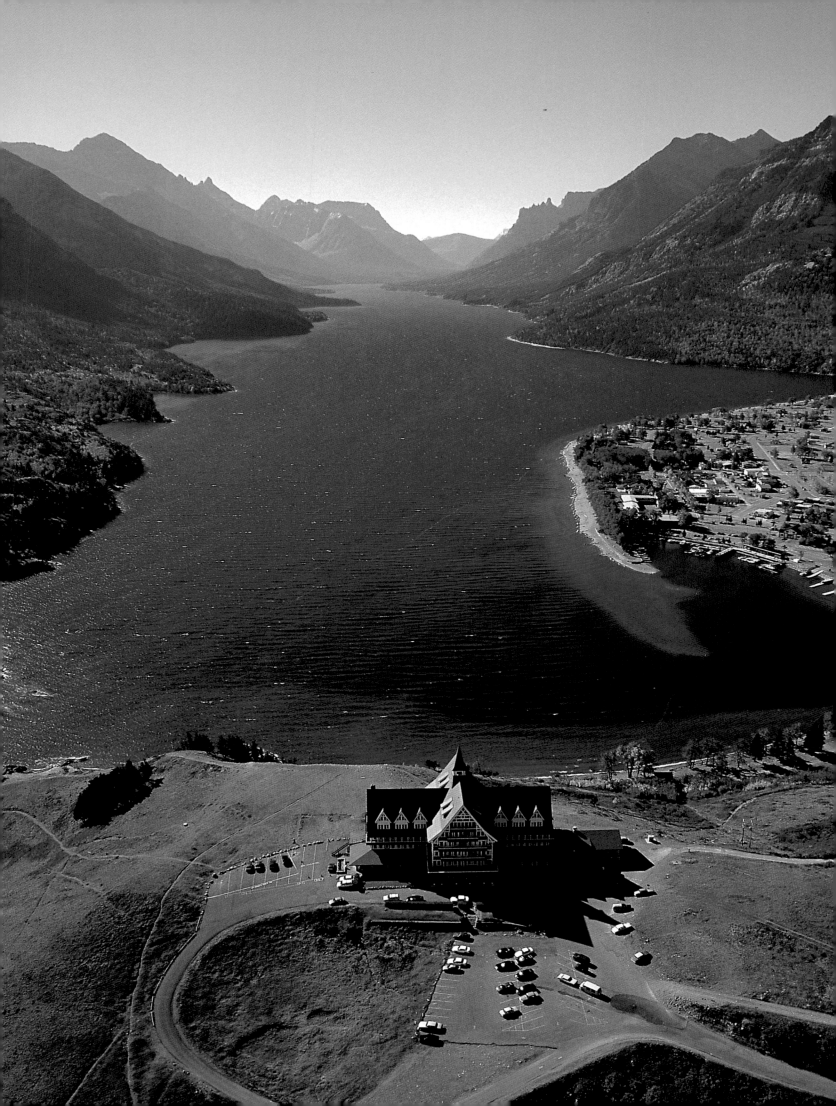

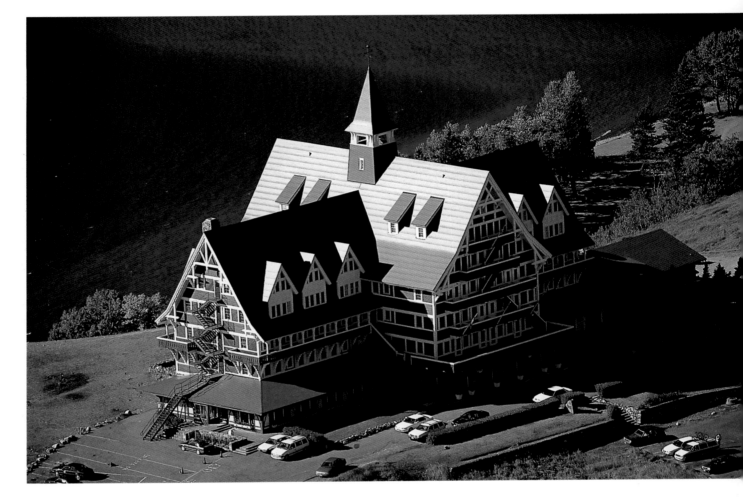

Above

Nestling in one of the most inspiring settings the Rockies has to offer is the first-class Prince of Wales Hotel. Overlooking Waterton Lake, it was opened in 1927 by the Great Northern Railway. [26]

Left

Waterton Lakes National Park, established in 1895, is one of the smallest of the Rockies' parks. In the southwest corner of Alberta, Waterton borders Glacier National Park in Montana. The two parks are known as the Waterton–Glacier International Peace Park. [25]

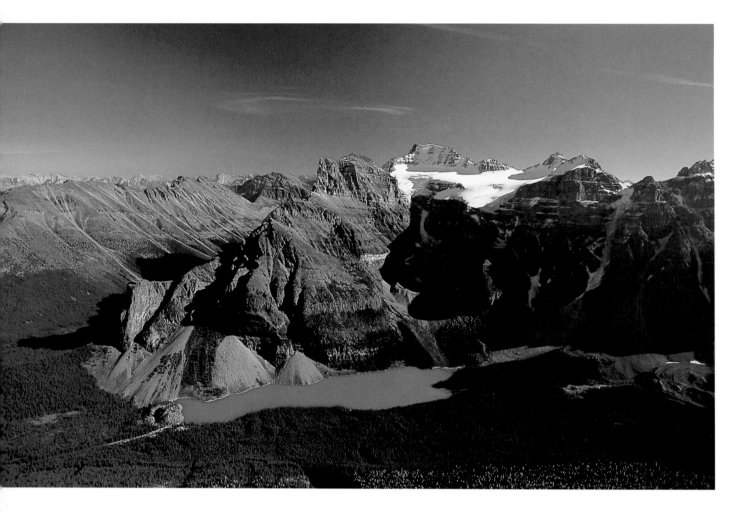

Above

The deep-emerald Moraine Lake is surrounded
by the Valley of the Ten Peaks. The scene became
famous when it appeared on the back of the
Canadian twenty-dollar bill. [27]

Right

Waterton Lakes National Park, a paradise for hikers
and naturalists, offers the greatest variety of plant and
animal life in the Rockies. [28]

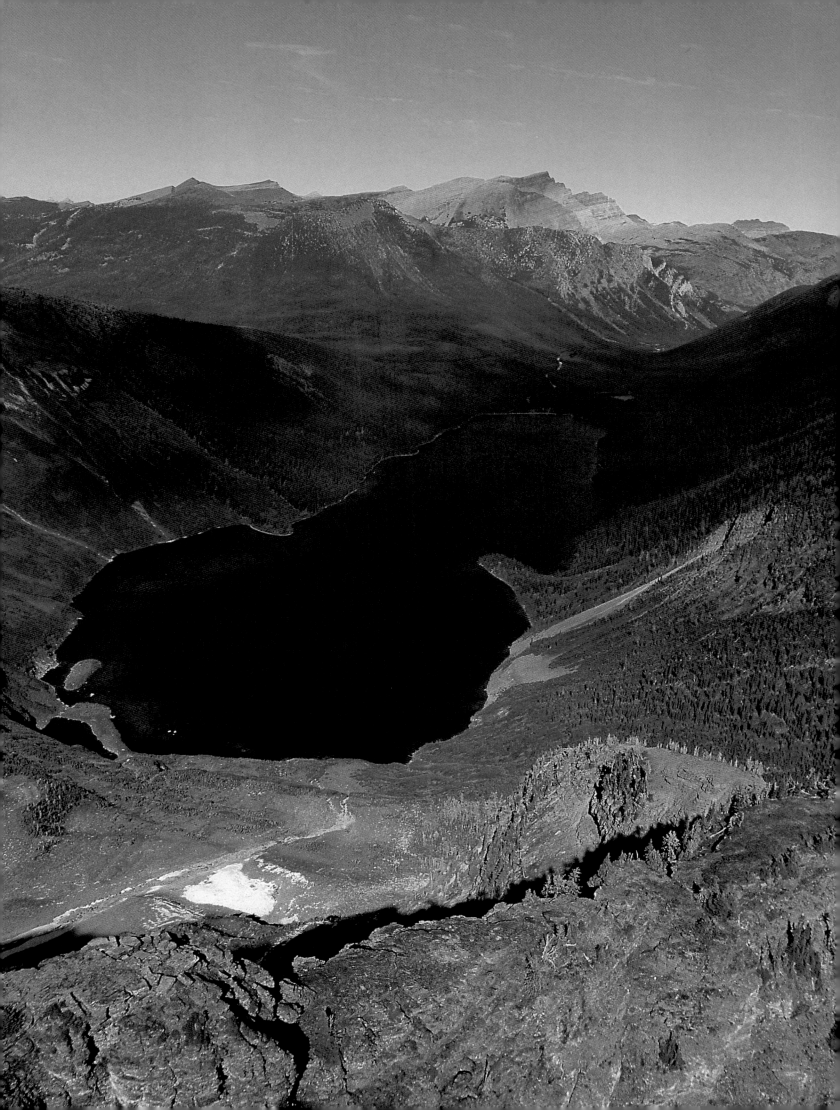

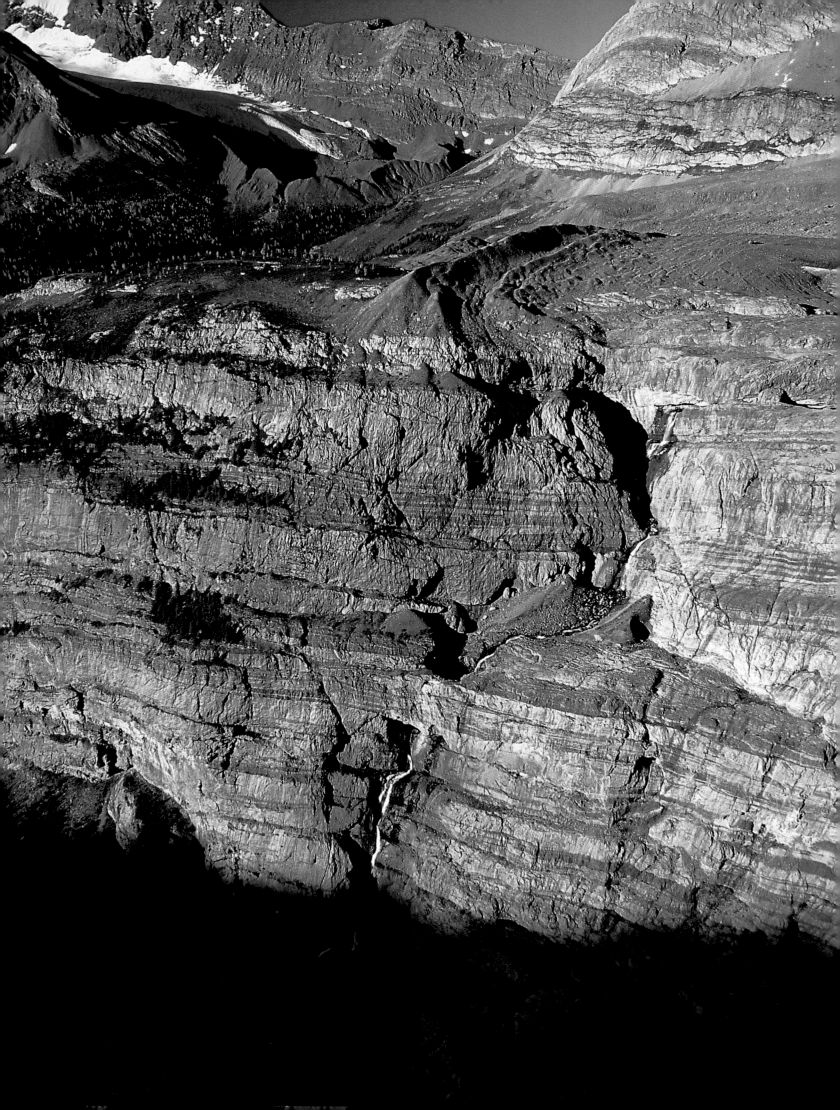

The mountains

(continued from page 73)

The front ranges are composed of huge slabs of sedimentary rock, hundreds of miles long, that have been broken and thrust upward. Beyond the steep and broken rock of the front ranges, the main ranges of the Canadian Rockies are composed of less steep rock formations. Here the mountains have not been subjected to as much force and motion. Finally, as you move west to the Kootenays and beyond, the rocks again become steeply tilted and the conditions resemble those found in the front range.

Forming the boundary between Alberta and British Columbia and marking the highest reaches of the mountains is the Continental Divide. Rivers on the west side of the divide flow into the Pacific Ocean, and those on the east flow into the Arctic and Atlantic Oceans. It is said that if a raindrop lands right on the divide, the moisture from it has an equal chance of winding up in the Atlantic or in the Pacific. From the Continental Divide, the mountains taper off both east and west. In the east the mountains eventually give way to the long, rolling ridges known as the foothills, which provide a fitting introduction to the Rockies for the traveler arriving from the prairies. To the west the Rockies give way to other, very different mountains as the land tapers quickly to the Pacific.

As you travel from the valleys to the tops of the Rockies, the temperature becomes progressively colder. Only near the top is the year-round temperature low enough to allow the remnants of glaciers, like the Columbia ice sheets, to remain intact. Because of their great size the Rockies have a huge effect on the climate of all of western Canada. They create the dry, clear air characteristic of the prairies as well as ensuring that a plentiful supply of moisture falls on the lush forests of British Columbia.

Left

Glacial water cascades off the Haig Glacier, down a cliff face, under a natural stone bridge, and into the belly of the canyon below. [29]

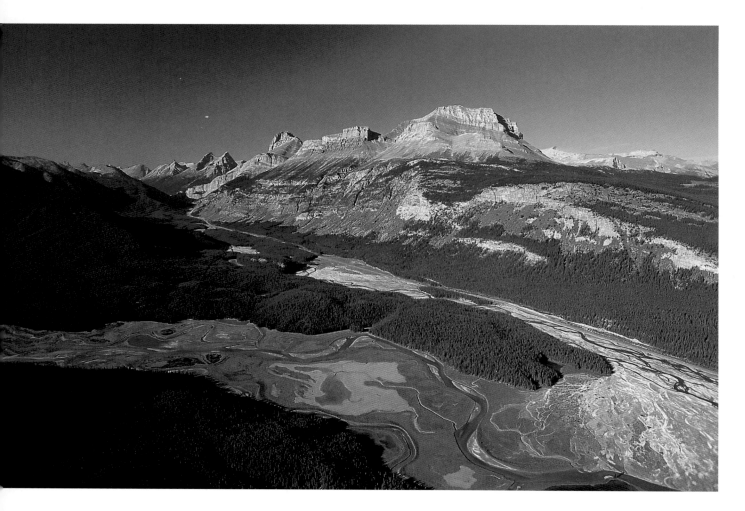

Above

In the shadows of the Great Divide, the North Saskatchewan River winds through Banff National Park, alongside the Icefields Parkway. Named for the chain of huge icefields that cap the Rockies along its route, the parkway is considered one of the world's great mountain highways. [30]

Right

Not as well known as some of their neighboring lakes, Waterfowl Lakes are just as breathtaking – and offer exceptional camping facilities. [31]

Pages 82 and 83

Massive glaciers carved these deep valleys into the Bow Range. [32]

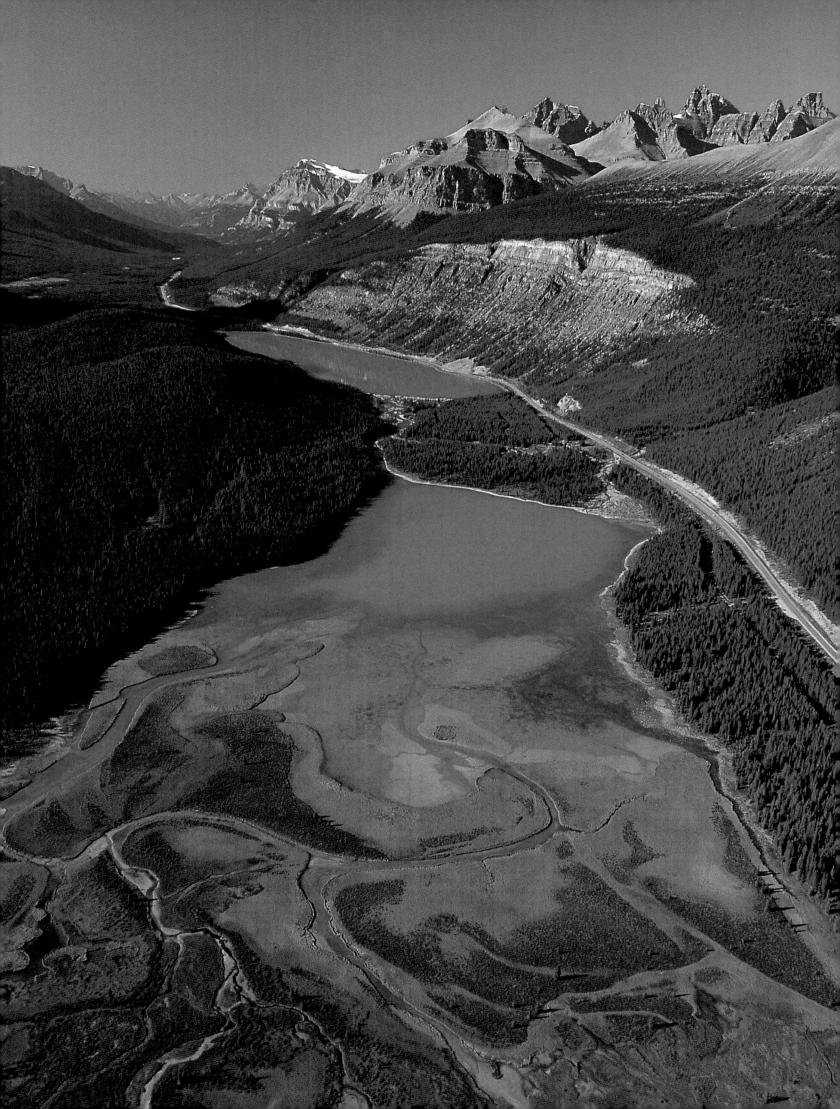

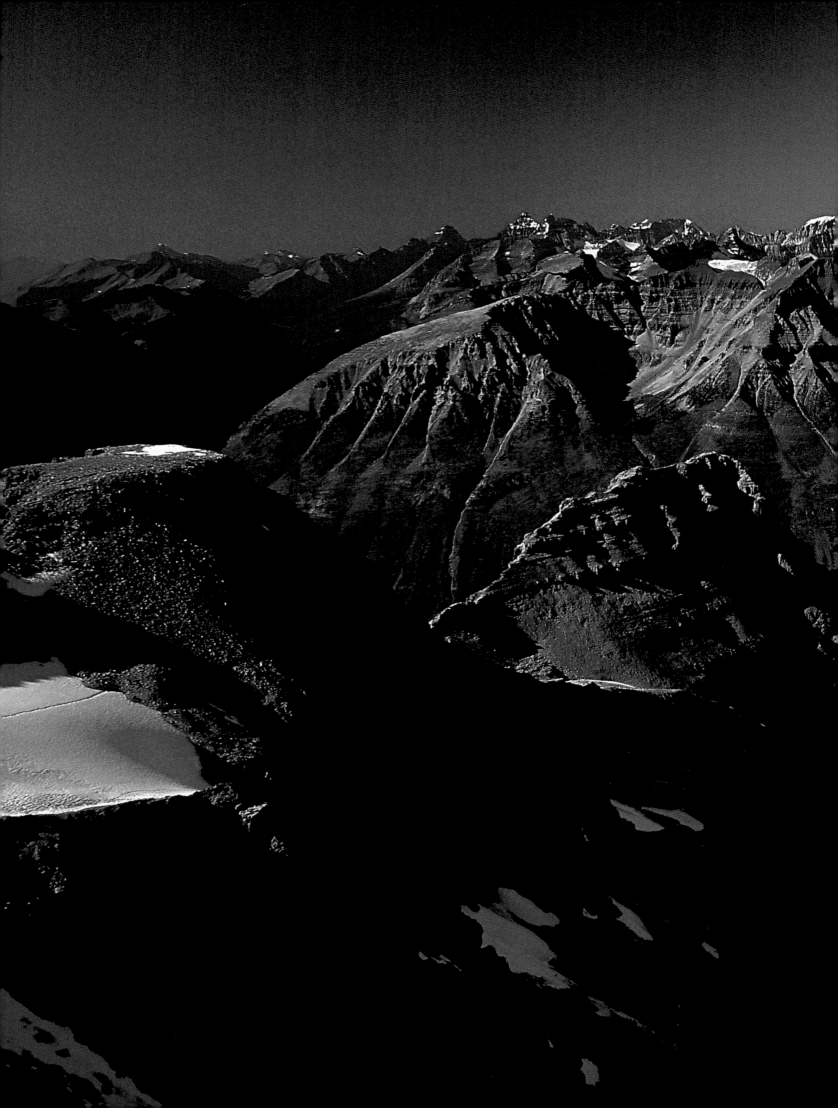

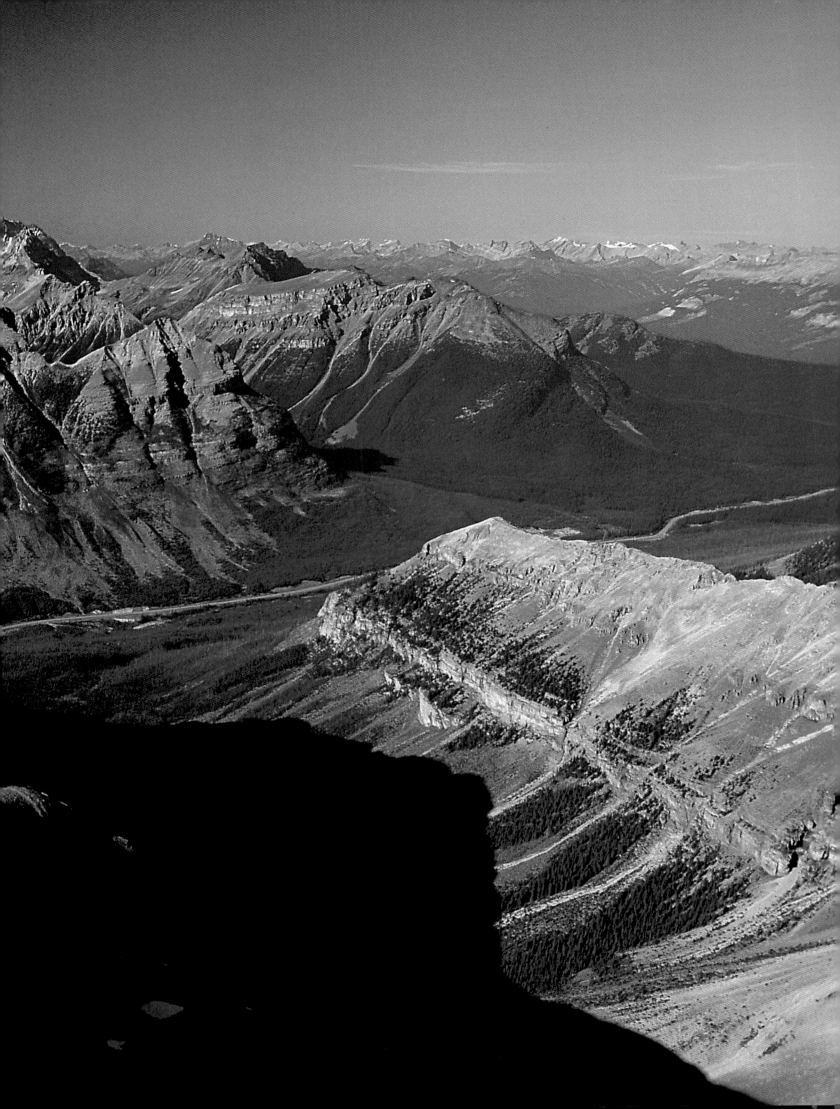

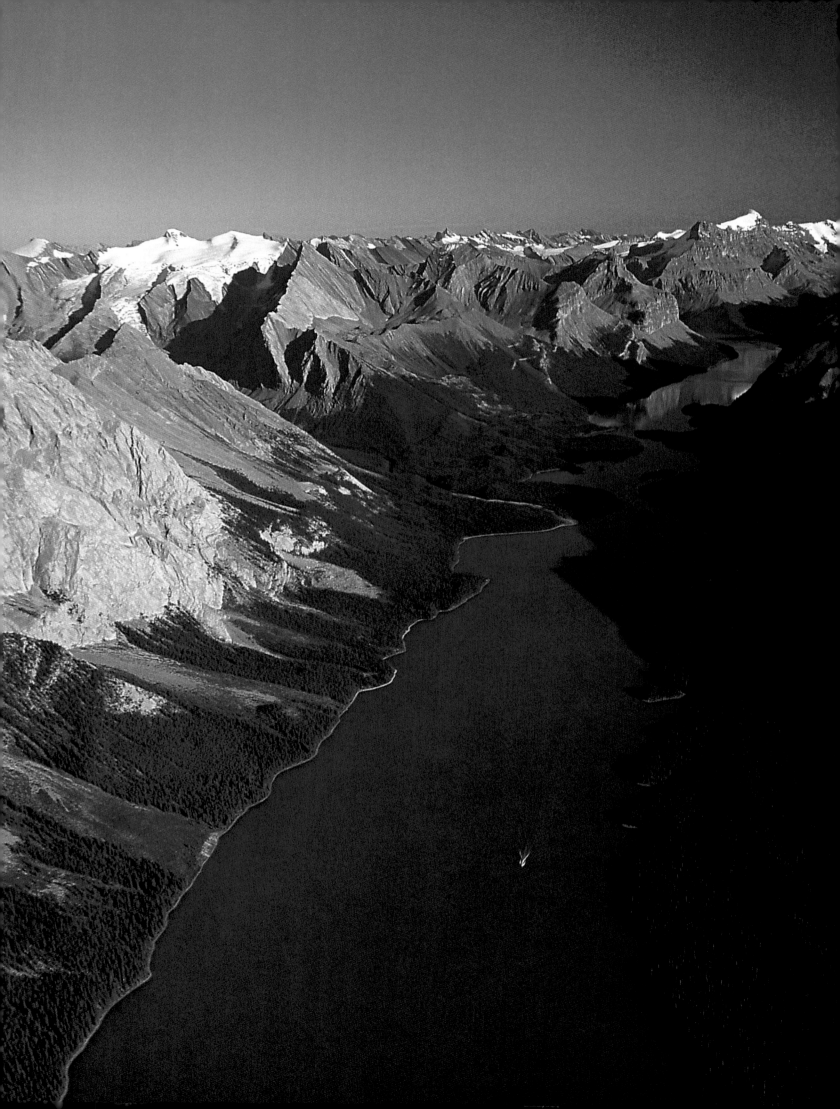

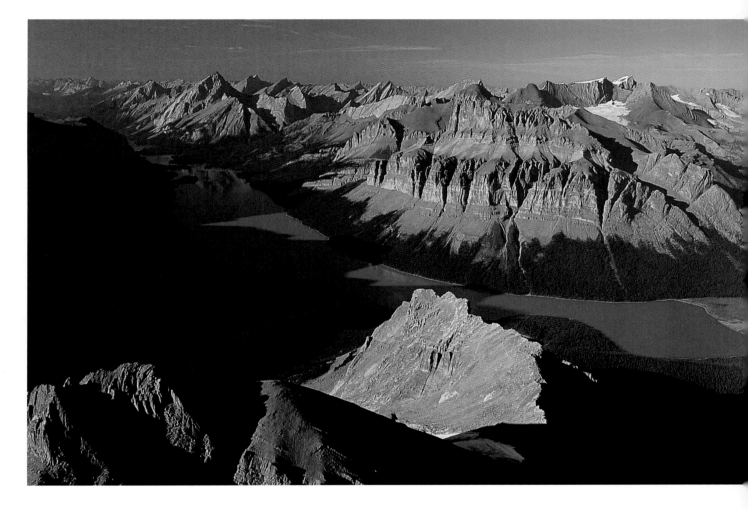

Above

Fed by the many glaciers that surround it, beautiful Maligne Lake is the second largest glacial lake in the world. [34]

Left

A cruise ship sails gracefully up Maligne Lake, legendary for its deep-blue waters. [33]

Pages 86 and 87

Alpine larches add a dash of fall color to the Ball Range, which provides a natural border between two national parks – Banff in Alberta, and Kootenay in British Columbia. [35]

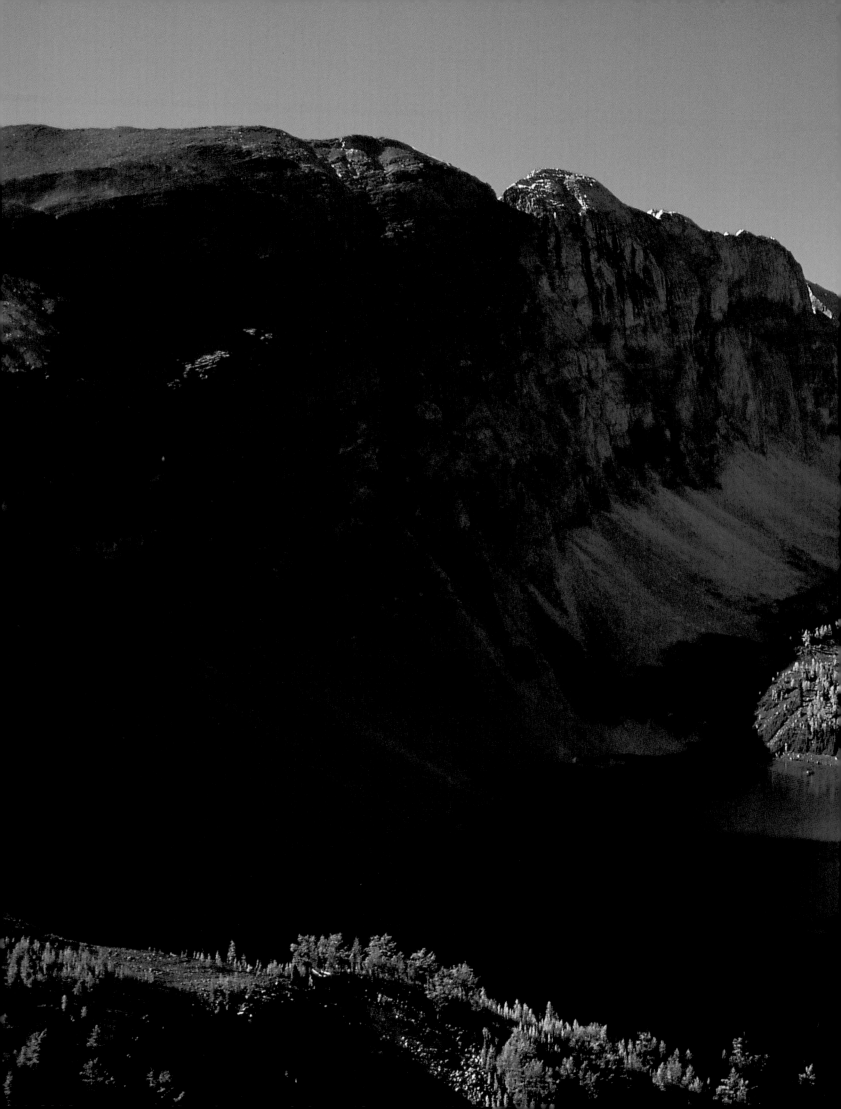

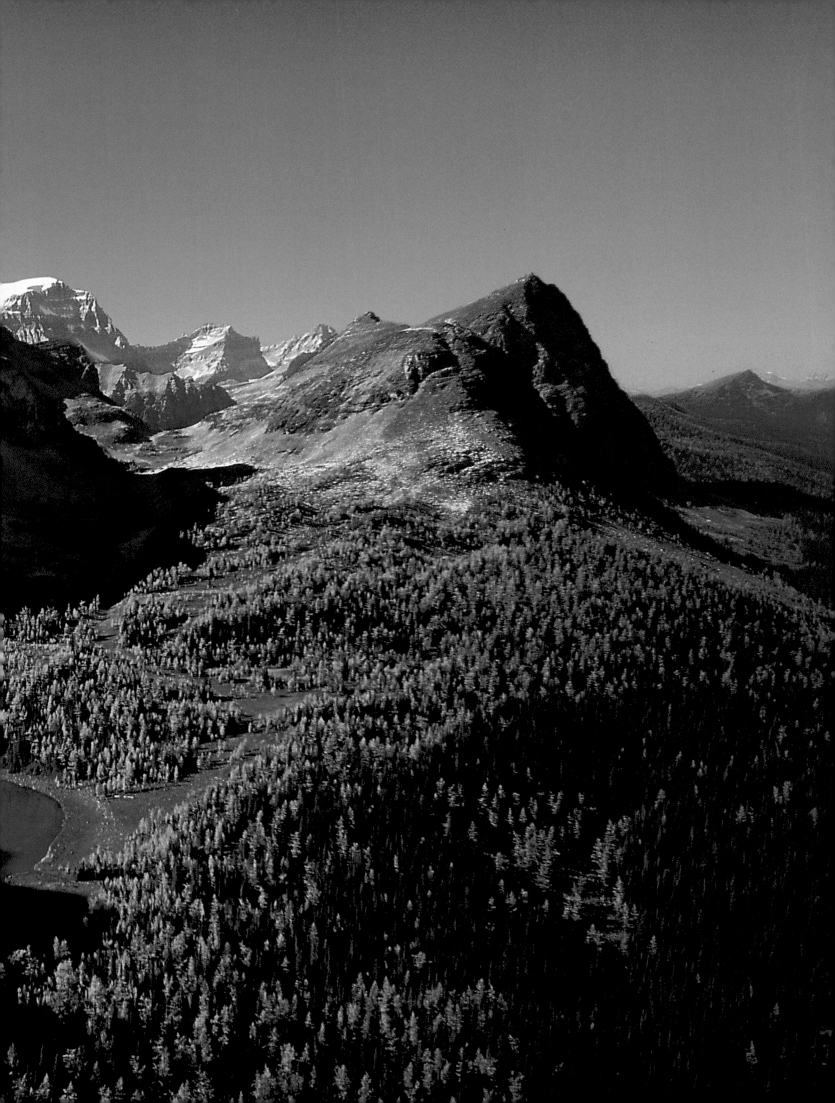

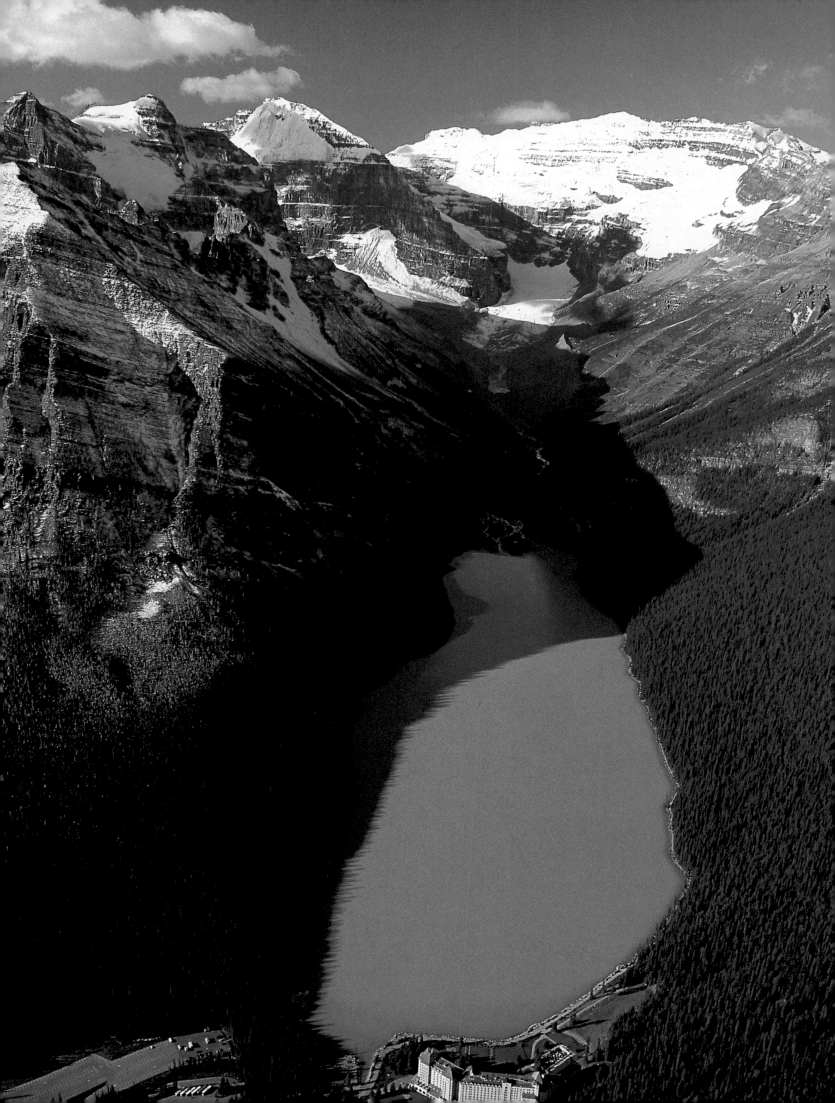

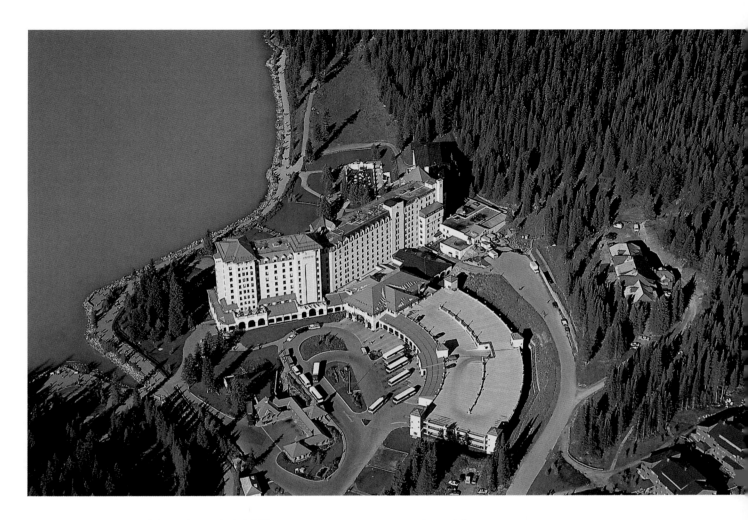

Above and near left

Guests at the Chateau Lake Louise have been enjoying the tranquillity and splendor of the area ever since the Canadian Pacific Railway built the first log hotel here in 1890. By the Roaring Twenties, the building had become a grand hotel, with further renovations undertaken as it celebrated its centennial. [37]

Pages 90 and 91

Hovering over Lake Agnes, we shot Lake Louise and the chateau from an unusual angle. In the bottom left-hand corner is the famous Teahouse; an observation platform appears in the center of the picture, on the ridge. [38]

Left

The jewel of the Rockies is legendary Lake Louise. The Stoney Indians called it the Lake of Little Fishes, and the first European visitors in 1882 named it Emerald Lake. It was renamed Lake Louise in 1884 in honor of Princess Louise Caroline Alberta, daughter of Queen Victoria. The majestic Victoria Glacier rests high above the lake. [36]

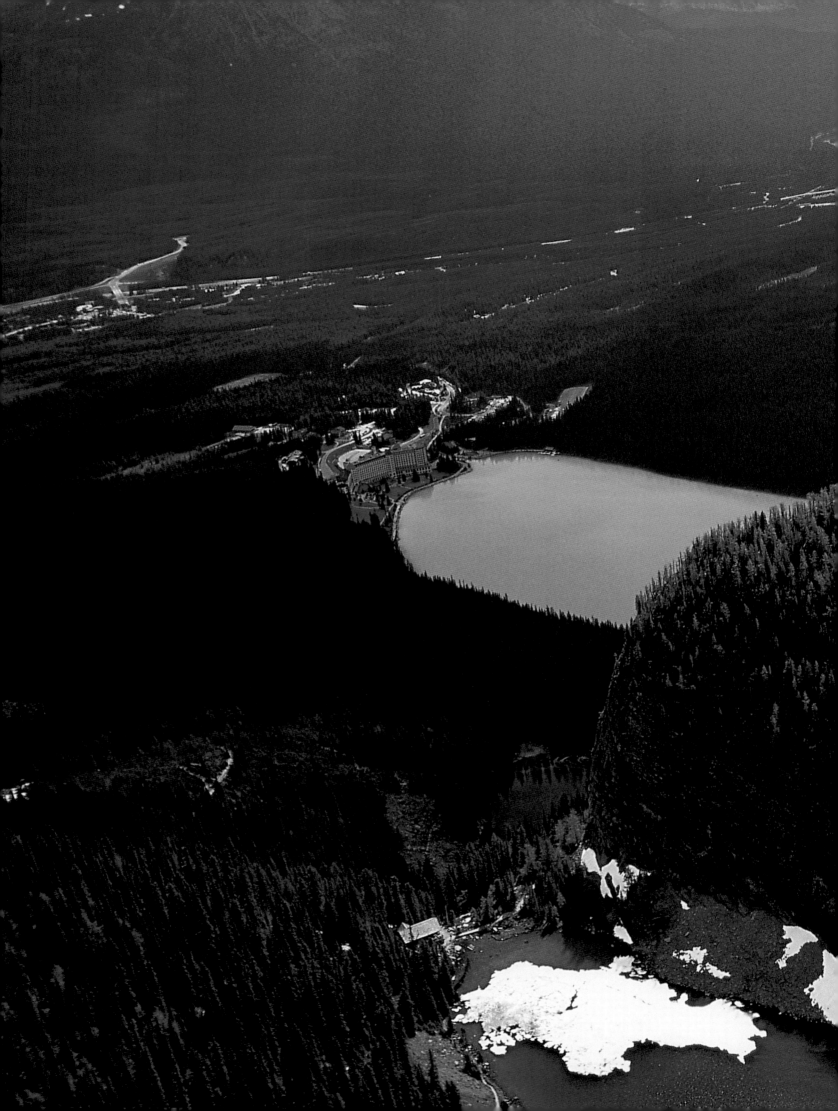

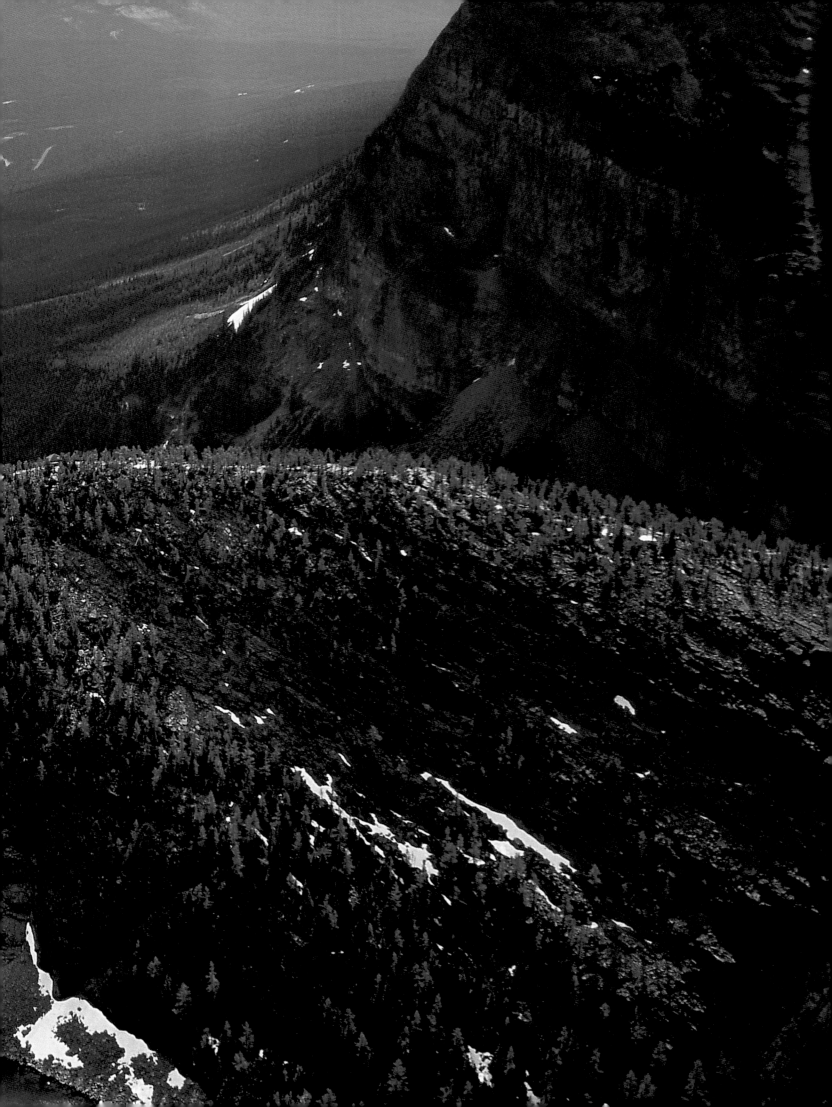

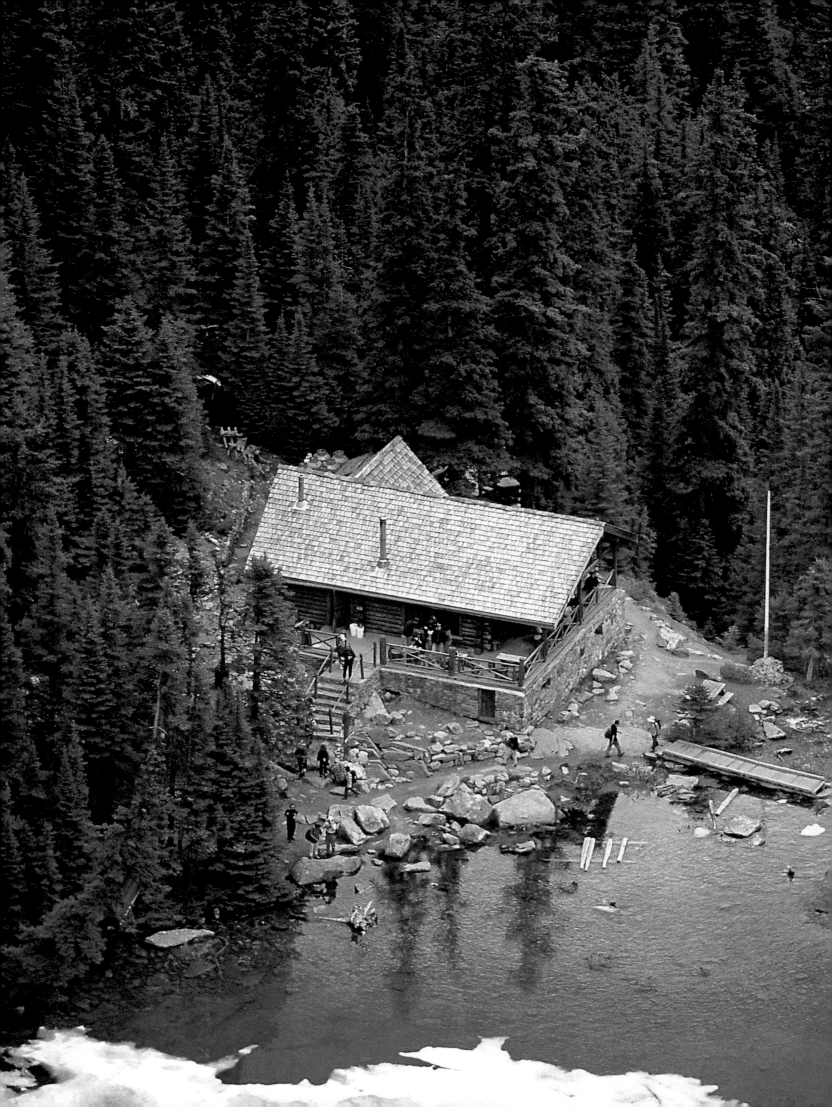

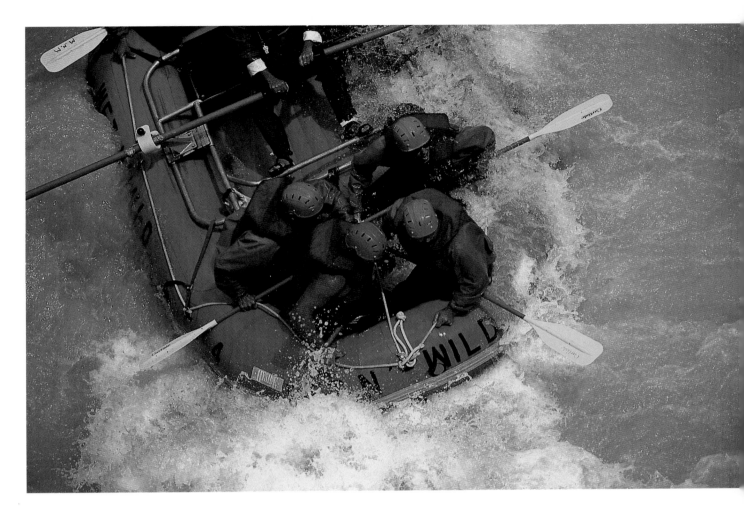

Above

Rushing through the turbulent waters of Kicking Horse Pass, rafters wrestle to control their craft. The lower canyon offers a long, continuous class four rapids – guaranteed to thrill the most hard-core rafter. [40]

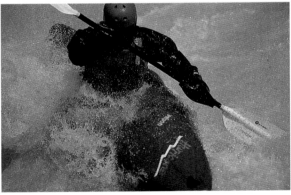

Left

The Lake Agnes Teahouse is accessible to the adventurous, who must hike the 3.4 km (2.1 mile) trail up from Lake Louise to the "lake in the clouds." The historic spot offers visitors some of the most celebrated – and hard-worked-for – baking in the Canadian Rockies. [39]

Near left

An intrepid kayaker shoots the rapids of the Kicking Horse, one of Canada's premier whitewater rivers. [41]

Right

In a fanlike array, canoes on Lake Louise lazily await their next paddlers. The pristine glacial waters have attracted tens of millions of admirers. So striking is the lake's color that, in the early days of tourism, the Canadian Pacific Railway was falsely accused of artificially coloring the water. [42]

Page 96

In dramatic solitude, Castle Mountain stands vigilantly over the Bow Valley. Its east tower, the Eisenhower Peak, rises to 2766 metres (9076 feet). It is named for the American general and president. [43]

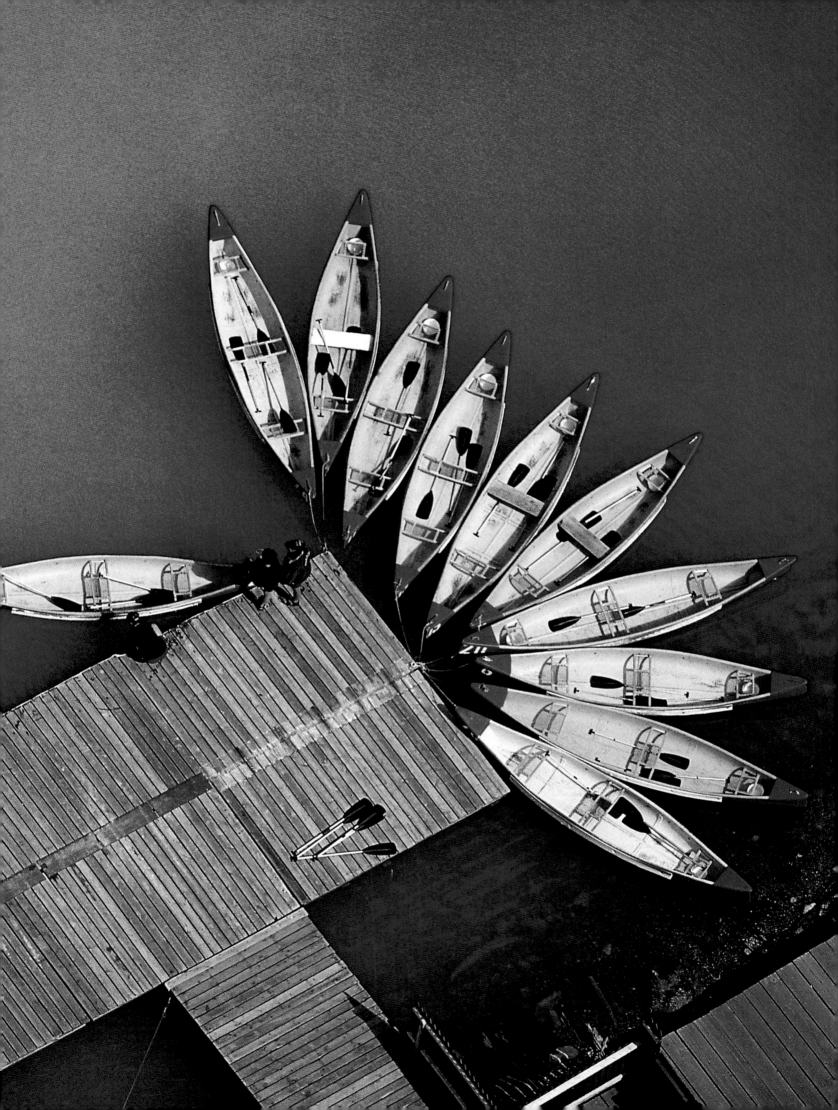

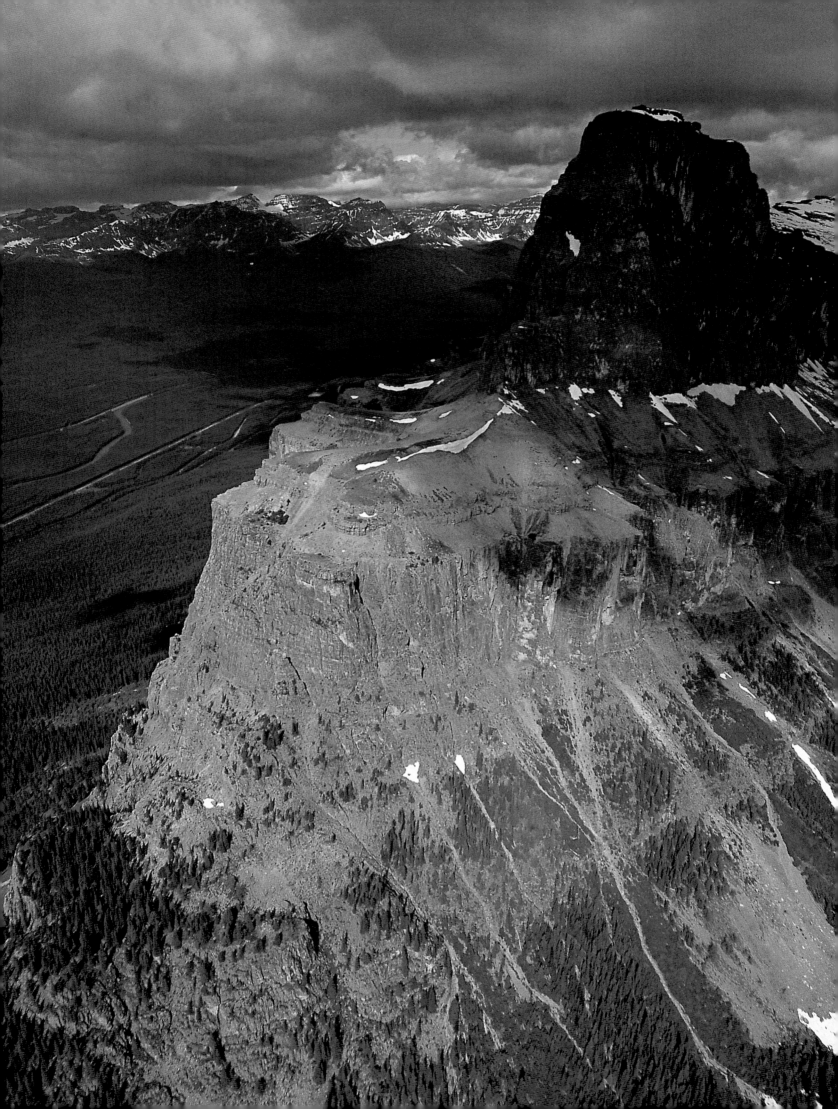

the glaciers

the glaciers

Only twenty thousand years ago, just a moment on the geological time scale, virtually all of Canada – as well as much of the United States, Europe, and Asia – was covered with thick sheets of glacial ice. Scientists estimate that as much as 3000 metres (10,000 feet) of ice covered Hudson Bay at the height of the last ice age, and that only eleven thousand years ago the ice was still as much as 1500 metres (5000 feet) deep over the Great Lakes.

Four great ice ages occurred in the relatively recent past. In each, the climate cooled and great quantities of snow collected in the high mountains. The first of these ice ages occurred about six hundred thousand years ago, the last about twenty thousand years ago. During each period the glaciers dramatically altered the Rockies' landscape as they carved and sculpted the soft sedimentary rock that makes up the mountains.

Visitors to the Canadian Rockies can still see remains of those vast ice sheets. The Columbia Icefield, which straddles Banff and Jasper National Parks, is the largest sheet of prehistoric ice in North America south of the Arctic. The icefield, made up of interlocking glaciers, covers about 325 square kilometres (125 square miles), and in places is over 350 metres (1200 feet) thick.

Today, glaciers still cover more than 10 percent of the world's land surface and contain 90 percent of the world's above-ground fresh water. So much water is trapped in glacial ice that, if the great polar ice caps were to melt, much of the coastal lands around the world would disappear beneath the oceans.

Even when the ice is gone, as it is in most of the mountains, the results of the glaciers are there for all to see: land scraped bare of every trace of soil right down to bedrock; rolling fields of glacial till; rocky soil; huge gravel pits and moraines that stretch for hundreds of miles; and steep mountainsides. The most familiar and reliable signs of glacier activity in the mountains are the broad U-shaped valleys chiseled by the ice. And many of the largest lakes in the Rockies are a direct result of the ice's action in gouging out the soft rock and then filling the area with meltwater as the ice melted and the glacier retreated.

(continued on page 119)

Pages 98 and 99
Looking out over the crest of Castle Mountain's southern ridge, one can see a few of the many cairns that stand in mute testimony to the victory of those brave souls who have dared to make the climb. [44]

Pages 100 and 101
Resting on the banks of the Bow River and cradled by the Rockies, Banff is one of the world's most beautiful mountain resorts. The town of Banff takes its name from Banffshire, Scotland, the birthplace of two major backers of the Canadian Pacific Railway. [45]

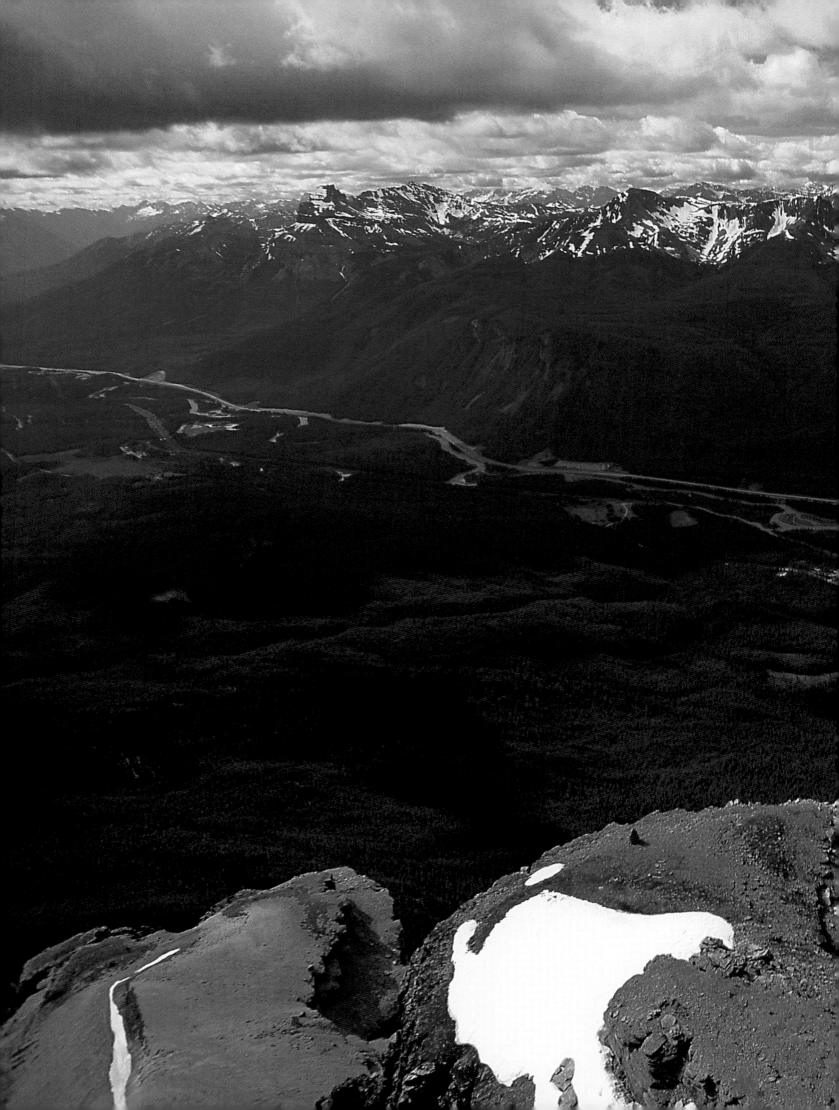

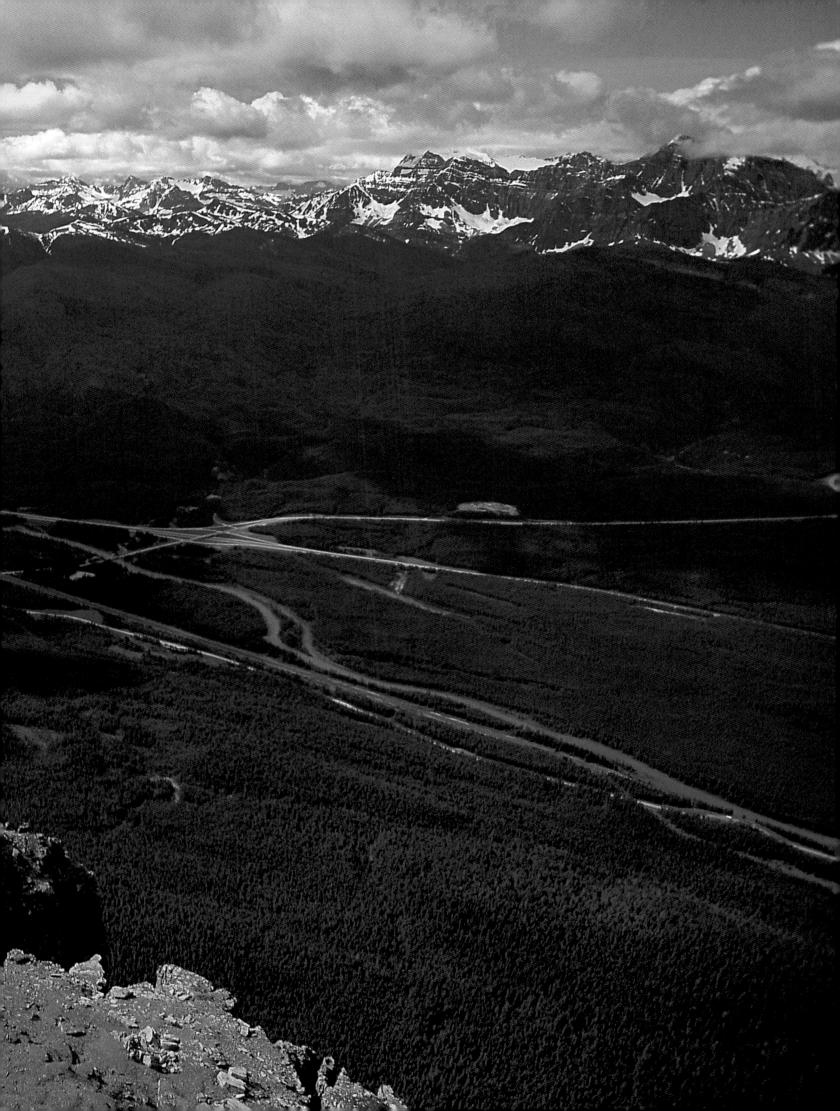

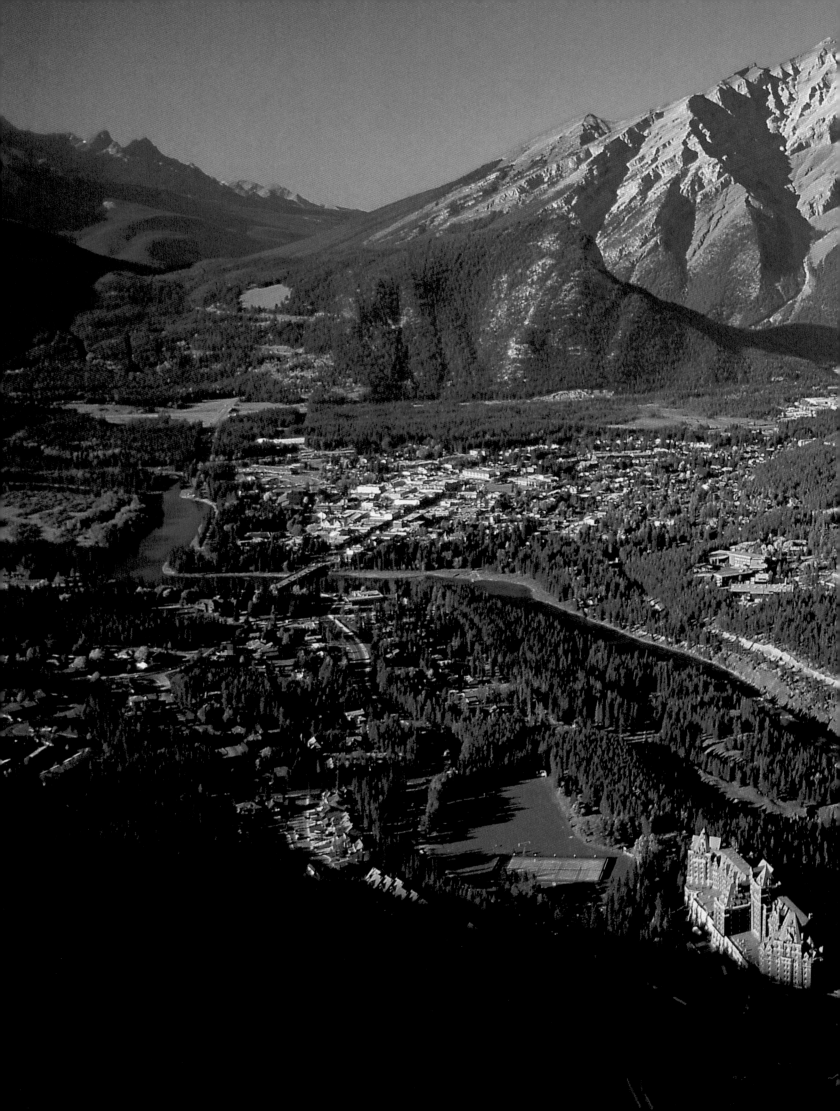

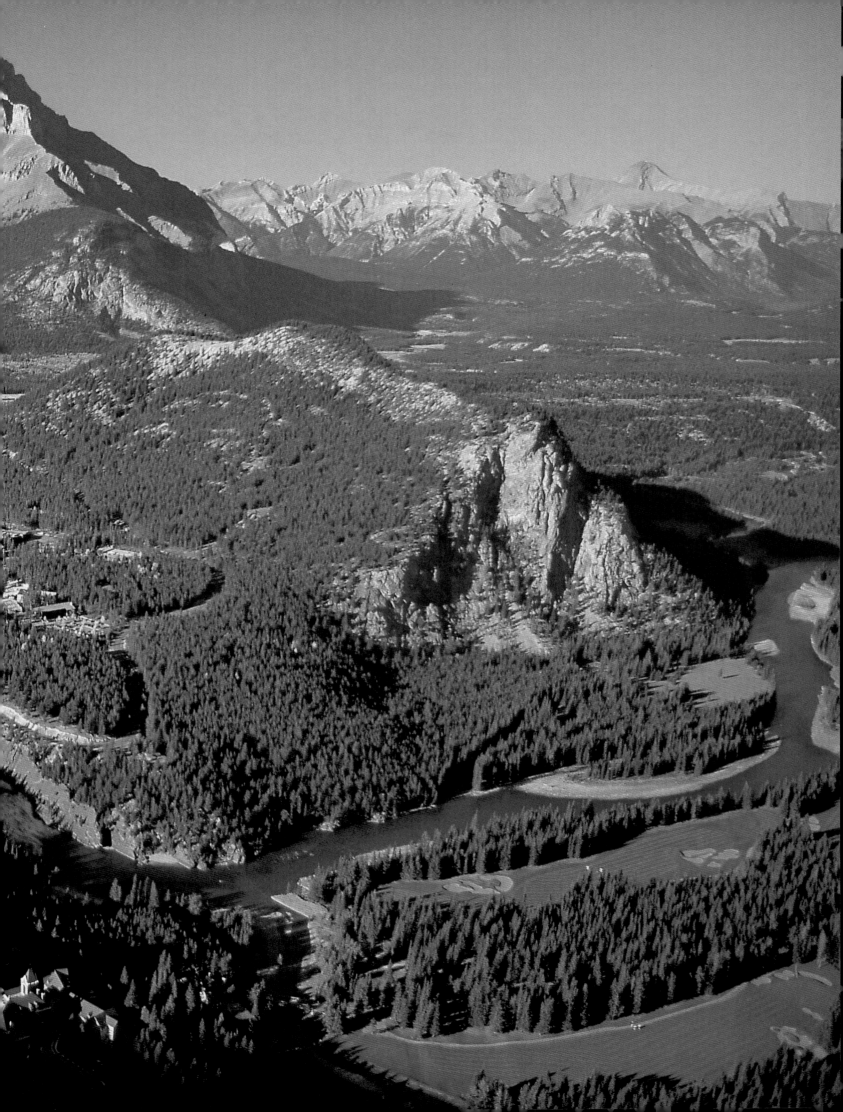

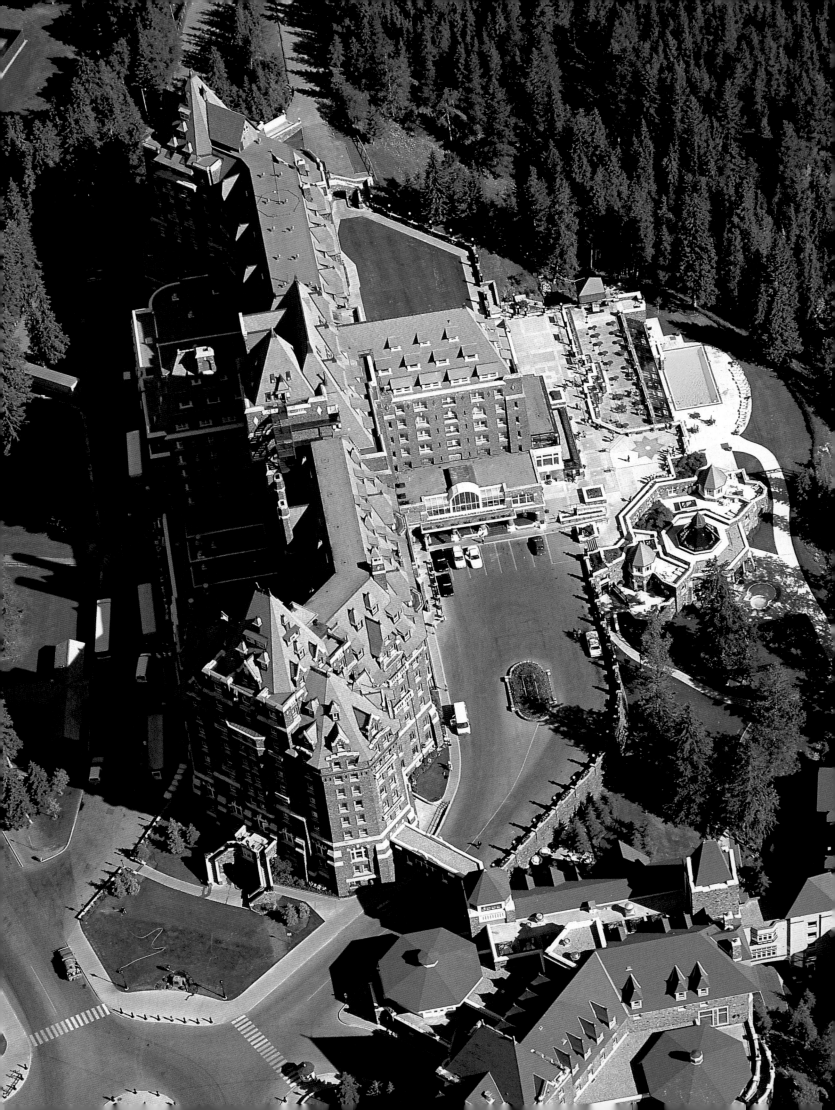

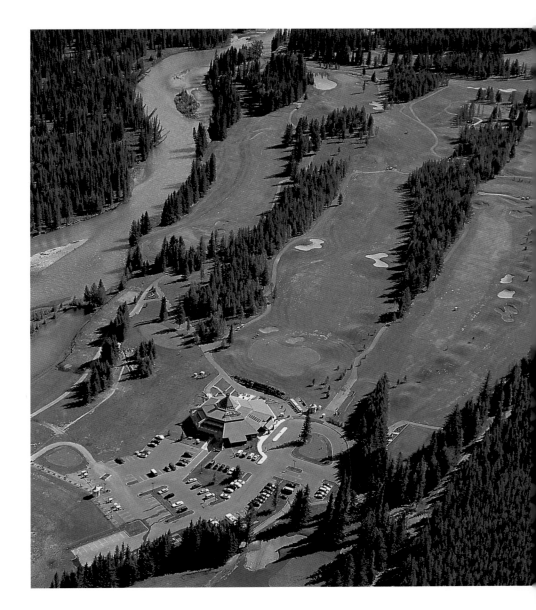

Above and near left

The championship Banff Springs Hotel Golf Course is as challenging as it is stunning. The par 71 course, designed by renowned golf architect Stanley Thompson, rambles beneath snowcapped mountain peaks and along the Bow River. Elk seem to enjoy it nearly as much as the golfers. [46]

Far left

The majestic Banff Springs Hotel was originally constructed in 1888 by the Canadian Pacific Railway. Enhanced by its spectacular natural environment, the hotel is run in the tradition set by the finest European hoteliers. [47]

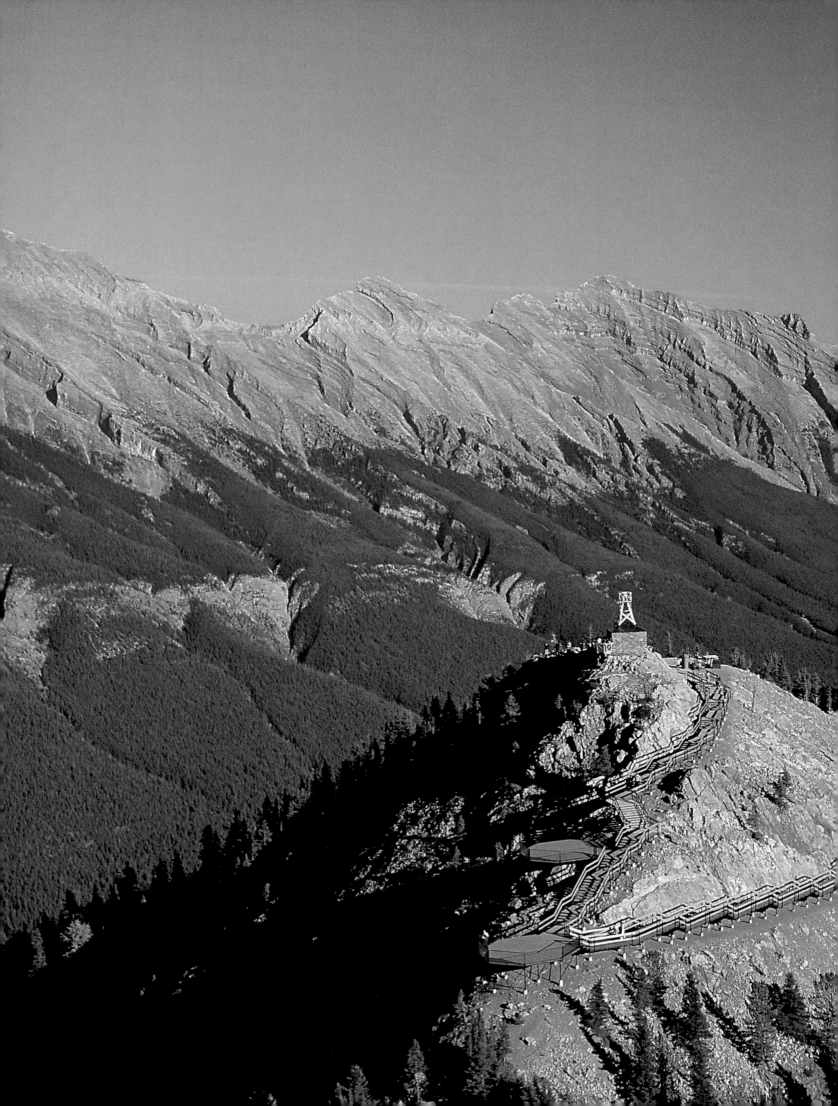

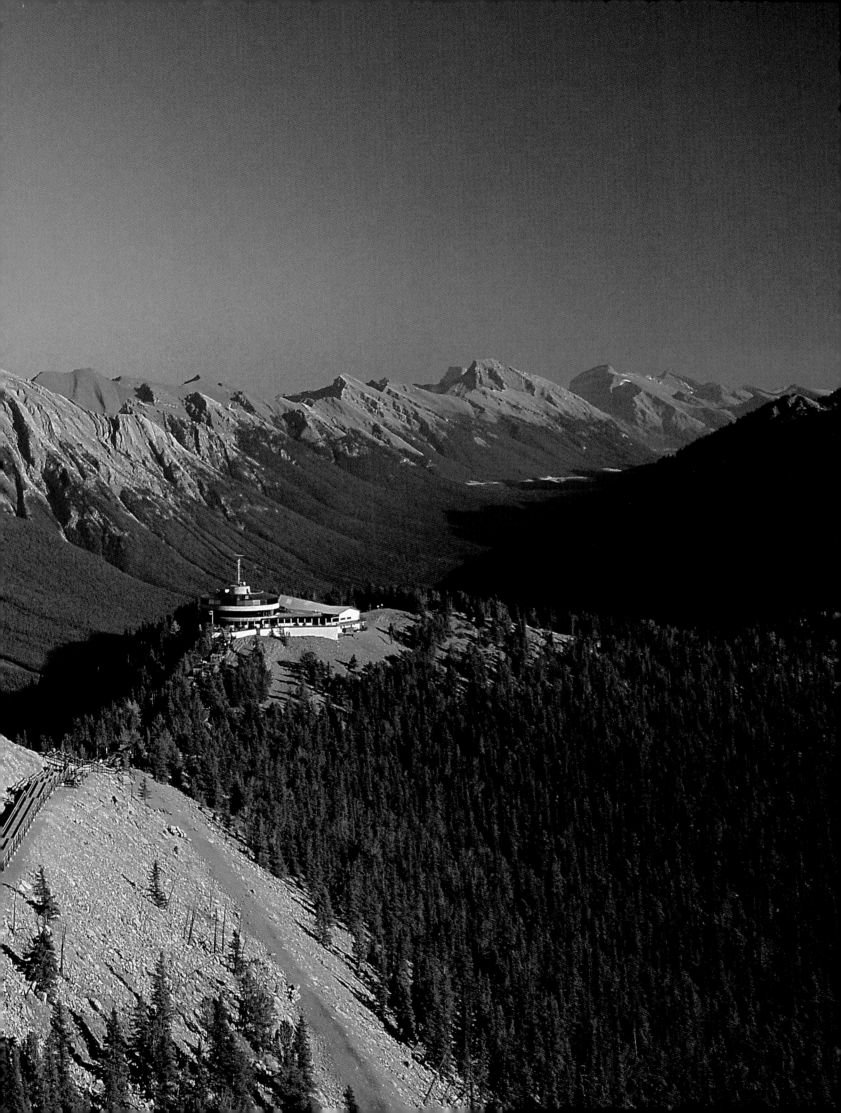

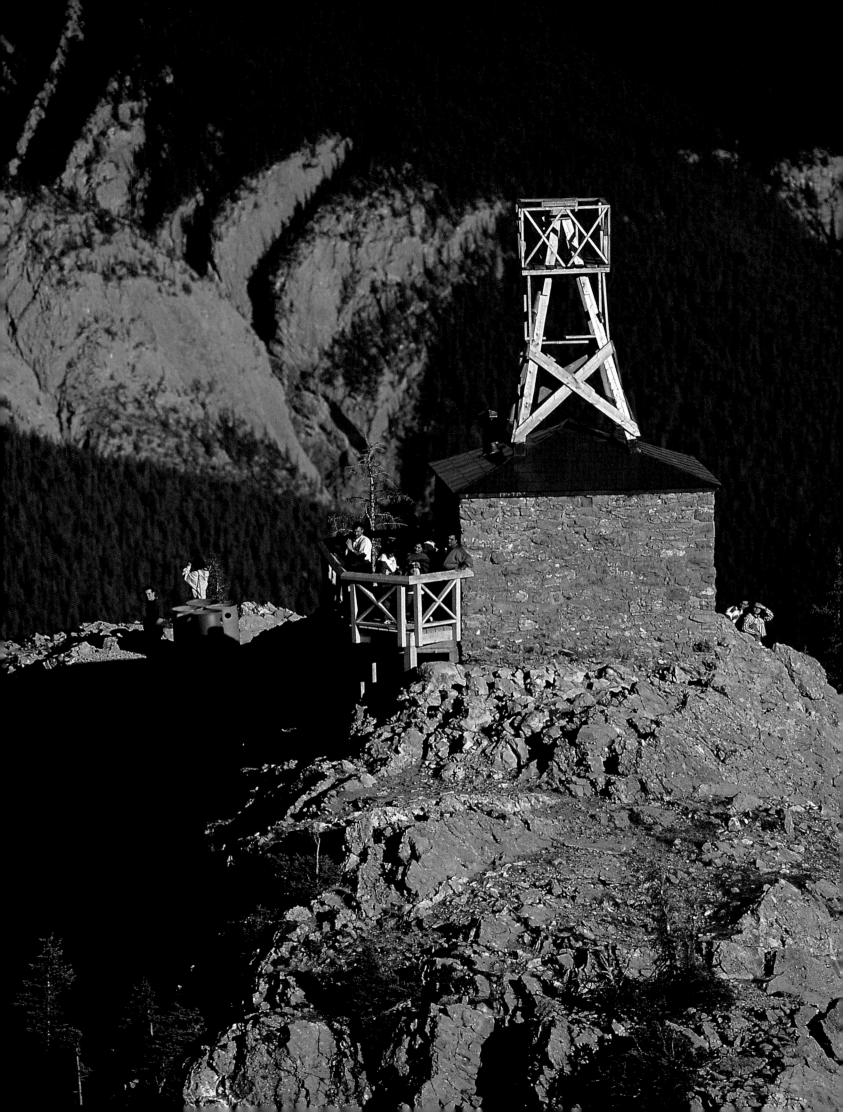

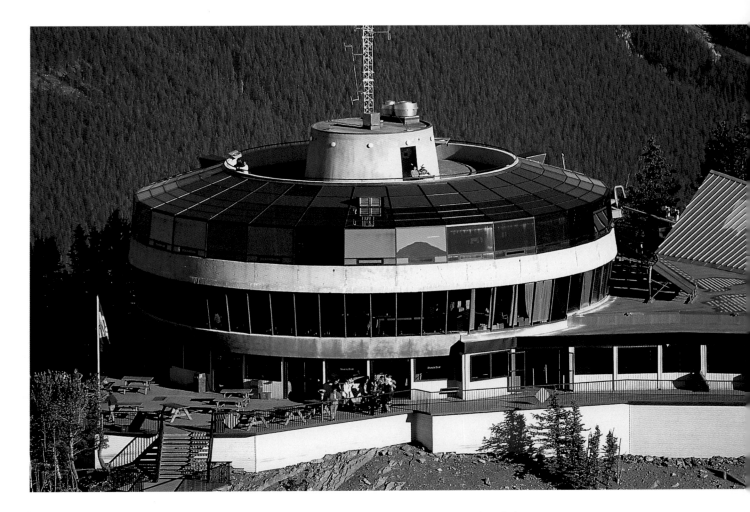

Pages 104–105, 106, and above
Glass-enclosed gondolas whisk four visitors at a time to the top of Sulphur Mountain. At the summit, passengers may hike the ridge or simply enjoy a meal in Canada's highest restaurant and take in the Rockies panorama that lies before them. [49]

Above
Bathers savor the moment, relaxing in the famous mineral hot springs of the Upper Hot Springs Pool while soaking in spectacular mountain scenery. The average water temperature is 40°C/108°F. [48]

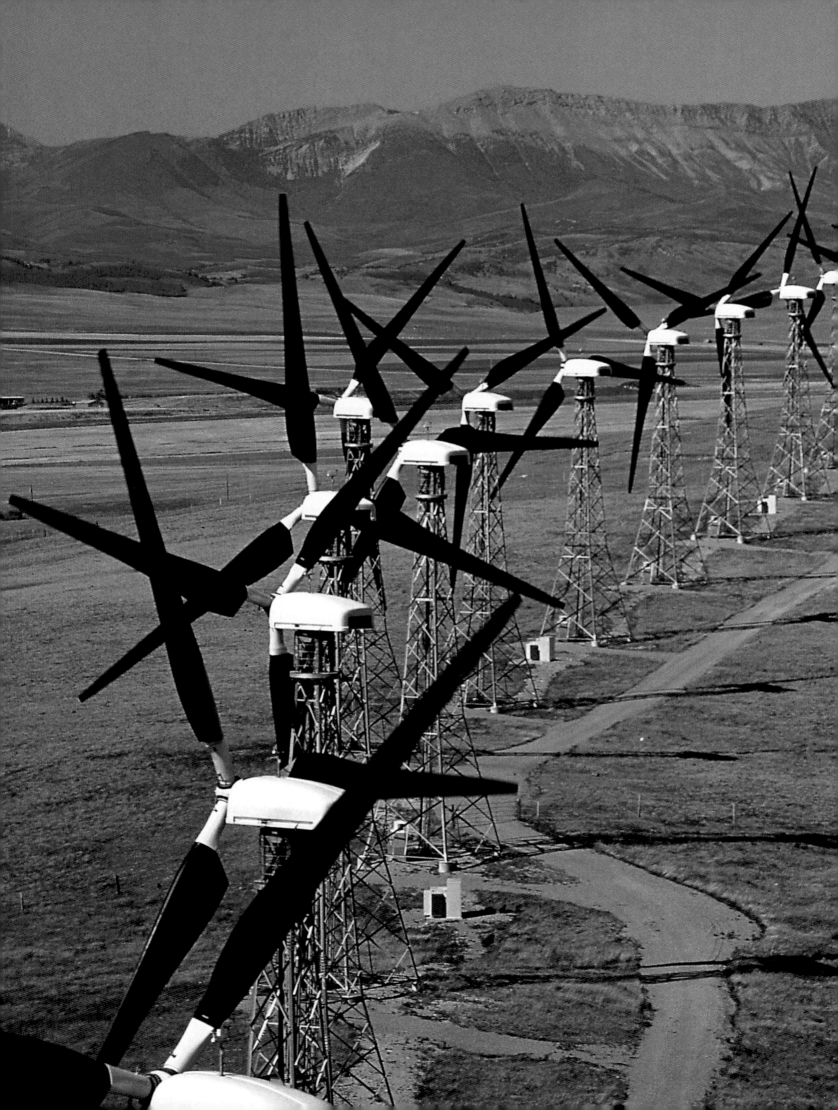

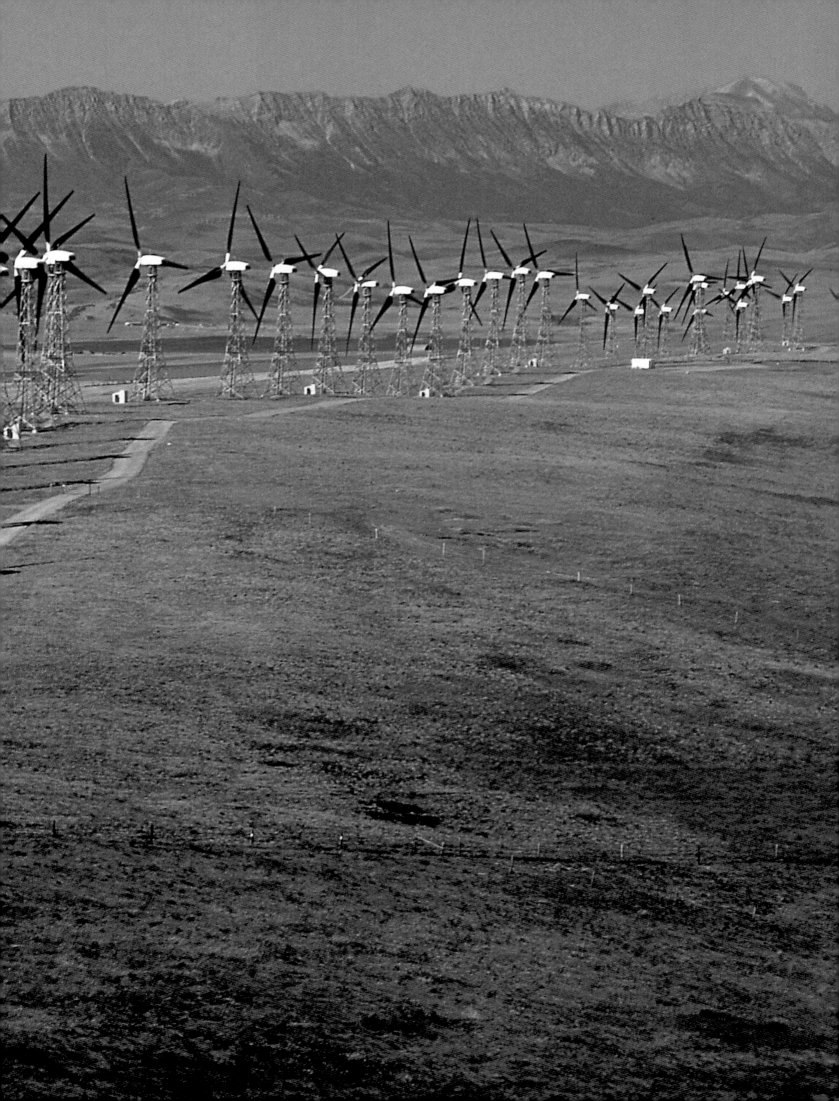

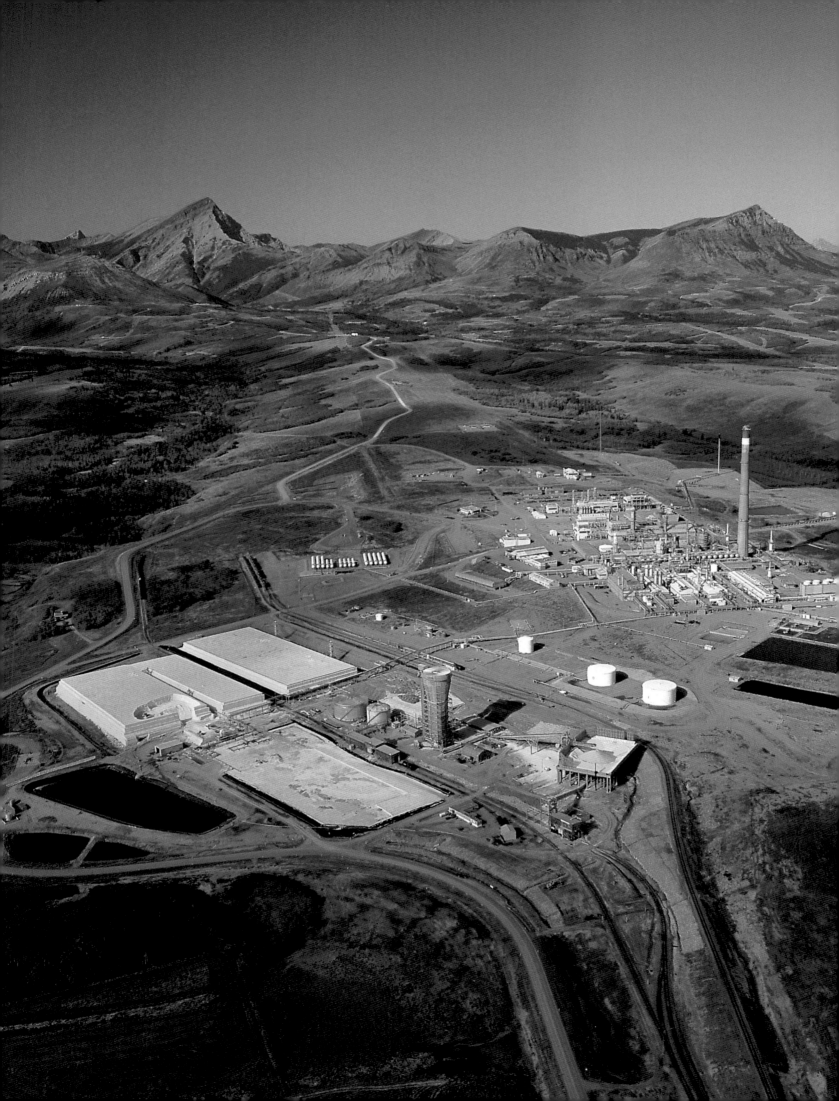

Pages 108 and 109
At Alberta's Cowley Ridge Windplant, 52 wind turbines are part of a green-power test project to generate electricity. Infamously frigid winters require that the turbine blades be treated with an ice-shedding coat of black paint. One wind turbine operating for an hour generates sufficient power to supply an average household's electricity for a month. [50]

Left
The Shell Canada Waterton complex is a gathering, separating, and processing facility near Waterton Lakes National Park. The 2200 metric tons of sulphur produced daily are used mainly in making matches and phosphate fertilizers. [51]

Above
The sour gas processed from the gas fields yields a variety of products, including natural gas, propane, and sulphur. [52]

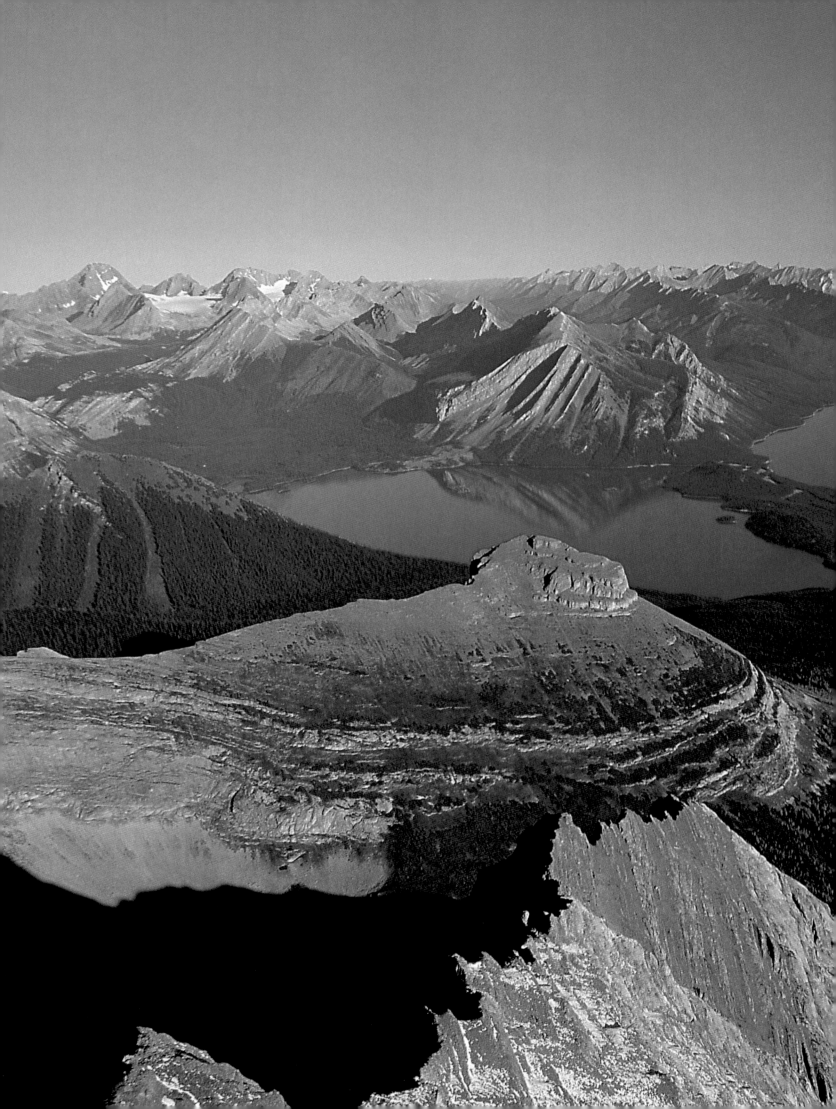

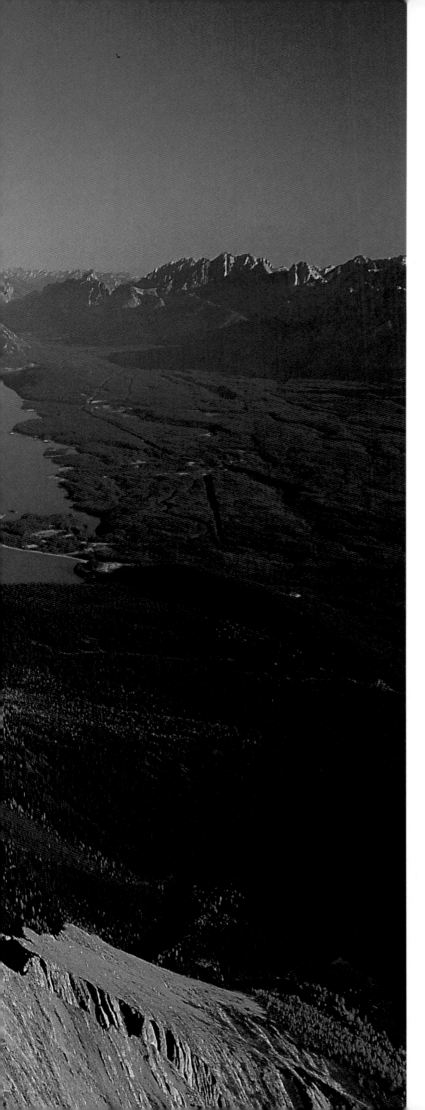

Left

From over the shoulder of Mount Foch comes an unobstructed view of the Upper and Lower Kananakis lakes. Abundant in natural beauty, Kananakis Country, southwest of Calgary, is fast becoming one of Alberta's favorite recreation areas. [53]

Pages 114 and 115

Mount Edith Cavell, just south of the town of Jasper, was named for the heroic British nurse who was executed for smuggling Allied troops out of occupied Belgium during World War I. [54]

Pages 116-117, 118

Holding our position off the shoulder of Mount Chown, we have a clear view of the immense Resthaven Icefield cascading into the valley below. Straddling Resthaven Mountain, the icefield is deep within Jasper National Park. [55]

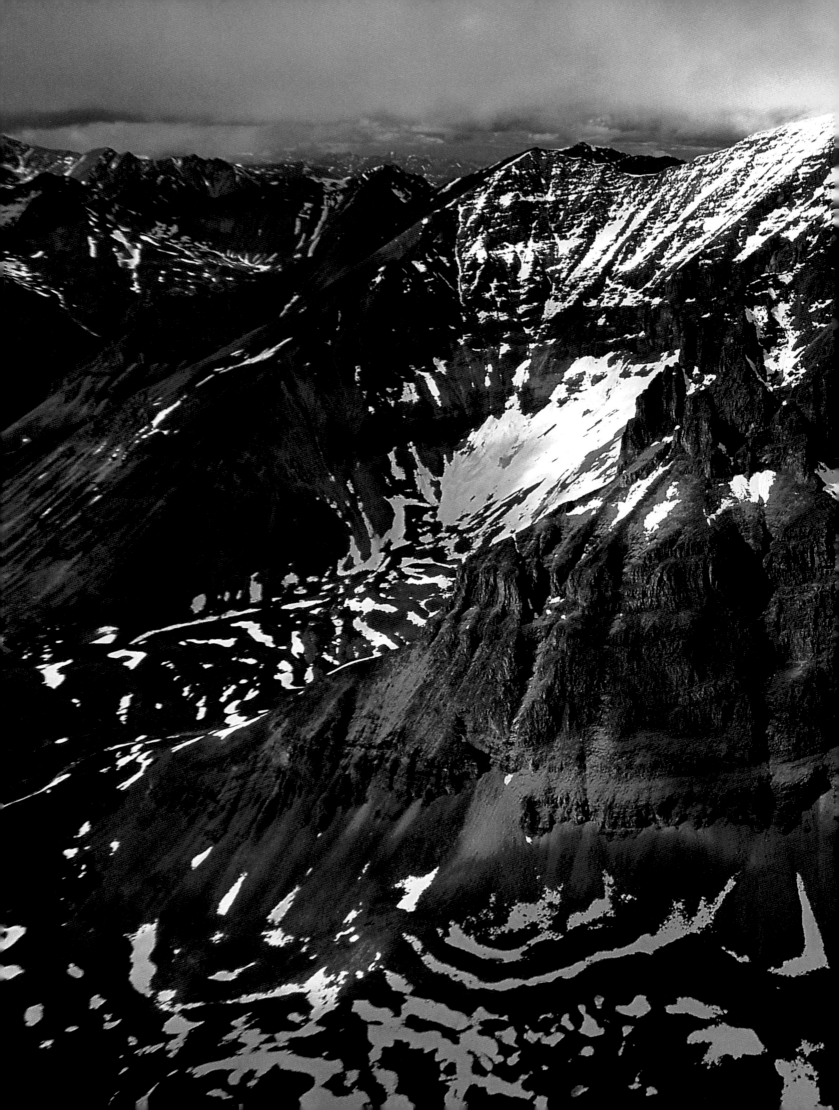

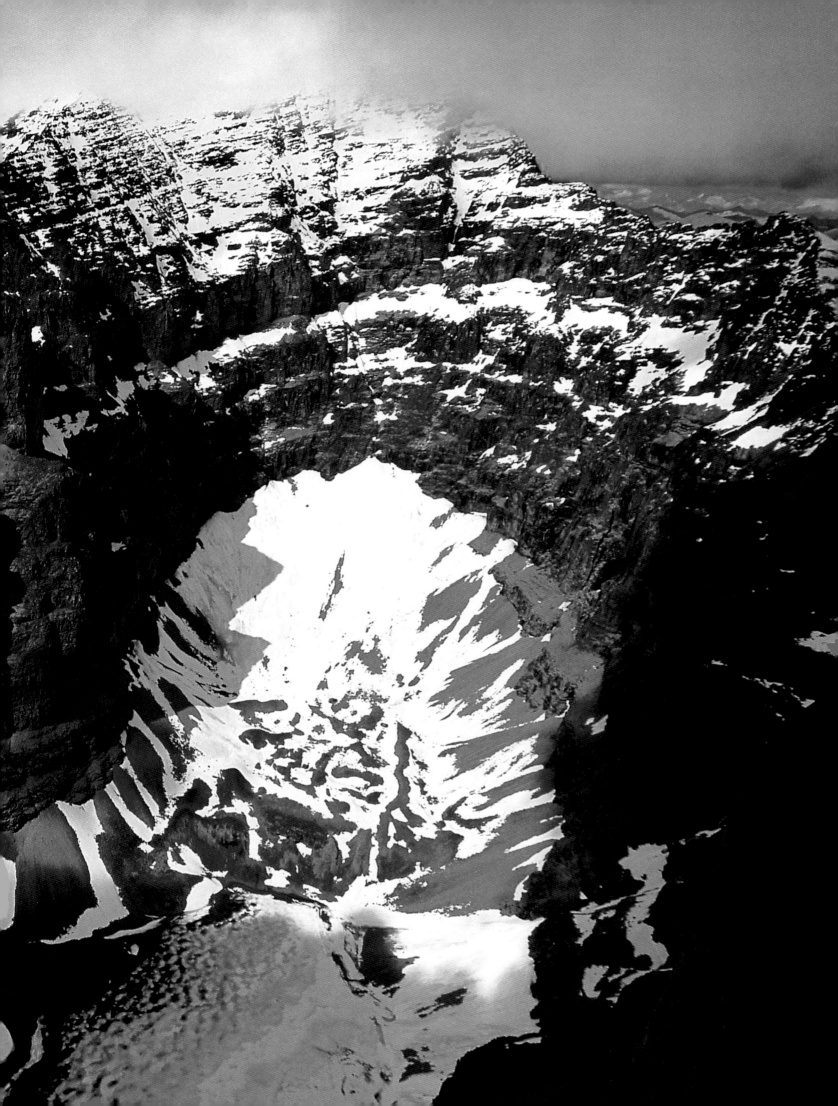

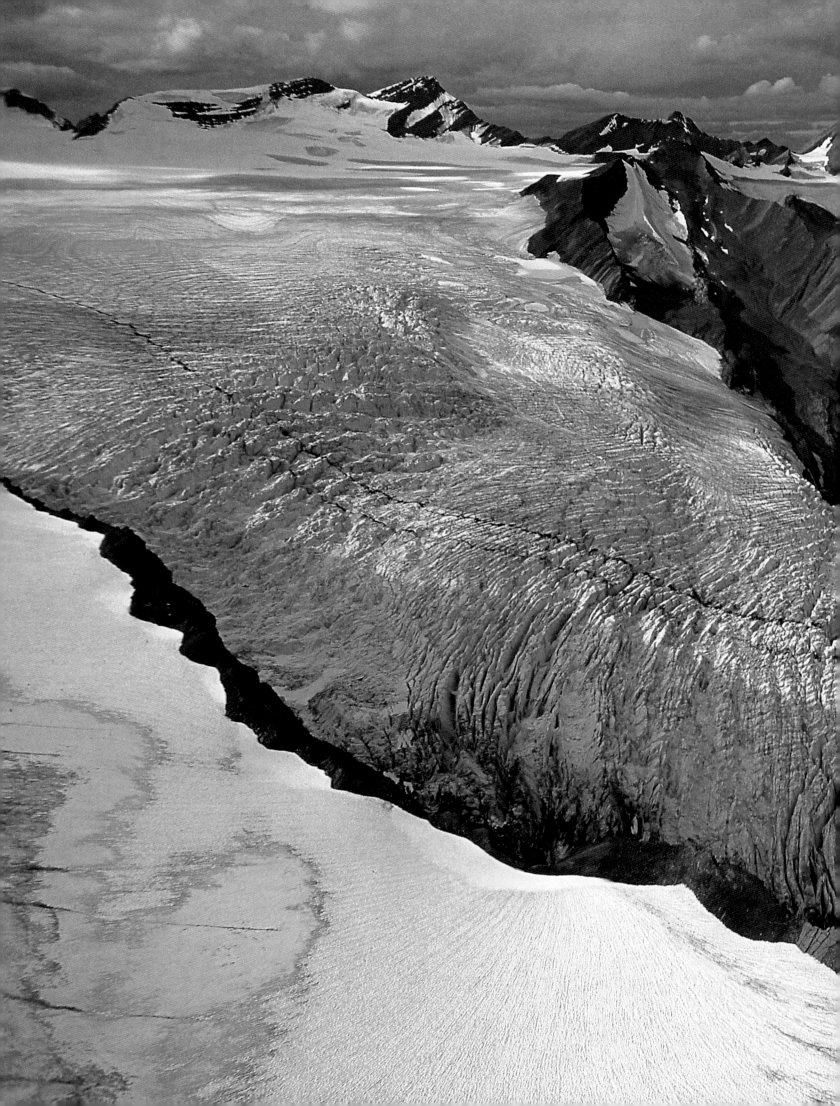

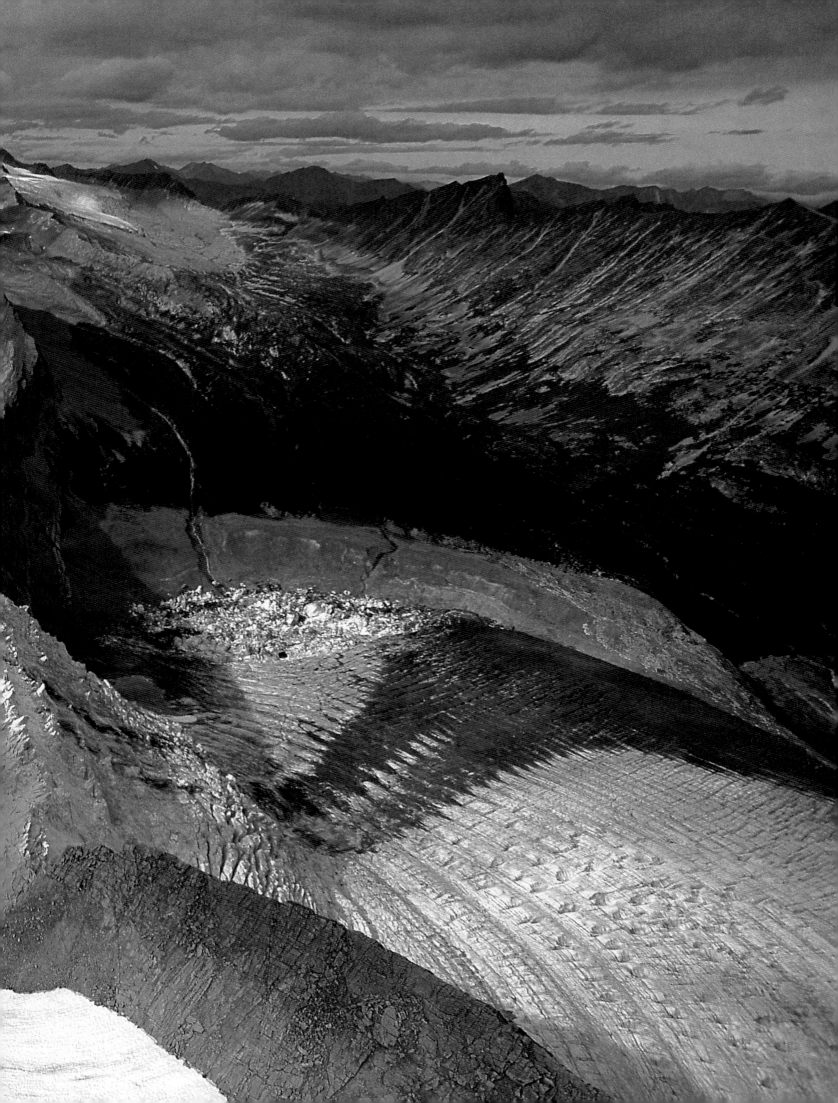

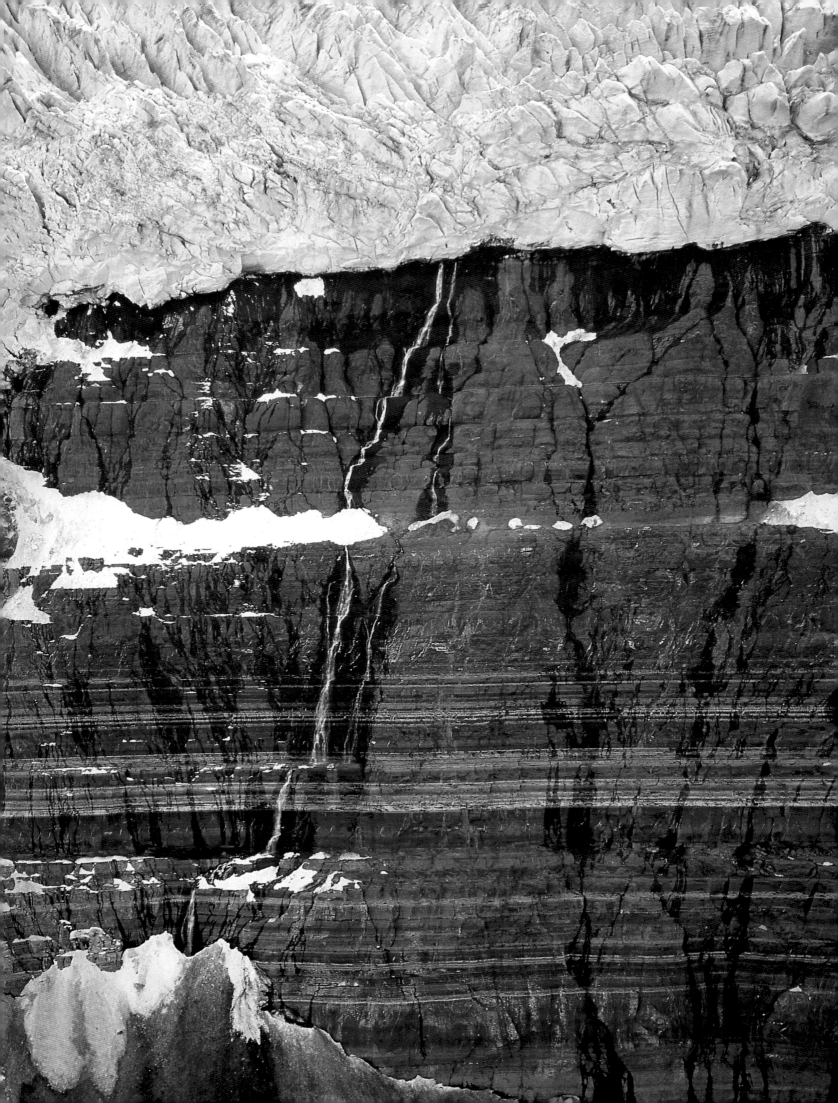

the glaciers

(continued from page 97)

The meltwater carries millions of the bits of crushed mineral-rich fragments of rock that the ice picked up as it moved south. The fascinating turquoise and emerald hues of the water result from the high concentration of minerals washed in along with the meltwater. The best known and perhaps most beautiful example of a glacial lake is Lake Louise, which sits above the Bow River Valley in Banff National Park, but many more are found throughout the Rockies.

Glaciers are born above the snow line when snow accumulates winter after winter in small hollows and mountain valleys. Over many years the snow compacts into ice as it melts and refreezes, and is compressed by the weight of the snow above it. Ice, no matter how thick, does not become a glacier until it begins to advance under its own weight. Ice needs to be about 18 metres (60 feet) thick to be heavy enough to move. Once thick enough, it begins to descend downhill, propelled by its own weight. The ice needs a thin film of water underneath to act as a lubricant and allow movement over the rough, dry ground. The warmer the glacier, the more meltwater and the faster the movement.

Glaciers have been major agents of erosion in the Canadian Rockies. As a glacier moves downhill on its cushion of meltwater, the bottom ice is under such pressure that the ice crystals elongate and slide on top of one another. The moving ice acts as a great conveyor belt carrying millions of tons of rock, sand, and debris over vast distances. The abrasive power of the glacier, which enables it to carve away all but the hardest rock, is provided by the sand and gravel frozen into the bottom and sides of the ice. Moving forward, the glacier becomes a giant sheet of sandpaper scraping the ground below.

These ongoing effects of glacial erosion can actually be seen close up, from the Icefields Parkway connecting Banff and Jasper. Yet even that view does not render its subject full justice. Far more dramatic is the scene from the air. From that perspective we are able to witness a tiny remnant of the ice age – and at the same time sense the power it takes to carve the fantastic peaks so characteristic of the Canadian Rockies.

Left and pages 120 and 121

Hovering ever closer to the massive icefields, we get an idea of the enormity of the yawing crevasses. [56]

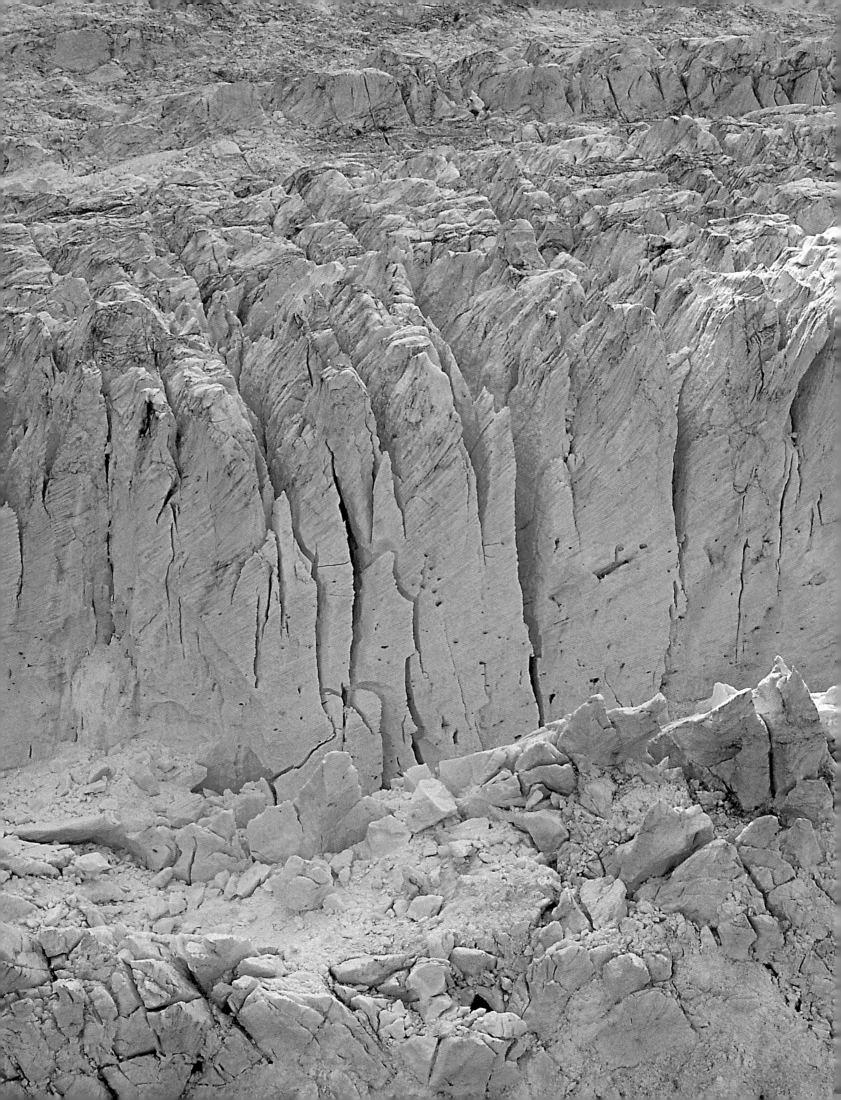

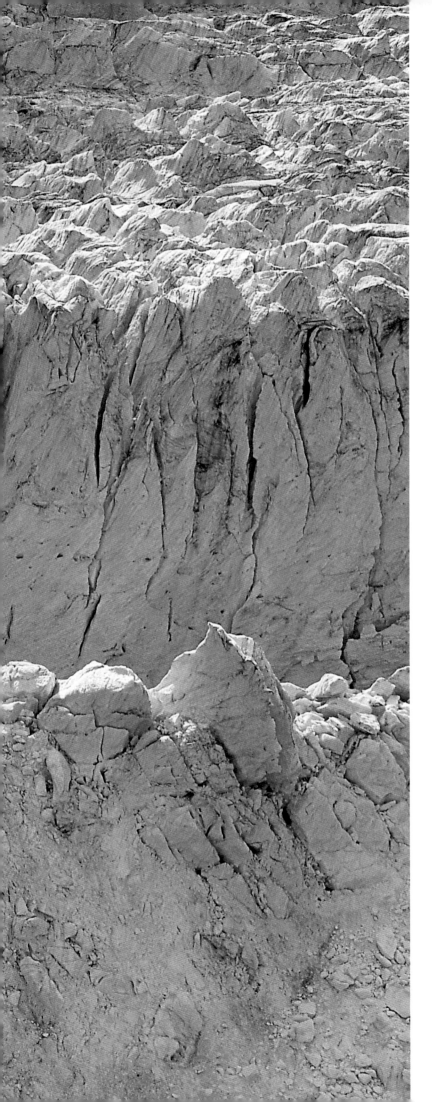

Pages 122 and 123

The Centennial Spires are hoodoos – strange columns of rock carved by wind and water.

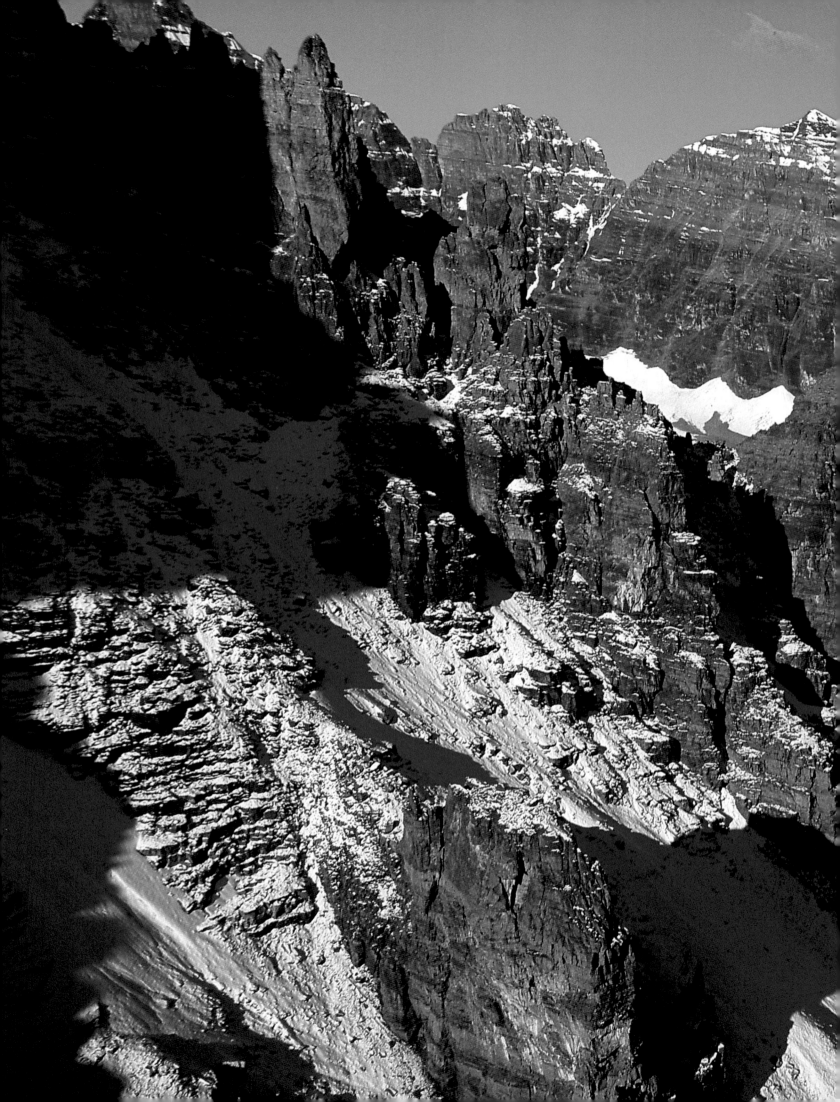

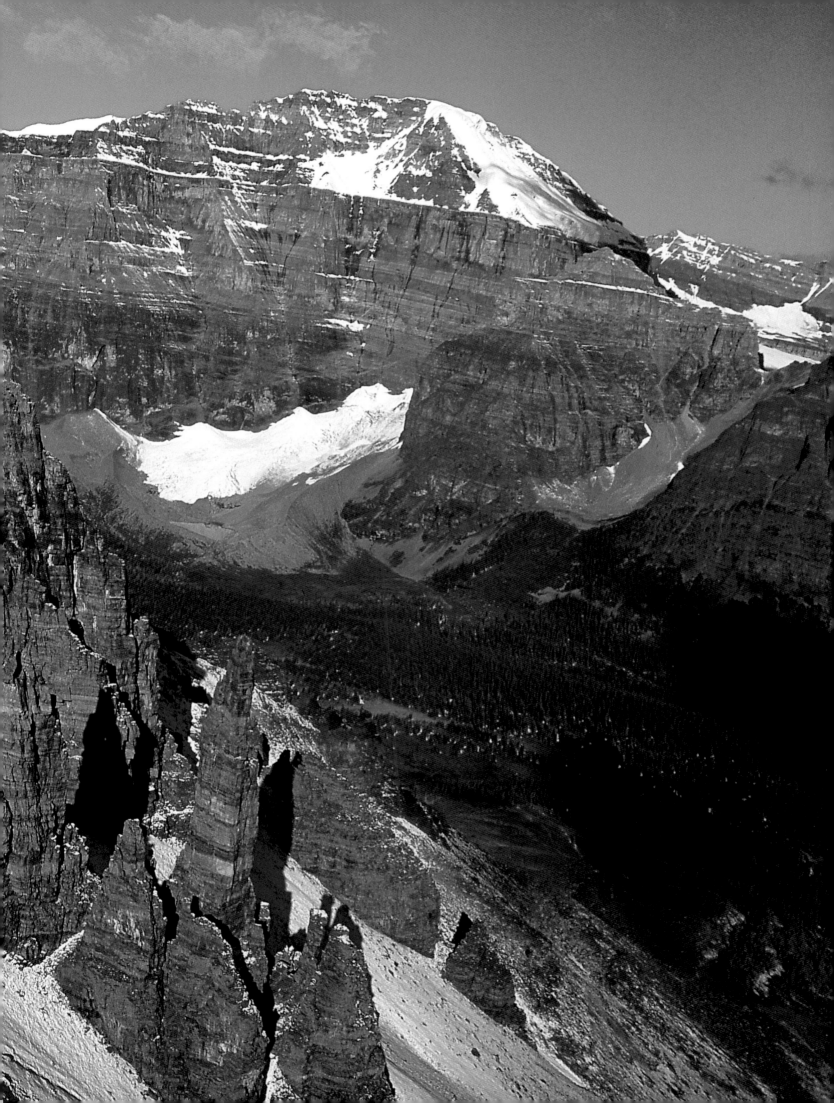

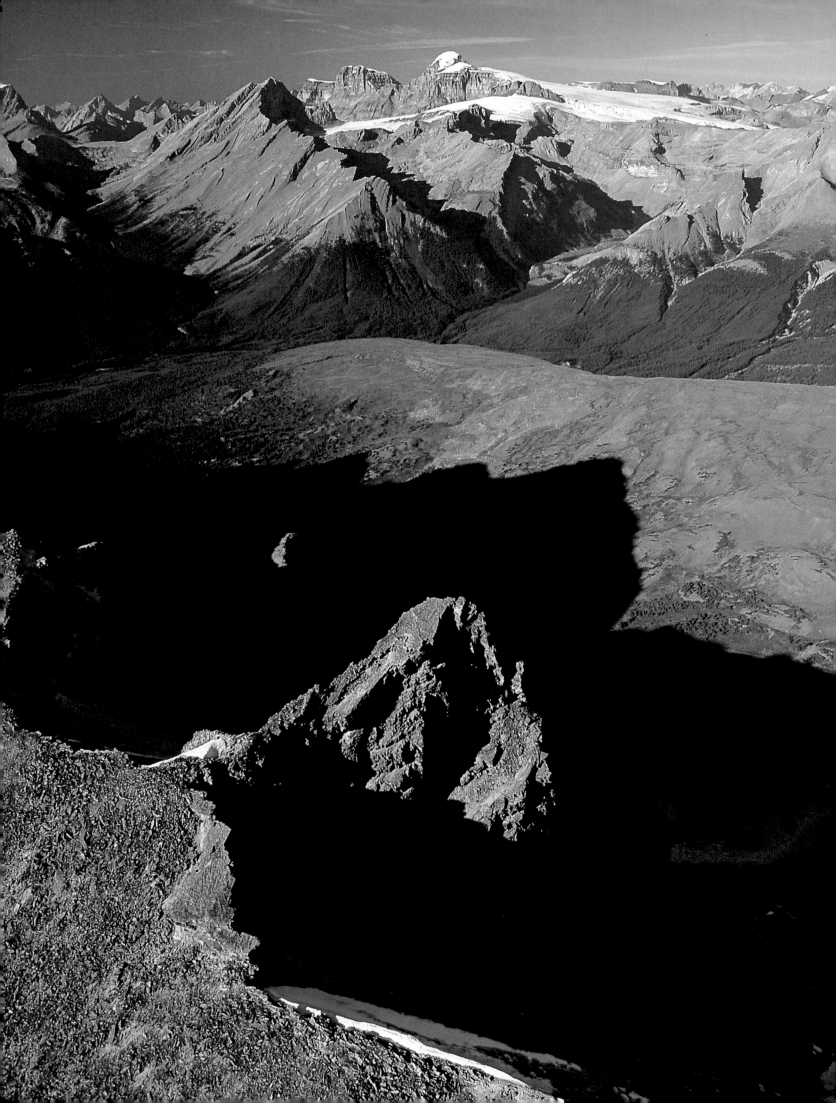

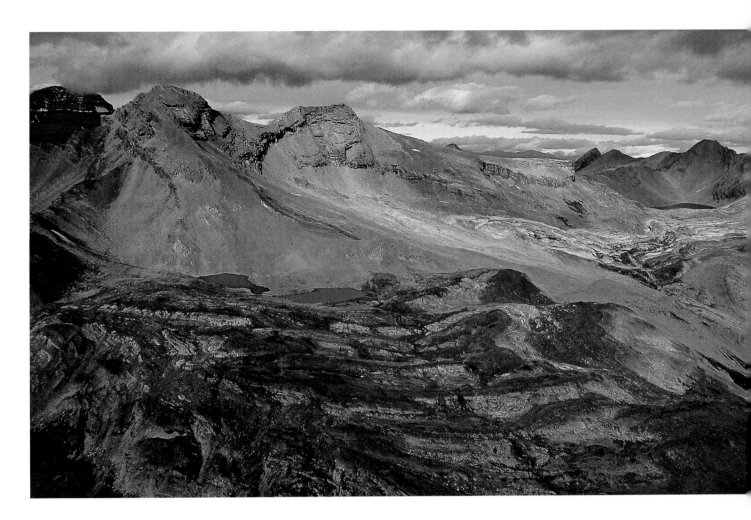

Left

Established in 1907, Jasper National Park plays host to more than two million visitors each year. [57]

Above

Rugged, diverse, and pristine, Jasper National Park is the largest and most northerly of Alberta's four mountain parks. [58]

Pages 126 and 127

Near Mount Edith Cavell and just inside the Alberta border are the Amethyst Lakes, an area becoming popular with hikers and campers seeking a more rugged outdoor experience. [59]

Pages 128 and 129

A perfect way to see Jasper is by taking the Jasper Tramway up Whistler's Mountain. Thirty passengers at a time make the 2280 metre (7500-foot) climb to the alpine zone. There, visitors enjoy breathtaking views of the surrounding mountain ranges and valleys. [60]

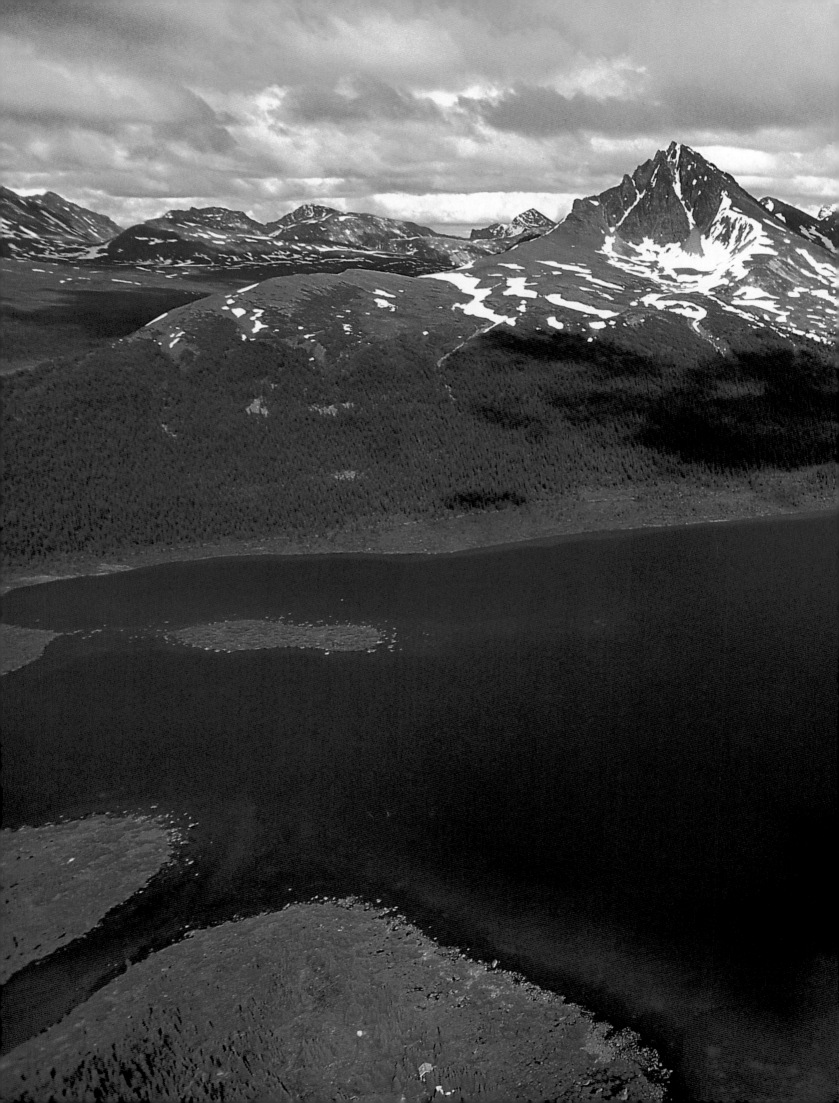

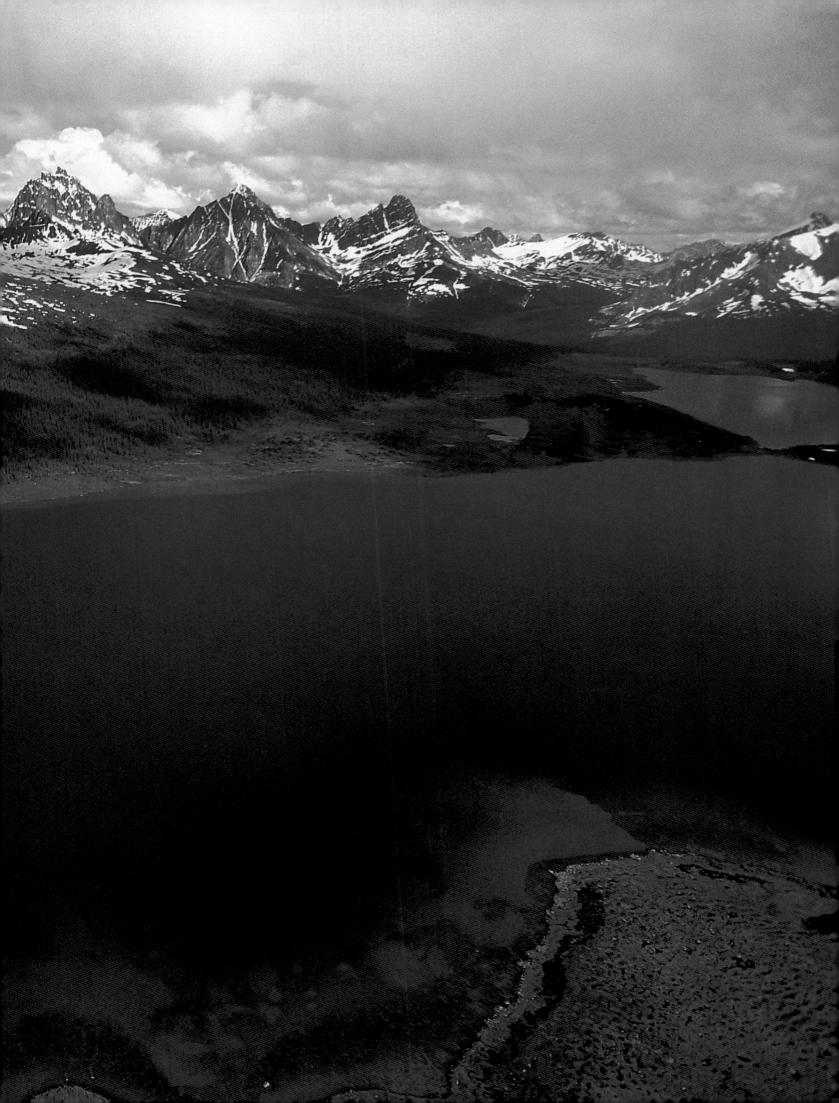

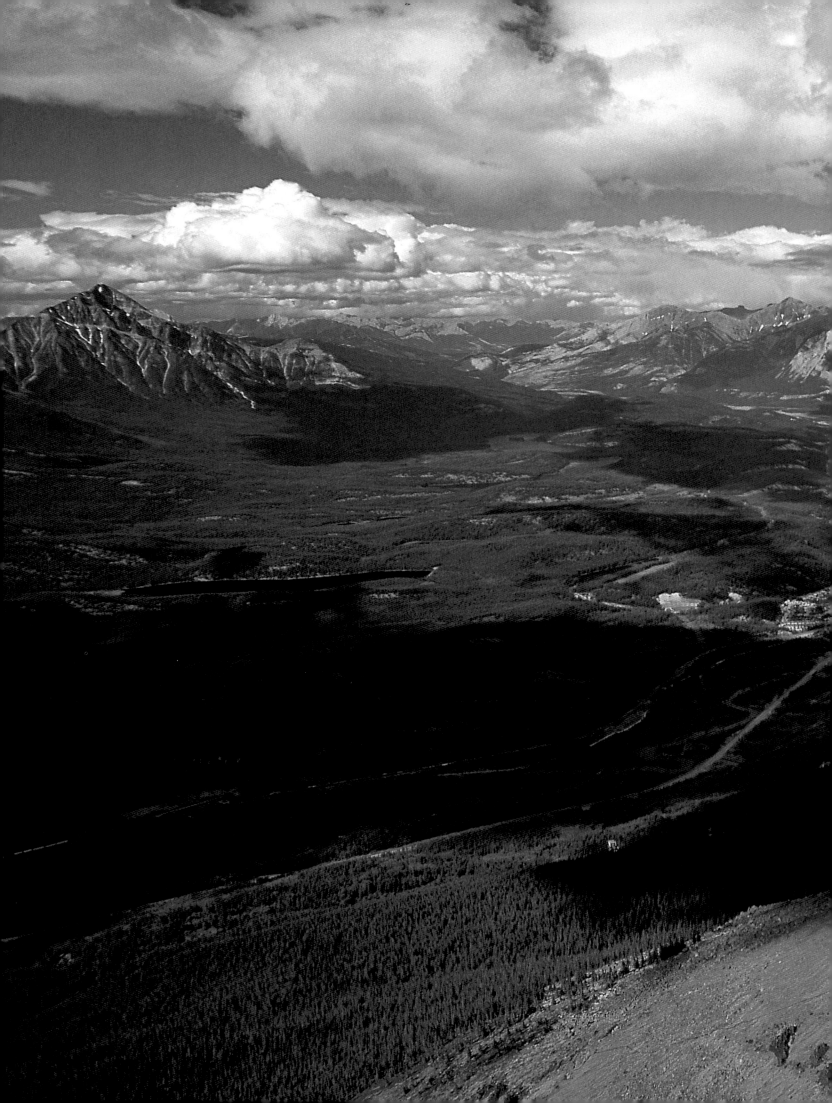

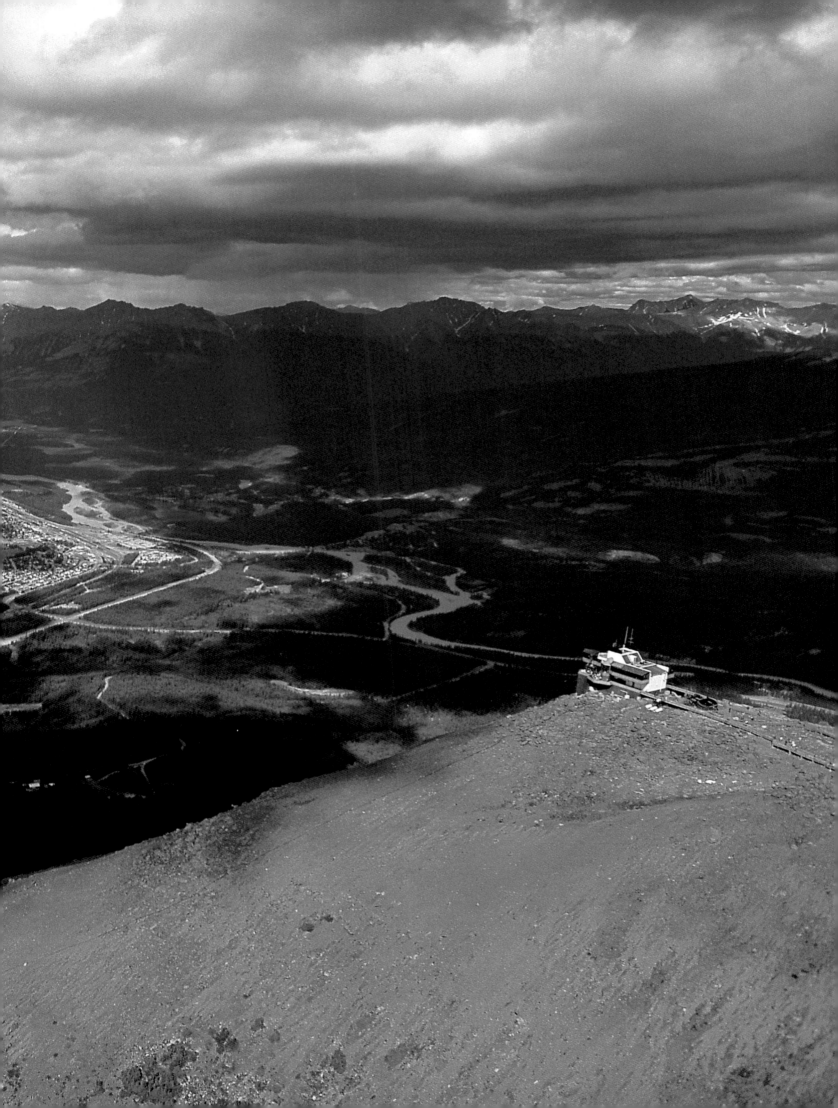

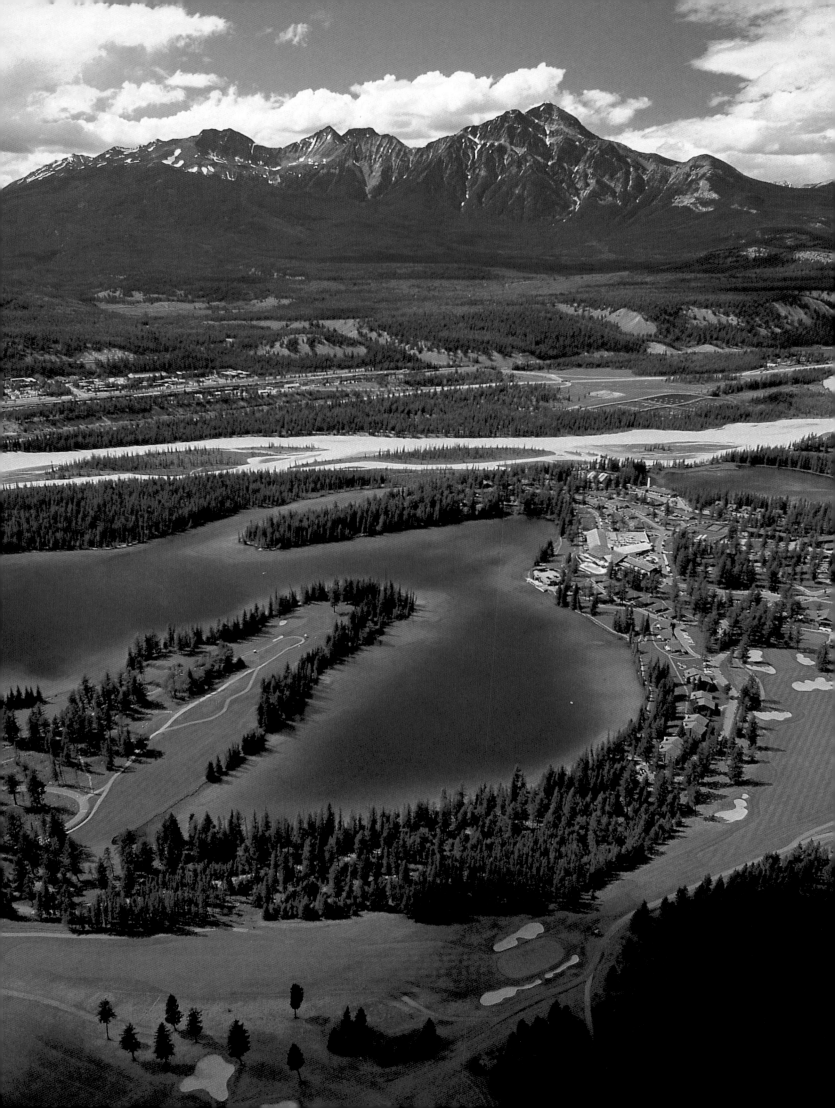

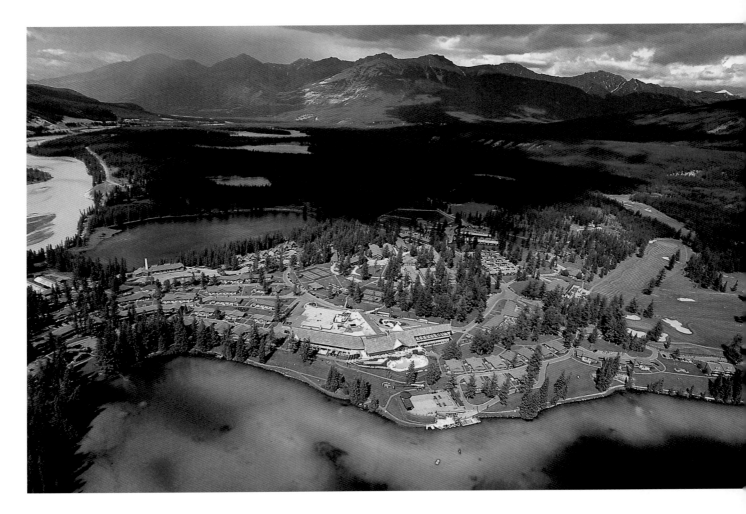

Above

As if by magic, the clouds have parted directly over the Jasper Park Lodge and a warm shaft of sunlight illuminates the lodge and adjacent chalets. The resort is world famous for its gourmet room service to the chalets, provided by servers on bicycles. [62]

Left

Cradled between snowcapped mountains is the Jasper Park Lodge. In the heart of Jasper National Park, this resort is rich in history and offers the "Grand Canadian Lodge Experience" to guests from around the world. The Canadian National Railway opened the first lodge in 1922, which consisted of eight log bungalows. [61]

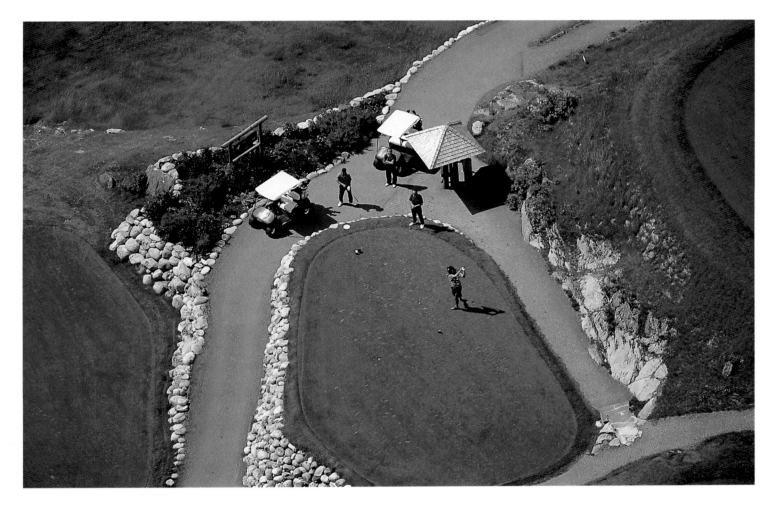

Far left and this page

Surrounded by vast open spaces, the lodge offers
endless activities in an exquisitely tranquil setting:
tennis, swimming, horseback riding, boating, or
golfing on the resort's own championship 18-hole,
par 71 golf course. It was here in 1947 that Bing
Crosby won the course championship. [63]

Pages 134 and 135

A sweeping view of the Columbia Icefield
with the Athabasca Glacier reaching out toward
the visitor center. Crowning the Great Divide,
the Columbia Icefield flows into both Banff and
Jasper National Parks. The massive icefield is one
of the largest accumulations of ice and snow south
of the Arctic Circle. [64]

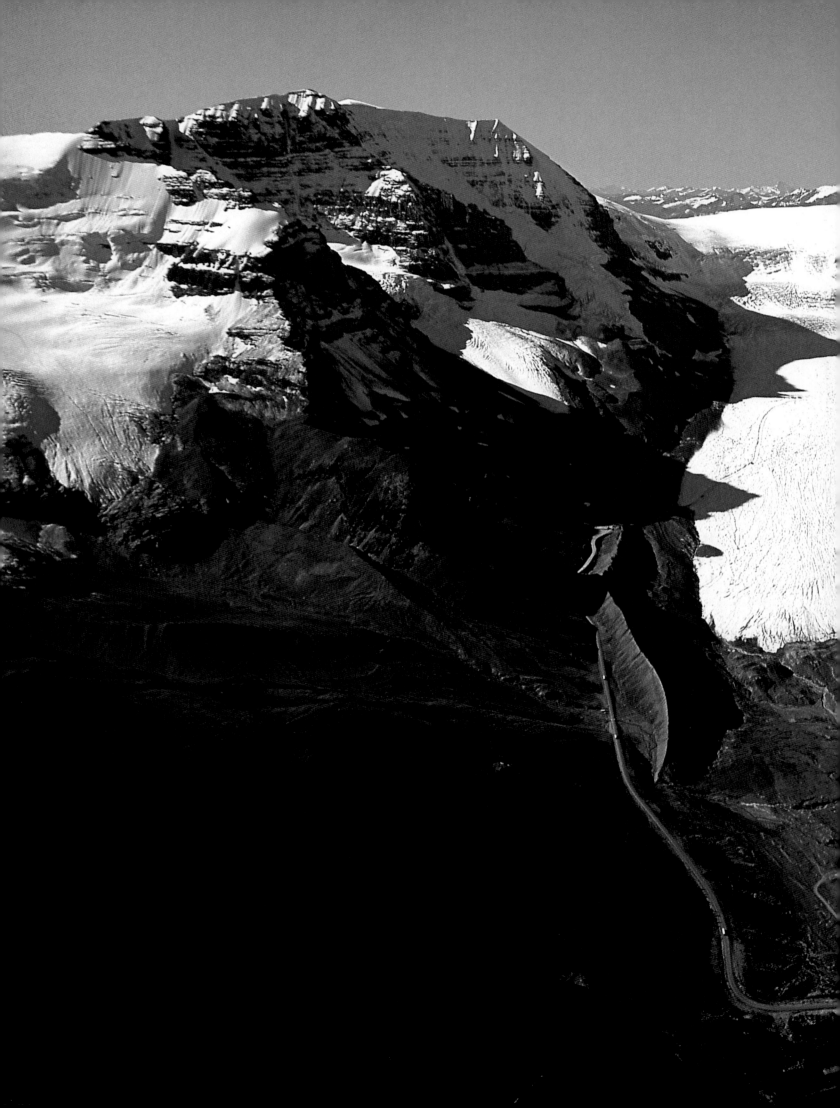

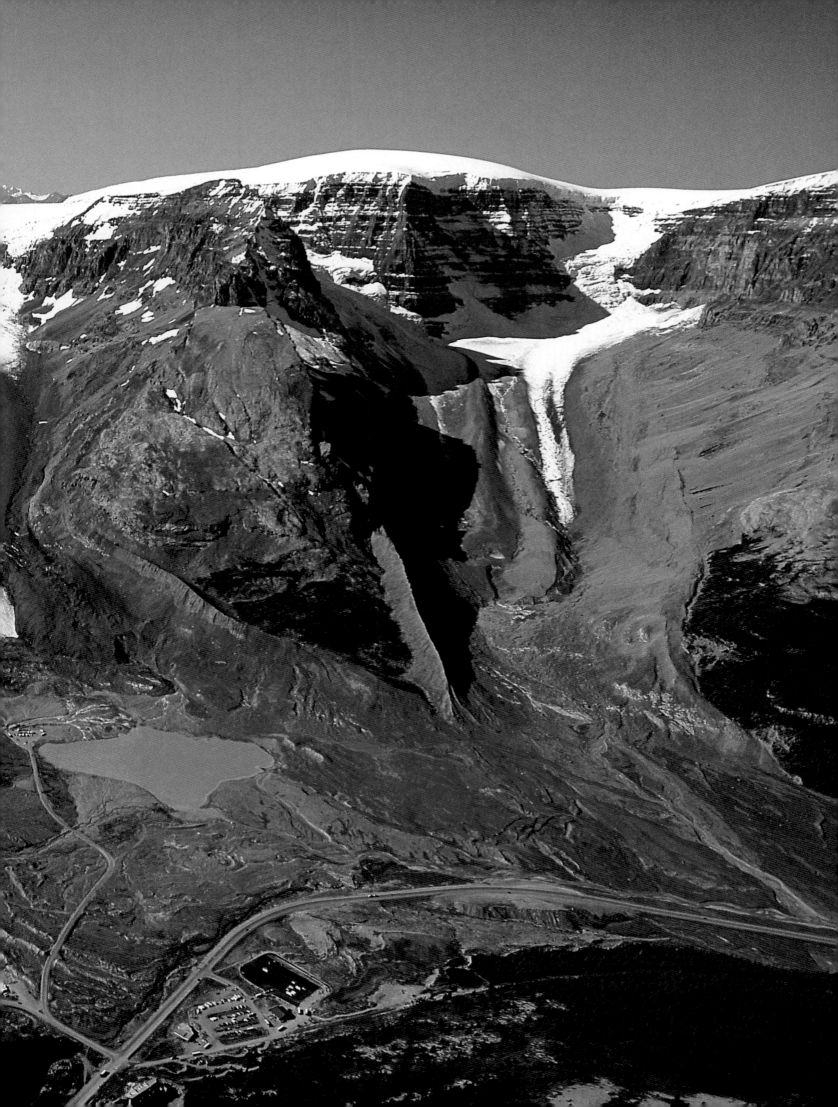

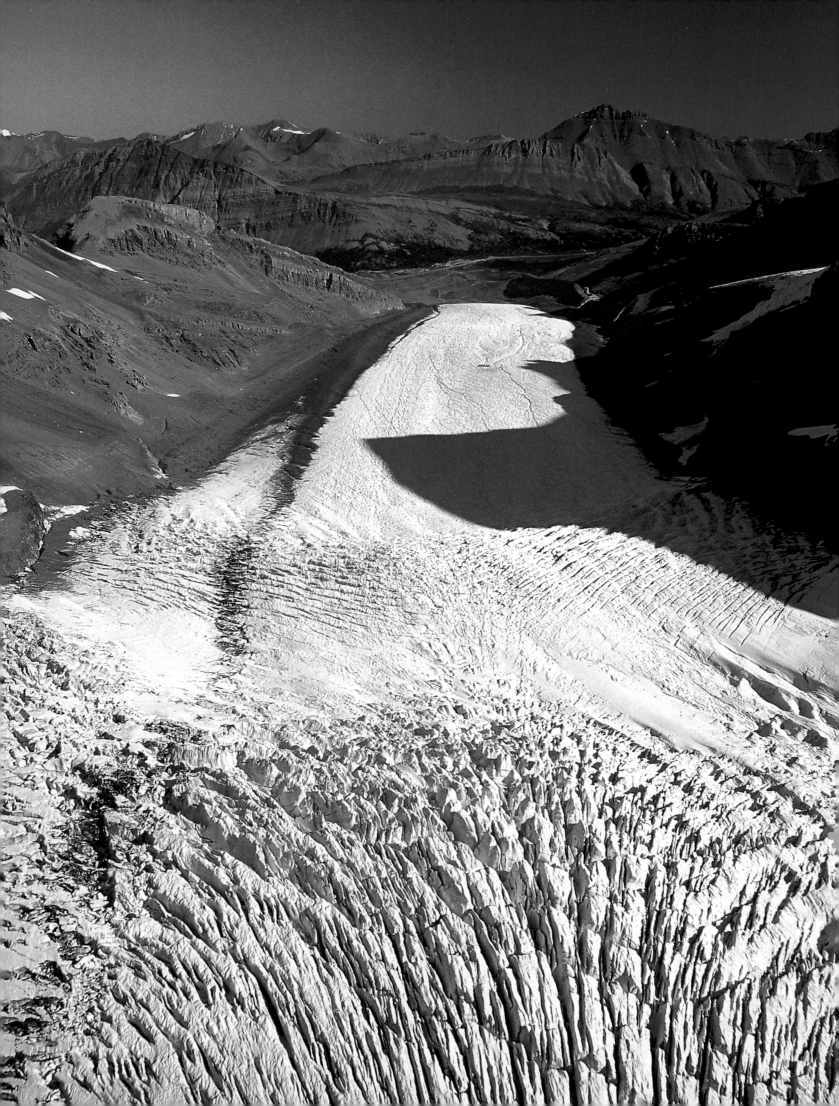

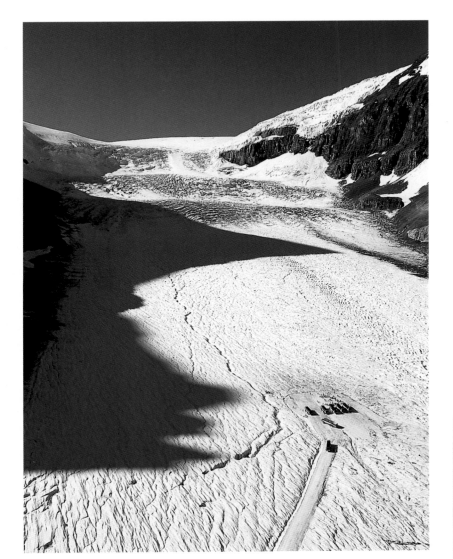

Left

A different perspective of the Columbia Icefield, as we look down from the top of the Athabasca Glacier toward the "snocoaches" and the visitor center. [65]

Above

"Awesome" is often heard as visitors make their humble trek up the frozen glacier, as if to pay homage to its grandiose presence. [66]

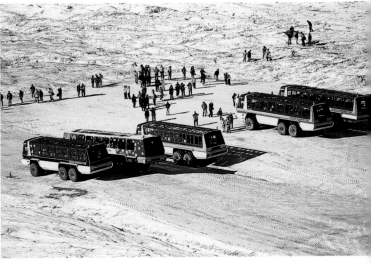

Above

Every year, many thousands of adventurous visitors take the "snocoach" tour halfway up the tongue of the Athabasca Glacier, experiencing what it is like to set foot on the remnants of the last ice age. [67]

Pages 138 and 139

Helena Ridge, resembling a giant stone sawtooth, lies just east – across the valley from famed Castle Mountain, and visible from the highway. [68]

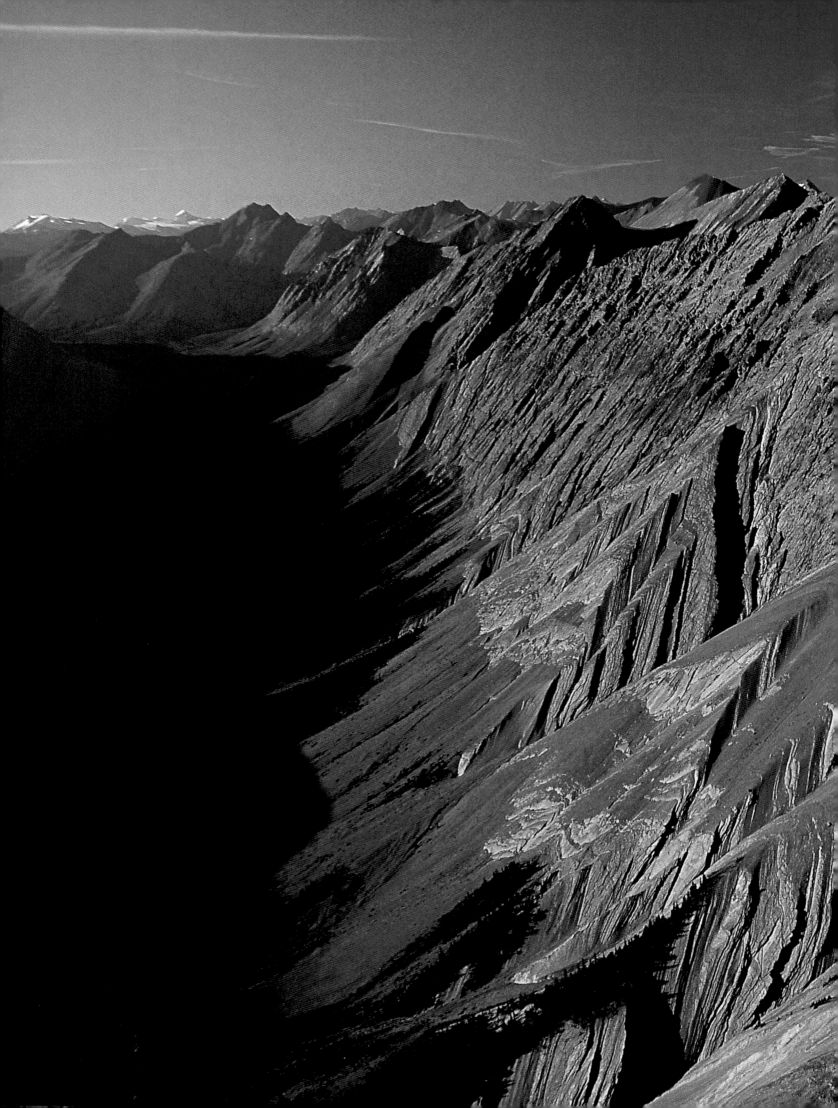

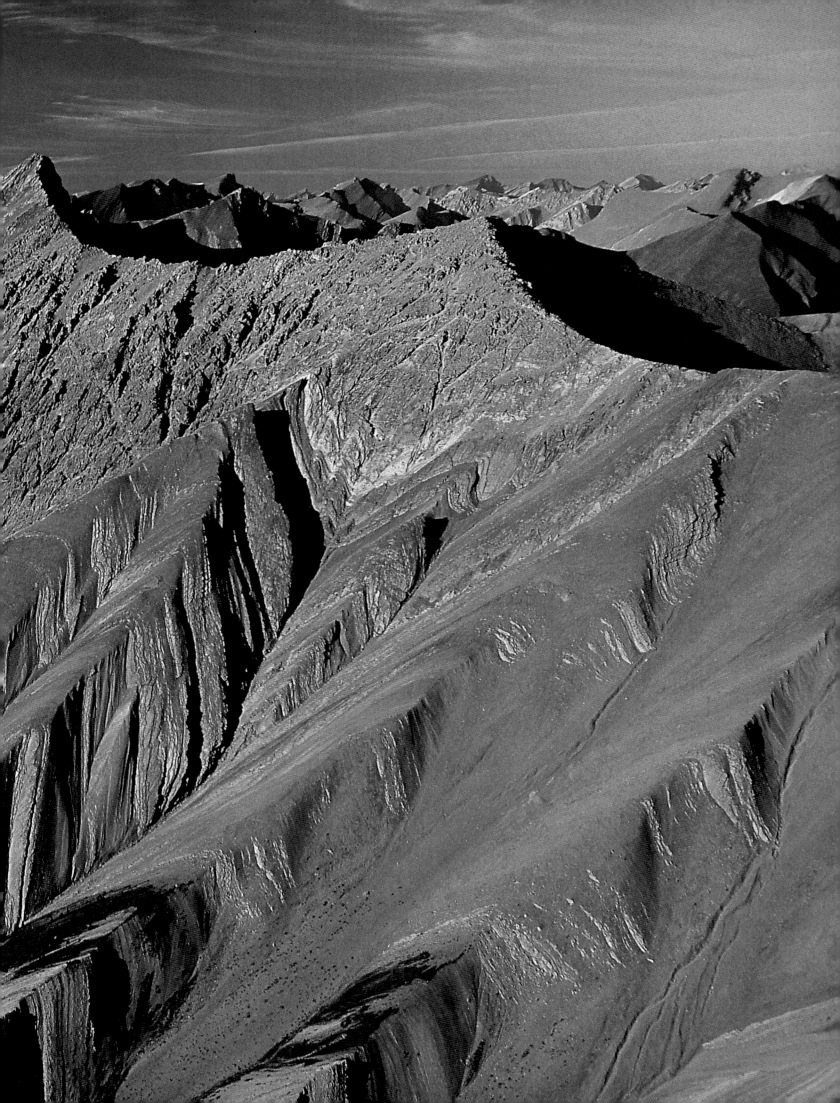

List of Photographs

Pages

About the Author

Russ Heinl has been a professional photographer for nearly two decades. Originally from Toronto, he now lives with his family in a quiet seaside village near Victoria on Vancouver Island. His passion is aerial photography, and his expertise has won him recognition as one of the best in the world. Russ Heinl's images have been published in his books *Where the Eagle Soars* and *Over Beautiful British Columbia*. He has also contributed to numerous other books, magazines, and newspapers throughout Canada, the United States, and Europe. He is especially proud to be under contract as an aerial photographer with Canada's famous air demonstration squadron, the Snowbirds.